C.L.R. James
The Artist as Revolutionary

C.L.R. James

The Artist as Revolutionary

PAUL BUHLE

VERSO

London · New York

This edition published by Verso 1988

Verso
UK: 6 Meard Street, London W1V 3HR
USA: 29 West 35th Street, New York, NY 10001-2291

Verso is the imprint of New Left Books

British Library Cataloguing in Publication Data

Buhle, Paul, *1944-*
 C.L.R. James : the artist as revolutionary
 1. Trinidad and Tobago. Trinidad. James
 C.L.R. (Cyril Lionel Robert),
 I. Title
 972.98′303′0924

 ISBN: 978-0-86091-932-2

US Library of Congress Cataloguing in Publication Data

Buhle, Paul, 1944-
 C.L.R. James: the artist as revolutionary / Paul Buhle.
 p. cm.
 Bibliography: p.
 Includes index.
 ISBN 0-86091-221-3: $35.00. ISBN 0-86091-932-3 (pbk.) : $13.95
 1. James, C. L. R. (Cyril Lionel Robert), 1901- . 2. Authors
Trinidadian–20th century—Biography. 3. Revolutionists–Trinidad–Biography.
4. Historians–Trinidad–Biography. 5. Marxist criticism. 6. Pan-Africanism. I. Title.
PR9272.9.J35Z59 1988
818—dc19
[B]

Typeset by Leaper & Gard Limited, Bristol, England
Printed in Great Britain by Bookcraft (Bath) Ltd, Midsomer Norton, Avon.

Contents

Introduction

This is an intellectual biography, strictly speaking, but also by necessity a political and cultural portrait. I make no pretence to a definitive statement, because the richness of James's life and the full trajectory of his influence will require a large collective scholarship barely under way. Then again, the story of C.L.R. James will look different, more complete and more understandable, from the mid-twenty-first century than from today's perspective. Here I offer a view informed not only by scholarship but also by my own encounters with the man and his milieux.

James has led a most fortunate life. He has often been called a Renaissance Man. That label seems imprecise, if only because his many-sidedness represents not a break from medieval constraints but rather an expansion upon the particular human possibilities in our own time. He has also been called a 'Black Plato', a characterization in some ways wildly inaccurate but not lacking a glimmer of truth. James has been an important West Indian (one could say, Third World) novelist, a keen sports critic, a leading historian, Pan-African theorist and spokesman of great pioneer importance, and a philosopher of universal scope. In his own eyes, he has also been a faithful disciple of Marx and of Lenin. All in all, James would seem to prefigure, in the paths he has taken, the personal range and the integration that the vision of a better society holds out to us all. He has insisted that only artists, and international figures who truly encompass diverse worlds within themselves, can cast their shadow into the future. James himself is both of these.

The Guyanese novelist Wilson Harris, James's artistic colleague for a quarter of a century, has suggested to me an underlying cause of James's significance. For several generations, we humans have all lived in a deep collective peril with no obvious or apparently 'logical' extrication. Our hope, according to Harris, depends upon breaking the 'charisma or total

1

spell [that] Death and violence exercise upon the modern world.'[1] To fall into casting blame upon one civilization or another, James and Harris agree, is to lose sight of the complexities at hand. James learned about himself as an artist through the great products of Western civilization, the Bible, Shakespeare and the classic nineteenth-century novel. But he also intuitively grasped, from his Caribbean surroundings, the incapacity of the accompanying 'master race' narcissism to encompass the many-sidedness of humanity. Confronting the enigma of Western civilization's self-destructive path, James has spent his lifetime searching out antidotes. 'I think,' says Harris, 'the essence of his imaginative engagement with many fields and areas of thought and being is rooted in an exploration of the building-blocks of his age seen through various windows and from different perspectives.'[2] This is likewise the essence of his proffered solutions. My task as biographer is to elaborate this notion in James's work, and the process by which he arrived at his conclusions.

All of James's long intellectual life, from his childhood window-gaze at Trinidadian cricketers to his relentless geriatric television-watching, he has used the available vehicles of mass consciousness, including his own, to apprehend the untested capacities of ordinary people. Therein lies a singular strength. The revolutionary ebb and flow in the twentieth century, no less than the uniqueness of his intellectual tasks, placed insuperable problems before him. More than once he tasted defeat. James invented, I will argue, new forms of intellectual approach to grapple with his own defeats and relative isolation. In doing so, he anticipated recent academic advances in social history, cultural and political studies. But as the resulting texts show, he had more important reasons for this heroic intellectual effort. James believed, and he never stopped believing, that ideas could move masses toward self-consciousness of their own historical tasks.

I will also argue, as a side issue, that the Caribbean, via James's illumination, has made an important contribution to the reinvention of the revolutionary project. From his earliest days, he has felt a sense of obligation to express and interpret the West Indian genius. Even as a British, American or Pan-African thinker, he remained the West Indian. To our collective loss, the appeal on behalf of his region has not been widely heeded. The Caribbean remains at best, in today's world economy, a resort mecca and an export district for musicians. More usually, as in V.S. Naipaul's writing, its societies have been viewed as an embarrassment to the West, mired in ignorance, rhetoric and permanent underdevelopment. Even the valiant opponents of the US intervention into Central America are likely to regard the 'Caribbean Basin' mainly as a site of historic victimization. C.L.R. James has never thought so.

James demonstrated the opposite in *The Black Jacobins*, the tale of

the most successful slave revolt since that of Spartacus, and the first blow for Pan-African liberation in the modern world. He stated in an interview with me several years ago:

> The West Indies is a microcosm of world civilization. The great problems are posed in such a way that everything can be seen.... Everything depended formally upon European literature, European institutions. And yet we are a distinctly Caribbean, Third World people; we are not dominated by the past civilizations. We are in a most unique situation.[3]

This combination is more than riddle. Here, First, Second and Third Worlds have met in a myriad of contexts, mirror to the connections across the world. 'That ground,' says Harris, 'may harbour doom', for it raises the stakes upon economic and cultural superiority, one group over another. Alternatively, 'it may harbour a gateway into regenerative capacities for true change and for ceaseless exploration of the mystery of change at the heart of human malaise or sickness in apparently incorrigible polarisations.'[4] The dual possibility has been for centuries evident in the West Indies. On the one hand, Toussaint L'Ouverture, the genius strategist of Black self-emancipation confronting the dark fascination of Napoleonic tyranny; on the other, Garfield Sobers establishing cricket as a classic, ideal art form which reconciles mind and body (at least on the playing field, as the finest of other art does in theatre, or on the canvas, airwaves or cinema). On the one side, ceaseless conflict predicting the spread of state-sponsored barbarism; on the other, an alternative which sums up the instinctive enthusiasms of the modern masses but which has so far rarely passed from cultural to political life.

Our damaging self-division – described variously as the product of Original Sin or sexual conflict or class conflict or even (in Arthur Koestler) a physiological misconnection of our animal nature to our evolved selves – contains the seeds of redemption. Or we are surely lost. The elucidation of our capacity to accept the historic and psychological dualities, to grow from them and where necessary, beyond them, is the essence of James's endeavour. Wilson Harris's location of James's genius is artistically precise and politically correct: 'the necessity of *individual* originality as much as it is involved in analyses in the life of the people or the body-politic.'[5]

The misunderstanding of this difficult point, and the seemingly divergent or scattered character of his work, have caused James the theorist to be badly underrated. So astute an observer as Perry Anderson, in *Considerations of Western Marxism* and *In the Tracks of Historical Materialism*, has restricted his discussion of creative Marxist minds in the post-1920 period to Central Europeans, French, Italians, and a recent

scattering of British and US academics. James can be found outside so-called *Western* Marxism but not outside either the West or Marxism. Defeat was written on the foreheads of the theorists Anderson considers central – Lukács, Korsch, Adorno, Benjamin and Sartre – and their thinking has been therefore 'marked by a sundering of the bonds that should have linked it to a popular movement for revolutionary social-ism'.[6] The ultimate locus of their theorizing became the university, their theory a forum for rumination at high levels of abstraction. James, coming from a Third World approaching emancipation, inserted himself into the Euro-American mass life which remained rich despite (in part because of) the collapse of revolutionary prospects, and returned to the Third World armed with the critique. He has emphatically shared the 'Western Marxists' enthusiasm for culture critique, and for philosophical revival. But he has never been overwhelmed by defeat.

Evidently, the parameters of the Marxist historical subject need to be broadened. I cannot do so here, in any general sense, except by extra-polation from James's own significance. Like the neo-romantic social historian Edward Thompson with whom he shares many (if by no means all) predilections, like Rudolf Bahro of utopian eco-socialist vintage, James shows a side of Marxism deeply ruminative but also deeply involved. Thompson and Bahro represent, obviously, the persistence and renaissance of long-hidden traditions within radicalism, from William Morris to Gustav Landauer. James is once more unique because the Caribbean has had to invent its own traditions from the borrowed and underdeveloped intellectual materials at hand.

This is not an uncritical study. I have made a point of arguing with James at several points, and of noting his limits and real failures in a long life of activity. The reader who has chafed at the limits of criticism (in, for instance, the collective *C.L.R. James: His Life and Work* [1986], produced under my editorship) will encounter this side of the book soon enough. If I am not more severe, it is because James's work has yet to be taken as a whole, in the sense of equivalent *oeuvres* of Lukács, Sartre, Gramsci or for that matter Lenin.

I have no more right than anyone else to claim James's intellectual–political legacy. To succeed in my goal of simply opening up the subject to the discovery, scrutiny and enjoyment of new generations would be to achieve a large purpose. But my satisfaction lies chiefly in imagining the myriad creative possibilities to which James's contributions can be put.

I have already made clear in various places that I share James's parti-cular socialist vision. From the first time I began to read his works, twenty years ago, he seemed to speak directly to me, a young radical in the heat of the 1960s seeking an unphilistine theoretical approach to

Marxism's insights and practical application. James has provided many different kinds of people, in a bewildering variety of circumstances, classes and continents, a similar insight into their own experiences and aspirations. It is one of his greatest talents.

Every literary experience of mine with C.L.R. James, including the present one, has been collective in nature. Recalling them gives me keen pleasure (for instance, the first James anthology, 120 pages of tiny print, selling for $1, which I published when I was twenty-six) and a reminder to acknowledge the comrades who helped me, and James, along on our path together: my fellow editors, especially Dave Wagner, James P. O'Brien, Edith Hoshino Altbach, Paul Richards and James Kaplan, for help and encouragement in the years 1970–73, when *Radical America* published the *C.L.R. James Anthology* (1970) and the pamphlet *Dialectic and History* (1973) along with numerous essays in various *Radical America* issues, and who aided me in the mail-order distribution of James's other available publications; the oral historians and sundry helpers at the Oral History of the American Left, Tamiment Library, New York University, including Dan Georgakas, Ellie Kellman, Jon Bloom and Jan Hillegas who assisted me in taping and transcribing the results from various veterans of James's 1940s–60s political groups; Noel Ignatiev and Ken Lawrence, who aided me editorially in the publication of a special *Urgent Tasks* issue (1981) on C.L.R. James, and Margaret Busby, who brought that issue into book form as *C.L.R. James: His Life and Work*; Franklin Rosemont who brought the Charles H. Kerr Co. to print a new edition of *State Capitalism and World Revolution* with my introduction; Paget Henry, who has collaborated with me on a counterpart anthology to appear soon, *C.L.R. James' West Indies*.

Next, thanks to all those who read parts of this book and encouraged me to write it: Paul Berman, Martin Glaberman, Constance Webb, Eric Perkins, Thomas H. Fiehrer, Grace Lee Boggs, Paget Henry, C.L.R. James, and most especially Anna Grimshaw. My gratitude especially goes to Constance Webb, who freely offered James's correspondence of the 1930s–40s, and to Margaret Busby who masterfully copy-edited the manuscript. Thanks to Jim Murray for his enthusiasm about C.L.R. James and for the ways he has aided James. Robin Blackburn and Colin Robinson of Verso Books overwhelmed my reservations about writing this book, and saw it through the publication process. Many anonymous comrades have provided C.L.R. James with indispensable services over the years. He could not have continued his work, nor I begun this project, without their assistance. It seems nearly but not quite gratuitous to thank 'Nello' himself. The two of us have, in an odd way, honoured the distance

between us, not only in geography but also in our very different political and cultural lives. Perhaps this book reveals a comradeship we have only begun to explore.

1

Trinidad Homeboy

In one of C.L.R. James's favourite modern novels, Wilson Harris describes the West Indies as a place where inhabitants since Columbus have been escapees seeking an elusive identity, and where today's West Indians can discover themselves by recuperating apparently vanished pasts.[1] *Ieri*, the isle of the humming bird according to pre-Columbian inhabitants (Trinidad by its modern name), is perhaps more than any other Caribbean society the victim or beholder of multiple identities. James's Trinidadian roots would continue to shape the diverse itineraries of his life.

Harris's literary imagery hardly coincides with the venerable Anglo-American stereotype of the Caribbean: colonial and post-colonial societies too childlike to manage their own affairs; or, on the other side of the coin, peoples athletic and carefree, the veritable personification of the *joie de vivre* repressed in the industrious nations. ('The flower garden of the gay, the spontaneous, tropical West Indians,' James called the latter image and added, acidly: 'We need some astringent spray.')[2] If observers have been caught off guard by the periodic flaring up of mass unrest since 1919, by the continued cultural and political renaissance of Pan-Africanist impulses and by the spread of internal violence in the most troubled Caribbean nation-states, they can take consolation in the poor warning given them. No one predicted Toussaint L'Ouverture, no one predicted Fidel Castro, no one predicted Bob Marley and no one predicted C.L.R. James.

But someone should have, in a general sense at least. The dean of contemporary West Indian authors, George Lamming, says that 'our human content bears a striking parallel with that expectation upon which America was launched in the result, if not the method, of its early settlement'. A sense of expectation and wonder, reinforced by reports of

the first European visitors to the Caribbean, mixed always with commercial motives of colonization. Europe sought out this new world, in part, as a result of its own ambivalent quest for self-perfection. From the point of view of subsequent Caribbean self-development, the region lacked the racial and demographic advantages afforded the USA as a predominantly white nation of small proprietors in a white-dominated world. But the Caribbean complexion, physical and cultural, is close to the various populations emerging now from modern oppressions as the United States two centuries ago emerged from older oppressions. 'The new world of the Caribbean', Lamming concludes, 'is, in the time sense of world, the Twentieth Century.'³ James has been both symbol and agent of West Indian maturation and re-emergence into world significance.

Caribbean Culture

The Caribbean at large and the British West Indies in particular have presented a story apart from the dichotomous logics of South and North America. Here, unlike South America, the Iberian tradition of the Counter-Reformation sunk few lasting roots; the culture of conquistador and priest founded no civilization out of time with the West. Puritanism had more of an impact, but hardly the obsessive and exclusionary Puritanism of Massachusetts.

Instead, a society sprang up suited to the oddly mixed ambience – Creole, white and Black, Mediterranean, European, African and Caribbean, religious and irreligious, industrious and decadent – of the seventeenth- and eighteenth-century sugar plantation. Often portrayed as an archaic remnant of the ancient world, the slave system had been reinvented for the exquisitely modern world market. Some ten million Africans were transported to the Caribbean, to be ruled by whites few in number compared even to the blackest regions of the US Black Belt. They provided the muscle, and at the level of agrarian production often the brains as well, which made possible an unprecedented creation of wealth. As for culture, the slaves and former slaves eclectically absorbed and refashioned the elements available to them.

They received little guidance or help, in this last regard, from the elite of planters and middlemen. Ruling values have tended, from the beginning to the end of Caribbean colonialism, to ape the most mediocre qualities of the various mother countries' cultures. This melancholy feature has bequeathed a heavy burden upon regional self-consciousness. As James has written of the modern Creole life, its possessors know precious little of their own identity and have cared to learn no

more. Its own singular human products, such as Alexander Hamilton and Alexander Dumas, made their fortunes through their escape from it.[4]

Colonial commentators, none too keen-eyed, compounded local philistinism with further obfuscation. James Anthony Froude's classic *The English in the West Indies* (1888) illustrated spectacularly the unwillingness of the Victorian English to *imagine* that former slaves could, in the foreseeable future, see to their own affairs. 'Froudacity' the emerging nationalists called that attitude, and with good reason. But they could hardly dent it. Social Darwinism had by Froude's time contributed further to the mental weight of white Christian mission and to the biological arguments of Black mental inferiority. According to the sturdy myth, 'Darkest Africa' – centuries if not eons behind the West – had sent forth children who would require many generations of careful, supervised preparation before walking upright into civilization.[5]

What James phrased so elegantly in 1932 had been clear to unblinkered observers for a half-century or more:

> It has to be admitted that the West Indian Negro is ungracious enough to be far from perfect. He lives in the tropics, and he has the particular vices of all who live there, not excluding people of European blood. In one respect, indeed, the Negro in the tropics has an overwhelming superiority to all other races – the magnificent virility with which he overcomes the enervating influences of the climate. But otherwise the West Indian people are an easy-going people. Their life is not such as to breed in them the thrift, the care, and the almost equine docility to system and regulation which is characteristic of the industrialized European. If their comparative youth as a people saves them from the cramping effects of tradition, a useful handicap to be rid of in the swiftly-changing world of today, yet they lack that valuable basis of education which is not so much taught or studied as breathed in from birth in countries where people have for generation after generation lived settled and orderly lives. Quicker in intellect and spirit than the British, they pay for it by being less continent, less stable, less dependable. And this particular aspect of their character is intensified by certain social [i.e. racial] prejudices peculiar to the West Indies, and which have never been given their full value by those observers from abroad who have devoted themselves to the problems of West Indian society and politics.[6]

James might have added into this equation the jumble of colonial economics. Born of mercantilism, the Caribbean under so-called 'Free Trade' (dubious because the colonialist defined the character and degree of 'freedom') of the nineteenth century slipped from commercial eminence to what Gordon Lewis rightly calls 'somnolent stagnation'.[7] From this lamentable condition it has never completely re-emerged.

James has sought, without much evident success so far, to dispel the idea that this stagnation can be traced to Caribbean inferiority or to some inherent and insuperable fact of the international market. Even apart from Trinidadian oil, the Caribbean has been able to maintain itself on a higher standard than most of Asia or South America. But its paternalist rulers, whatever the colour of their skin, have been unable since the early nineteenth century either to create a bonanza exploitation for themselves or to let the islands go some uncharted, truly independent route. Paternalism has been a bad fit for the rulers, but especially for the Caribbean population. They, the lower class, have lacked both means and goals for productive lives in the usual Western sense.

In such a system, paradoxes tend to run rampant and human resources of all kinds go to waste or worse. By the turn of the nineteenth century, Trinidad had the largest (save for Cuba) free Afro-Creole population in one of the most urban and cosmopolitan societies of the region. Traces of previous Franco-Spanish domination survived in local traditions and institutions, a fact of considerable social and cultural importance. But prestige economic resources, with few exceptions, never left the hands of absentee investors, primarily British, who lacked the will even more than the means to reorganize production on a more efficient basis. Planters and their agents showed not the least interest in diversifying the agrarian production. Native consumption, in the near-subsistence economies, moreover created no further incentive for international trade. Soon, new competitors in the sugar trade – Indian and South American cane, European and American beet sugar – exceeded Caribbean production in both volume and efficiency. Within the region, capital-goods investment in Cuba left the British West Indies a veritable backwater.

A perceived scarcity of Black labour, substituting for all the complexities of production and the world market, came to dominate economic calculations. A British parliamentary decision had been made at the time of Trinidad's 1797 annexation from Spain not to import the mass of slaves necessary to expand the island's plantation economy. At this moment, liberal anti-slavery sentiment began to gain a mass following while British industry replaced the slave trade as a primary economic lever. The decision therefore proved a judicious one, and not only from a humanitarian standpoint. Slavery, on a relatively small scale, proved (despite minor rebellions) socially manageable. The emancipation in 1833 plunged the island into a crisis. Freed Blacks marching on the capital peacefully but no less forcefully declared their unwillingness to accept an apprenticeship system which would return them to a peonage reminiscent of slavery. Another solution had to be found.[8]

Investors transformed the demography of Trinidad through East Indian

migration, perhaps better termed a compulsory movement of contract labour. From the 1840s to World War I, more than a half-million travelled to the Caribbean, mostly Trinidad and the Guianas. The emerging gentry lacked the resources and confidence to make the best of even this windfall. Unable to manage the new workers as slaves or as free labourers, unable to acculturate them to the degree Blacks had experienced, the Creoles ruled over their new charges without moral compunction or any degree of economic success. From the point of view of economic development, the solution compounded the problem: the abundance of cheap labour provided still fewer incentives for mechanization. With seeming inevitability, Trinidad had by the end of the nineteenth century become not only a poor and undervalued, but also a more socially chaotic extension of the Empire.[9]

The political system further militated against a sense of democracy or potential nationhood. Britain from the beginning feared a parliamentary majority of non-English in Trinidad, if colonists were given a significant measure of self-rule. Abolitionists understandably shared the apprehension of less liberal forces in this regard. From another point of view, all non-Afro-Caribbeans shared an interest, despite their manifold other differences, in keeping the coloured population out of power. Britain met these common needs by bestowing upon Trinidad an undemocratic system exceeding that of the modestly self-governing constitution in Jamaica or Barbados. Far from a bridge to independence, the Crown Colony structure ensured direct British rule without the prospect of competing local assemblies of any colour or composition. In 1903, Joseph Chamberlain stated that nothing but the Crown Colony *could* properly rule Trinidad. From the crabbed viewpoint of the Empire, with the preservation of privilege as the ultimate norm, perhaps he was right. Many Trinidadians, locked into the logic of the situation and fearing change for the worse, no doubt agreed. Those few political rebels (mostly Creoles) who attempted to address the dilemmas at hand demonstrated, by their very impotence to make changes, the power of the reigning system.[10]

Cultural divisions underlined the practical absence of a self-constituted Trinidadian public. The capital, Port of Spain, was characterized by its perennial water shortage, due to the individual 'plunge baths' filled with up to 8,000 gallons daily for the relaxation of the tiny ruling group. Colonial administration succeeded magnificently in perpetuating a fractured society of the variously disenfranchised, presided over at short range by pseudo- (but never to be-) English. As James would argue in *The Life of Captain Cipriani*, the complex codes of race produced in the colonial administrators a profound arrogance, in the mixed races a perpetual flattery of the rulers (or simply those more fair-skinned than

themselves) and in the majority a sense of political helplessness. French and Spanish Creoles in particular, proud of antedating the British takeover, maintained a Eurocentric, almost aristocratic distance from all others and saw their especial salvation in a status quo that some colonial administrators had already begun to doubt. For that matter, East Indians and Africans of the same labouring class looked upon each other with incomprehension and suspicion.[11]

Modernizing Trinidad, ill prepared to manage change, blundered from one stage of society toward another. Even colonial administrators acknowledged that their charges would one day 'come of age', but how they had prepared the natives for self-government no one could say. English rule deprived Trinidad of the economic means for independence. The ongoing costs of Trinidadian government rested financially upon the taxation of hapless small property holders who in effect already subsidized the sagging sugar trade. What little surplus Trinidad produced could be plundered at will. Not only would the Empire continue to rule without providing so much as the necessary financial support for the unworkable structures it had created. When it felt Imperial resources strained, it would exact tributes (£100,000 in 1917) vast for the local economy. Meanwhile, the colonial racial norms, far from abolished by the approach of the twentieth century, essentially extended downward into the population. As Paget Henry has argued slavery's 'culture of silence' was succeeded in the long run by a system of Black uplift (so considered) which selected and educated individual students, English-style, so as to offer image but not substance of individual fulfilment. For the precious few who 'succeeded' in these terms, escape from all things Black became life's futile aim. Only the vibrant folk culture offered alternatives, and those weighted in the extreme difficulties of repression and the absence of intellectual articulation.[12]

Enter James

If we should suddenly shift perspective to the postmodern standards of the late twentieth century, Trinidad in the year of C.L.R. James's birth (1901) seems to have been an exotic and marvellously attractive land. We can admire and almost envy Trinidadian culture for the same reasons that contemporary white administrators regarded it as mired in hopelessness. Music, language, clothes and culinary styles bristled with native innovation. Christmas and Carnival, overwhelmingly Black rituals, concentrated contradictions into a mass fantasy at once submissive and rebellious, European, African and East and West Indian. Nowhere did carnival society thrive as in Trinidad.

Carnival, reinstating a collective spectacle which had almost vanished from Europe, already suggested crypto-nationalist themes with a nationalism far different from that known in Europe, North or South America. Here, as Bakhtin had observed for Rabelaisian France, the bifurcation of mind and body and differentiation of self from nature had not yet been successfully imposed; nor had the mass-formulated grotesque realism so obvious in the carnival costumes been displaced by upper-class aesthetics and commercial popular culture. Dancing and music, particularly the use of drums, had long been viewed by colonial authorities as incitement to dangerous passions. The very etiquette of stick-fighting, the most symbolic (if very physical) contest of the urban slums, must have seemed to imply another struggle, against the British administration. Suppress they did, with a stronger police force and rigidly implemented laws against stick-fighting and drumming. (An 1883 ordinance banned 'singing, drumming, dancing and other music-making by ... rogues and vagabonds or incorrigible rogues.')[13] But the authorities could only treat symptoms and not causes.

In Sylvia Wynter's semiotic terms, the failure of repression has a deeper meaning in Trinidadian society. The generalized aesthetics of the bourgeoisie, by which it comes to know itself as a class, attain no security here. The definition of property-holders as the proper *polis*, a principle clear in the West since the English Revolution, had in the process of colonization created the category 'Negro' as the absolute opposite of the citizen. The rising bourgeoisie also defined the bimodal Head/Body and Reason/Instinct categories to suit its new sense of rationality against the 'unreason' of the fading aristocracy. It linked that aristocracy (at least ideologically; in practice, British aristocrats and bourgeois mixed amiably) with an *outmoded form of existence.* But Carnival time, which expressed autonomous rules of behaviour demanding participation rather than bourgeois spectatorship, seemed to violate all the laws of social progress. The 'Negro', purportedly incapable of self-rule, had appropriated the historic prerogatives of the aristocrat to himself in a ritual moment of avowed unreason. No wonder the authorities used force against this breakdown – in several directions at once – of the ruling ethos. The demoralized Trinidadian petty bourgeoisie and the Colonial Office retainers stood helpless before the celebration of a folk culture they tyrannized but could not abolish. Or they joined the festivities, deserting for the moment their own *raison d'être,* to a social event intermittently more powerful than all the distinguished texts and the political prestige of the system they represented.[14]

Some of the rowdiness, the pageantry and unregulated mass participation could apparently be quelled. But diverted from one direction, mass enthusiasms soon turned to others. The beating of sticks in various

lengths and width to produce differing sounds, the 'tamboo-bamboo' which presaged the mighty steelband of the 1930s–40s, substituted for the forbidden beating of skins. More immediately apparent, the 'European instruments' permitted by law offered a vehicle for calypso, hitherto sung in Creole tongues but adopting English as the universal Trinidadian expression.

A generation or two later, new popular music forms across the world, based in folk traditions but revised for greater accessibility and commercial potential, took shape with the appearance of formerly rural audiences in new national markets. The Greek retibka, the Polish–American Polka and the Nigerian Tiv among others emerged. Calypso, without benefit of gramophone recordings until the 1920s, evoked an extraordinarily early response, in international terms, within the condensed British West Indian cities. Charged from the beginning with social themes, calypso offered an almost mass-culture medium in the calypso tents of Trinidad's Carnival, and the equivalent of a national stage and reward-system in the festivals and prizes. The compactness of the islands, the overwhelming non-white population and the diversion of politics into cultural idioms contributed to its dynamic. Emotional outbursts historically put down in the slums became the source for collective self-expression through the best calypsos, the anthems for the theatre of the streets. That a Port of Spain shopgirl might scrimp an entire year to manage her fanciful costume for the brief spell of Carnival tells us something about the sustaining power of the mass imagination. Unwillingly and unwittingly, British rule promoted a West Indian culture with far-ranging implications.[15]

British education also had its benefits. Lacking most other avenues of self-development, Trinidad's 'respectable' classes of non-whites and semi-whites naturally craved education as the road to success. In a generation or two, its educated professionals who finally made the progress that had been denied to parents and grandparents would overproduce themselves in such numbers that they would seek (and find) their fortune throughout the English-speaking world. If the educational system in the early decades of the twentieth century therefore naturally favoured whites and Creoles, it permitted fortune to shine also upon a slowly increasing number of bright, mostly lower middle-class East Indians and Blacks.

From the viewpoint of a young, precociously scholarly boy, even a Black boy, the ideals behind the system had further virtues amid colonialism's obvious faults. Not only did the better schools educate for personal success on a modest scale, but teachers and administrators genuinely believed that the noblest values of Western civilization could be grasped from great literature and social games. Within that frame-

work, the 'school code' decreed equal treatment to all worthy pupils. Honest if condescending, even in many cases idealistic, pedagogues watched for local talent and gave it early rewards. Those fully educated still advanced into a backwater, but a backwater of the most developed political system in the world. They might be expected to achieve a certain dignity and self-confidence, however dubious its source, that they could not gain so readily where (as in India, for instance) the system had been set among an alien population and faced continual rebellion. At least that is the way a son of a schoolteacher and an educated woman, grandson of a skilled sugar plantation worker and another schoolteacher, might view the way things worked: limiting, certainly, but unobjectionable within the framework of rules which supposedly governed practice fairly.

Destined to be shaped by these rules, Cyril Lionel Robert James, born in Port of Spain on 4 January 1901, spent most of his early years in Tunapuna, eight semi-urbanized miles away. His parents' house sat perched between the main road and the wicket, aimed symbolically at both economics (or politics) and sport. His family had for two generations, on both sides, embraced respectability with a ferocious grip, 'not an ideal ... [but] an armour' against the angers of lumpenization. They had been more or less successful in this effort. From his grandfather who taught Sunday school in frock-coat and with a silver-headed cane to his mother, the only non-white woman to take tea with the white parson, they carried themselves with a sense of extreme and even exaggerated dignity. All achievements remained precarious. But craft workers, schoolmasters, close readers of the press and (at least in one essential case) of fine literature, they made a coherent life for themselves that would be the envy of colonized peoples across the world.[16]

The life of a Trinidadian schoolteacher must be especially noted here. James was to say, many decades later, that next to the schoolteacher in the small village only the priest and minister were held in higher public esteem. The schoolmaster educated on all fronts, for all ages, and in that sense represented the social and cultural link of the villager to the outside world. In Tunapuna, even more so in Arima, a community with a distinctive Black middle class and elected officials where the family moved in his teenage years, James's father was an intellectual guide to the flock. Himself child of a middle-class family fallen upon hard time, the elder James drove himself and his son in the only direction where a Black might gain both security and distinction.

An educated Black woman such as James's mother was an even more unusual colonial figure. Her father, a native Bajan (which is to say, Barbados-born) railroad fireman, rose to the exalted status of the first non-white engine-driver on the Trinidad Government Railway. A public

figure who knew the white magnates well and (at least in his mind) acted as an equal among them, he held himself so proud that he once single-handedly repaired a locomotive in the urgent cane-cutting season but refused to reveal to the whites the secret of his success. If they, with their engineering degrees, did not know, he was not about to tell them. We might say that James's maternal grandfather had continued to acquiesce in their ultimate rule, but demanded his own code of honour. James understandably views him as a spiritual ancestor. Faced with the early death of his wife, this unique man sent his daughter into a Wesleyan convent where she gained a good education and 'a nonconformism of . . . depth and rigidity'.[17]

'My chief memory,' James wrote in a private memoir,

> is of my mother sitting reading and I lying on the floor near her reading until it was time to go to bed – 9 o'clock. She was a very tall woman, my colour, with a superb carriage and so handsome that everybody always asked who she was. She dressed in the latest fashion – she had a passion for dress and was herself a finished seamstress. But she was a reader. She read everything that came her way. I can see her now, sitting very straight with the book held high, her pince-nez on her Caucasian nose, reading till long after midnight.[18]

Contemporary England could hardly have produced a more perfect candidate for the spectator's section in the republic of letters.

She imbued her son with the enthusiasm of an inveterate reader. He began, very early, to read the books she had finished. 'I followed literature because of her,' he told me. Not that she pressed culture upon him; rather, her example showed him what he might interest himself to do. She brought vast quantities of novels, indiscriminately good and bad, into the house, offering the boy in his earliest reading years an instant source of both literature and reinforcement. Thackeray's *Vanity Fair*, which he absorbed at the age of eight and read repeatedly for a half-dozen years, offered the bookish child 'refuge into which I withdrew'. That satirical classic, along with some military history and a portrait of Napoleon, gave him the first glimpse of a British Empire fallible within and vulnerable without.

Beyond a Boundary (1963), James's semi-autobiographical account of his life in cricket, opens with the striking image of a window on the cricket matches, reached with the aid of a chair which also brought access to the books on the top of the wardrobe. These two sources fuelled the boy's imagination and reinforced an early inwardness. Books helped him to explore, one might gather from James's hints, the meaning of the vicarious experience. Writing exercises continued and broadened the exploration. By the age of seven or eight, he had begun composing his own stories, a practice which his mother also encouraged

in a general way. She had nurtured the writer's instinct in him. But her firm moral principles even more than her husband's also ruled out Carnival and Sunday entertainment of any kind for *her* child. He would have to escape her control to find the writer's material.

These images of middle-class respectability, given out freely and almost nostalgically in *Beyond a Boundary*, do not do full justice to the difficulty of the family situation he had described in private letters. In his earliest memories of the rural village where his father had moved to teach school, James recalled a dwelling of some twenty-five square feet for himself, his elder sister, his younger brother, his parents, the largest area of the house being a cocoa store-room. The next dwelling they took had only two rooms, shared with two young aunts and a grandmother who washed clothes and worked as a seamstress for a living. A thatched cottage whose roof permitted the rain, it had fleas aplenty. But they could afford no better. At a salary of $40 or $50 per month, his father 'was always desperately in debt'. Each house was scrupulously clean, everyone decently fed, with sometimes even a servant hired for periods to help with the work. But if the family situation improved as his father successively found new quarters for them, the James clan remained part of a middle class forever on the edge of ruin.[19]

As he recounted privately, James indeed grew up well-mannered and intellectually curious, but also extremely restless and more than a little detached. Although generally happy and well treated, he felt no particular love for his parents. Likewise, while church-going he possessed no real spiritual commitment. Once, when his mother seemed near death, he wept but remembers it had been 'for show'. He resented enormously his confinement on Sunday from the cricket game, especially when his father would go to play. He resented even more, if possible, the sickly brother who consented to play cricket only so long as he, the brother, could bat. In this uncensored memoir, the pathos of the scene becomes more apparent. Books served essentially as escape from this confinement. Here began the lifetime habit of reading and thinking through what he would call 'long, long solitary hours' of the day. Here also the writer's separation of himself into a world of his own making surely had begun as well.[20]

Early schooling, as James described it privately, furthered the separation of self (including knowledge acquired) from the formal structures of respectability. A primitive village schoolhouse held 120 students – poor Blacks and Mulattos, with a scattering of East Indians and Asians – many barefooted in common poverty. All activities in the school centred on the yearly examination, administered by a visiting white bureaucrat. Inasmuch as the teacher took in special pay (and the possibility of promotion) for producing students with high scores, a practice of

cooperative cheating developed with the help of the teacher. The examiners, mediocre men flattered, toasted with champagne or otherwise accommodated, never learned or never acknowledged the truth. As the schoolmaster's son, 'bright as a new shilling' and considered by everyone a promising scholar, James recalls himself indifferent to the privileges of a fundamentally mediocre system: 'I just lived along.'[21]

Other than books, cricket – except of course on Sundays – offered the available escape from routine. From early childhood, he would resist with all his energy the entreaties to come home from watching matches. For months at a time deprived of the presence of his father, who was teaching elsewhere on the island, James drew close to a grown cousin, a powerful blacksmith who had in his youth been the only Black on the otherwise lily-white Tunapuna Cricket Club team. Practically all the ancestral men of the family had played and, like Cousin Cudjoe the blacksmith, remained close students of the game. For them, as for so many other educated and semi-educated English-speakers across the world, cricket embodied an organic approach to life and an endless source of contemporary fascination. It 'proved' to the colonizer, one could imagine, that 'civilizing' had been a successful mission; and to the colonized that civilization was by no means the monopoly of the mother country but a larger game that anyone could play. It also served, *sub rosa*, to reflect the artistic creativity and rebelliousness which found no place in Trinidadian culture outside the unrespectable calypso and no space in politics at all. Observers rightly called it the game that defined Trinidadian life.

If one aspect of the young boy was set into motion as he looked out upon that field with the keenest interest in every stroke (also those who cut the strokes), and the other aspect took flight from his passion for books, he brought the interests together naturally in the available literature on cricket. Abundant in the popular magazines, local and international press, cricket reportage offered James a mental world of surprisingly broad horizons. When the family removed to Port of Spain, after a few years in Arima, he could read two daily papers and on Sunday two sporting papers, from which he clipped and filed his own research on the fine points of the game. If he were not to be an alien in his own environment of far less intellectual boys and girls, this inclination surely provided the bridge. He became secretary of the school cricket eleven, and at fifteen wrote his first essay, on cricket. Here at the pitch, if never quite in the same sense as his schoolmates, he commanded native ground.[22]

His divided self proved both his downfall as a precocious scholar and his remaking as a rebel. At the age of eight, with half a year of his father's tutoring, he achieved a special mention in the national competi-

tion for a place in the secondary schools. The following year he 'ran away with the examination', in his own words, the youngest ever on the island to win.[23] That he did so against boys of eleven or twelve was extraordinary. His father, like all Trinidad schoolmasters, was judged by his ability to produce prize pupils, and that he had done so with his own son brought wide recognition to the family. From here, the young James could surely move up through secondary education to an island scholarship, thence to law and medicine, even to the Legislative Council. Wealth (according to the existing standards) and fame fairly beckoned. And indeed, at Queen's Royal College he began brilliantly, taking a second in a nationwide essay contest. But psychic catastrophe intervened.

Almost inexplicably, he spent his energy upon cricket at every opportunity, cheating himself of his opportunity to win exams and his parents – especially his father – of their highest hopes. Worse, the young James brought them shame and virtual scandal: reported for failure to maintain a certain standard, he stood the risk of losing his exhibition and the public humiliation of defeat by insubordination. Within the norms set out by the Empire and accepted by the Black middle class he had become a classic underachiever. He could not or would not play the game of advancement according to their rules.[23]

Decades later, James would ascribe the onset of an ulcer to this troubled period of his life. He might have ascribed his making as an artist to it as well. He had suffered from and rebelled against, consciously but mostly unconsciously, the dichotomies fostered by the system. He had not grown into books, at a precocious age, in order to prepare himself for success. He took avidly to the classic curriculum of Greek and Latin, French and English literature, ancient and modern history. But the forms of scholarly competition had little to do with learning. Besides all this, nose-to-the-grindstone scholarship would have removed him from the popular culture of cricket – his one certain contact with ordinary boys and pleasure for its own sake – just as surely as a total abandonment of intellectual life would have removed him from the aspirations of his parents' generation.

He was no feckless rebel in any case. He honoured, as Sylvia Wynter has best described, a separate code dictated by the game and its place in the vision of the good life. On the field, he adopted an absolute morality of fair play and unquestioning obedience to the umpire's decision. Meanwhile, he did not reject the self-proclaimed basis of modern culture; indeed, he raced through all of Thackeray, Milton, Spencer, Hazlitt, Lamb and, of course, Matthew Arnold, among many and varied others in the school library. He read Shakespeare, which established for him a basic framework for understanding human nature and for the

writer's use of language. He memorized the famous political speeches. He had no mere self-interest in this knowledge, and has remained forever baffled by his schoolmates who threw down their Latin books after classes ended. He also read more sports magazines than any of his classmates. He often broke with the letter but always clung to the spirit of the existing ideals of wisdom and scholarship, for no reason he himself could readily grasp.[24]

He later grasped a part of the problem. He had begun to apprehend the paradox of living in the periphery, and of himself 'come to maturity within a system that was the results of centuries of development in another land ... transplanted as a hot-house flower is transplanted and [which] bore some strange fruit'. He was, he began to understand, a real if distant descendant of Western culture. Greek literature and Greek culture seemed more compelling than anything he could recognize as African. He had, in spite of his early academic shortcomings, educated himself into 'a member of the British middle class with literary gifts'.[25]

Indeed, by his later teens James had quite a distinguished record of achievements. Two of his essays (the first on a historic Oxford–Cambridge cricket match and the second on 'Literature as an Instrument of Reform') had been published in his school journal. One, he recalls, was the talk of the island. Growing to his full height of six-feet-two-inches, he also became an impressive athlete. He set a high-jump record for his school and for Trinidad. He served as goalie for QRC in a first-class college football league. By careful study as well as continual play, he emerged as a promising if not outstanding cricketer: a defensive batsman, a medium-fast bowler and captain of his school team.[26]

Now he confronted a sporting question of great personal importance. When he reached his cricket peak in 1918, he joined a newly-formed team, the racially variegated Old Collegians, which broke up with the end of the season. The next choice of the first-class club came down to Maple – the brownskin, middle-class team – or Shannon, the able team of the Black middle class and the symbolic representative of the population at large. Already a young man who gave literary talks on Wordsworth and Longfellow, James was a natural for Maple, i.e. the upwardly-bound Black perpetually in the presence of those lighter than himself. 'Faced with the fundamental divisions in the island,' he says, 'I had gone to the right and, by cutting myself off from the popular side, delayed my political development for years.' He had indeed reached respectability, even making peace with the family after a last, tempestuous quarrel with his father.[27]

Relative to these boosts in status, such slights as the subtle colour prejudice of an individual teacher, or the departure of a white school

friend for England, or even the refusal of the Army to take him as a volunteer for the First World War, seemed almost unimportant. He bore no apparent grudge on his own behalf. He testifies that race hardly emerged in the conversation of the age. The little Black Puritan, as he retrospectively calls his youthful self, had emerged unscathed and actually empowered by his actions within the system.[28]

Then again, he was not altogether a Puritan. In a section of his unpublished autobiography, James reveals himself to have been the sort of boy offended at the 'little books with dirty pictures' handed around by his schoolmates. He recalls masturbation, from the age of eleven, as a purely physical act with no special fantasy association. The fantasy grew more definite with advancing teenage years, until at sixteen he lost his virginity to a schoolgirl of the same age. Then, almost unaccountably, he put sex upon the backburner for sports and reading. It returned through the social life of the Black middle class, ostensibly rigid but not without moments of release, especially during Carnival. Like his contemporaries, he made efforts at seduction. But as he learned more about the psychology of seduction and resistance, he also became determined to treat the subject with dignity and knowledge. 'I was a very moral person, that is to say, I lived by moral ideas,' he insists. Six volumes of Havelock Ellis's *The Psychology of Sex* he read from cover to cover, and he felt ready to face the world. He had, in any case, faced down the psychological storms of youth without retreat or false bravado.[29]

The proof lay in his quietly satisfying life during the 1920s. He came to be regarded, he says, as the bright boy who with single-minded devotion could have earned a scholarship to England, but who instead had stayed behind, at least for the time being, and had transformed himself into a semi-public resource. A schoolmaster almost as soon as he graduated with a school certificate from Queen's Royal College in 1918, he found his work 'rather exhausting; but I couldn't leave it alone'. The inquiries of students and teachers pressed him in his predilections 'to keep going, and gathering and going out'. He remembers that he used to lecture his own students on the need for the economic, political and literary sides to any phenomenon for basic historical understanding. He therefore simultaneously explored West Indian history and cricket history, alone and with his students. He taught a young Eric Williams, aged eleven or twelve, 'everything he knew', forming a relationship that would last forty years. But James also educated himself with wide reading, to the point where Trinidadians came to see him on questions of literature. They paid him well for his status. He won still more local respect.[30]

One incident in his teaching tells us a great deal about his gradual approach to higher aspirations. Prompted by the desire to teach his

students Shakespeare (a Shakespeare question invariably appeared in the major preparatory exams), he staged with his class a full public version of *Othello*. It drew an enthusiastic response, and James went on to write a now-vanished drama about local life and to produce it with his students, for the public. His life as dramatic coach and dramaturge ended here, until the middle 1930s. He lacked, he says, the instinct of the playwright, and consciously had to dramatize his own story line. He had substituted careful preparation for instinct, as in his own cricket playing, without deceiving himself about the limits of his talents.

James also lived the vigorous life of a slightly bohemian young man. He attended social events, danced, listened to jazz from America and the first calypso records made in Trinidad. A lover of Verdi and Beethoven, he grew locally famous as an intellectual who believed calypso to be a serious art form. Calypsonians sought him out and he sought them out at Carnival time. Already a respected cricket correspondent, he now elaborated his dual existence as scholar–littérateur and cricketer – the first all week and the second (by his own account) all weekend, in season and out, spring to autumn. He also made the implicit connection between national history, adopted sports culture and the wholly unique cultural innovations: all these belonged to Trinidad.

No young man in Trinidad, one might suggest, would have been better suited to translate these experiences into politics. What made James so slow to be taken with the political enthusiasm that would shape his later life? He has never attempted to answer the question himself. Critics, including admiring critics, have tended to describe him as a 'man of words' rather than a 'man of action', which is surely true but hardly self-explanatory. Unlike his counterparts and comrades of the 1930s–70s, he exhibited in his youth none of the burning resentments which plunge a young idealist into the fray. His rebellions had been different, directed more within his potential self than against society.

Let us compare the young James, for a moment, with other non-white pioneers of world Marxism. M.N. Roy, fourteen years older and also the son of a teacher, grew up amid nationalist ferment and religious enthusiasm. By the age of fourteen he regarded himself as a full-time revolutionary, although only a journey via the United States to Mexico confirmed his Marxist orientation. He had, really, no other life outside anticipation of and preparation for the Revolution. He went on to become one of the most prominent non-white figures in the Comintern, a founder of India's Communist movement and in later life a self-styled Radical Humanist. Ideas Roy had aplenty, but plans for action precipitated and fashioned the development of particular ideas.[31]

Harry Haywood, destined to become C.L.R. James's Pan-African counterpart in the American Communist Party, was born in 1898 in

Nebraska, the son of former slaves with mixed Amerindian blood. In the tolerant atmosphere of Omaha, Haywood read his autodidact father's library of history and literature, and even acquired a brief Anglophilia from a Black school janitor! In the army during the First World War, Haywood gained a close-up look at virulent racism. Stumbling into the Chicago Race Riot three months after discharge, he soon left behind considerable prospects for Black middle-class respectability and, via Garveyism, set himself upon the course of revolutionism. By his mid-twenties, Haywood along with a handful of others attempted to fuse Black nationalism and Bolshevism. Presenting his ideas to an eager Comintern, he too became an international revolutionary figure at an early age.[32]

The contrast of James with George Padmore is perhaps the most striking because the closest to home. A childhood friend with James in Arima, Padmore (born Malcolm Nurse) had been born to a father not only more distinguished as a teacher, but also distinguished by his outspokenness. Unlike James's father, who ducked controversy, Padmore's father, James Nurse, went out of his way to defy Colonial Office opinion. For that bravery (or rashness) he paid a severe price. His son, young Nurse, grew up political and could not wait to leave Trinidad. Almost upon arrival in New York City, he had become a Communist sympathizer. In a few short years, Nurse would transform himself into Padmore, editor–publicist and ideological commissar of Black radicalism.[33]

Sylvia Wynter offers a different illumination, linked to James's compulsive love for cricket. He writes of having in earliest childhood watched from his window a certain widely proclaimed good-for-nothing who happened to live next door. This Matthew Bondman (even symbolically named) refused wage-labour, declined to bathe, walked about barefooted – to the great indignation of James's maternal grandmother – and peppered his language with invective. But he could bat like a genius. 'Good for nothing but cricket' meant, Wynter suggests, that the labourer upon whose back the Empire had been built now refused the code of the 'deserving proletariat'. James could not understand how someone brilliant at cricket *could* be 'good for nothing'. He had already intuitively moved beyond the framework of the bourgeois and also of the orthodox Marxist worldview in which *labour* defined self-realization and the development of productive forces is seen as the ideal of progress.[34] He had only to grow up enough to make sense of his own budding insights.

'My Puritan soul burnt with indignation at injustice in the sphere of sport,' he records.[35] As observer and as sports journalist, as scratch-game participant with world-class athletes, he awakened to the realities of Trinidad and of the Negro. Passed over for their race in the choice of

the West Indian teams, fine players had been deprived of their great opportunity. 'No wonder men and women stood in the street and wept,' says James. 'Plato and Pythagoras, Socrates and Demostenes would have understood that these public tears expressed no private grief.'[36] The improvement of Black players had made a challenge inevitable, and it is James's thesis that they carried with them the growing self-consciousness of the region. Wilton St Hill, left off the 1923 team, bore a wound for himself and his ubiquitous fans. St Hill did not recover, but Learie Constantine, as we shall see, carried James and the West Indians a large step further in their self-awareness. Meanwhile James, writing as boldly as he felt safe to do in the sporting pages, had already taken up the essence of his political positions. The *system* of racism in sports (and, he now began to understand, in literature and in politics) was the culprit. Racism violated the rules of fair play, evidently and flagrantly.

No radical movement, no widely held political conception then in existence would accommodate an idea better suited to the rest of the twentieth century. Aesthetics, and not bourgeois or Communist-style proletarian aesthetics, offered the best avenue for experimentation. James need not have been conscious of his theoretical probings. He had not yet sharpened the tools to work out the parameters.

Littérateur Comes of Age

Meanwhile he had reacted casually, with interest but not much involvement, to the most important radical events which had touched the island hitherto. Working-class unrest had immediately followed World War I, as in the United States, Canada, Europe and elsewhere. In Trinidad, the abolition in 1917 of the indentured labour system for East Indians produced a shortage of cheap labour. A notorious Habitual Idlers' Ordinance permitted authorities to turn the unemployed into chattel remanded to government-owned agriculture or to private farmers, and prompted great public resentment. Longshoremen struck warehouses in mid-December 1918, driving scabs from the premises. Their march through Port of Spain shut down the city in December 1919 and offered an object lesson in what a later generation would call Black Power. (Indeed, Marcus Garvey's paper, *The Negro World*, officially banned but surreptitiously available, became noticeably influential at this time.) The authorities rushed in troops from Jamaica and proclaimed a new series of law-and-order acts. James, who himself took no part, recalled to me that 'the soldiers didn't frighten anybody' because of their affinity for the determined masses.

James's first political hero, the Corsican-descended Arthur A. Cipriani, seized the moment. As James would detail in 1932, Cipriani had come from a socially prominent Trinidadian family reduced considerably by misfortune. For most of his life, Cipriani had been an obscure horsebreeder and horsetrainer. The war experience galvanized him. From his raising a volunteer regiment (against the racial bias of the Empire) to his defence of the men in the field against British officers, Captain Cipriani had become (or revealed himself to be) a natural leader. Back in Trinidad after demobilization, he became active in the nearly dormant Trinidad Workingmen's Association (TWA), founded in 1897 but never much more than a body of small merchants and professionals friendly to the cause of labour. Against the backdrop of the longshoremen's 1919 action, Cipriani reorganized the TWA into the first true institution of Trinidadian labour. Cipriani quickly emerged as the great public hero of the urban masses. He and his weekly, *The Socialist*, sounded the tocsin for radical reform along the lines proposed by the British Labour Party.

As Cipriani took the mayorality of Port of Spain and, by 1926, a seat on the Legislative Council, he rallied tens of thousands to his renamed Trinidad Labour Party. He raised the banner for such varied measures as the minimum wage, the eight-hour day, workmen's compensation, campaigning against child labour and for compulsory education, upgrading of teachers, native control over natural resources, universal suffrage and an end to all racist practices. He ran up against a formidable wall of hostility from the local employers and the Colonial Office. James recalls an official asking him what would happen if Cipriani were seized, and responding that the workers would burn down the city. Whatever the reason, Cipriani was not suppressed, only limited by statute and by practice. Publicize the ugly side of the system Cipriani could and did; alter it, he could not. 'He died,' as Gordon Lewis says, 'with the Crown Colony system still basically intact.' But he had thrown down the gauntlet, taught political language and agitational technique to a generation of West Indians. He had, as James would say, expanded their view of themselves.[37]

With Cipriani, James joined intellectual and cultural interests to a measured politics. In the intimate social world of Port of Spain, Cipriani knew almost as much about James as James about him. The older man (now aged fifty) asked the notable young schoolmaster to write for the TWA organ, *The Socialist*, about cricket and about national history. James gladly complied. A later James might well have become an editor of the paper, lieutenant and political heir apparent to the leader. This James did not. Once or twice, as he recalls, he took the rostrum to speak for Cipriani's various candidacies, although such acts by a civil servant

could easily cost a job. Cipriani did not ask, nor did James apply, for deeper involvement.[38]

James's literary bent, meanwhile, began to impel him toward a cultural politics congruent with Cipriani's radical reformism. James and his friends had thus formed the Maverick Club in 1919, for non-whites only, with James naturally as secretary – almost as if he had simply moved his cricket functions to another quarter. They published lectures, gave lectures and wrote essays on the usual subjects of English literature and drama. According to James's recollection,

> We lived according to the tenets of Matthew Arnold, spreading sweetness and light and the best that has been thought and said in the world. We met all visiting literary celebrities as a matter of course.[39]

This is certainly correct, but it may not be an entirely complete account. The Maverick Club sprang up amid a vigorous burst of Garveyite literary expression. *The Negro World* in particular published much poetry and literary analysis, but with a unidimensional race-centredness analogous to the class-centred quality of Communist publications. That was not for the likes of James's circle, although their very existence hinted at a kind of *negritude*. They sought to find their way, as non-whites, in a white literary world. They read carefully the British mainstream press, the British and French political and cultural magazines, and set out 'to master the literature, philosophy and ideas of Western civilization'.[40] They intended to pass their erudition on to the Trinidadian masses, but only in some vague and unforeseeable fashion. The club lasted a mere two years, but served a purpose beyond the expectations of the participants. Succeeded first by more informal encounters, the Maverick had prepared the way, by the end of the decade, for the most important literary formation Trinidad had yet seen.

Here, Trinidad took the lead among all the Caribbean islands. Alfred Mendes, a middle-class Creole with an English boarding-school education, had fought in the First World War and returned with developed left-wing sympathies. Mendes joined James and others in a circle around a young librarian, Carlton Comma, who had his own rich supply of books and periodicals. Mendes could afford, among other things, the jazz records that James savoured; he might be regarded as the first in a long line of well-to-do benefactors of the promising young man. Regularly a circle of non-white writers would gather at Mendes's house, listen to records, argue, and read each other excerpts from works in progress.

In the first years of the century, an *All Jamaica Library* ('dealing directly with Jamaica and Jamaicans and written by Jamaicans') had

been attempted without much success. Literary- and political-minded papers, such as the *Barbados Herald,* had been launched in the wake of the war. Individual authors had published works, including one or two (Claude McKay's *Home to Harlem* being the outstanding example) with international appeal. But only in the 1930s did group projects spread from island to island, including the memorable organ of Negritude, the Martinican *Légitime Defense* of Aimé Césaire and Étienne Lero. From that time forward, literary development would become almost steady. Trinidadians had consciously or unconsciously formed the bridge. In that achievement, quite as well as his own writings, James played no small role.[41]

Trinidad, edited by James and Mendes, was a journal of fiction, poetry and music criticism, reflecting the creative but somewhat aesthete sense of the group and managing a mere two issues, Christmas 1929 and Easter 1930. In those few pages, it raised a storm. The short fiction echoed McKay in the straightforward treatment of slum life, especially the life of the prostitute-type women. Letters attacking the purportedly 'obscene' character of the literature poured into the office of the *Trinidad Guardian.* A Boy Scout wrote to condemn the 'disagreeable implications' about 'the fair name of our beautiful Island'. Compared to these charges, the sympathies of *Trinidad* for the Russian experiment and for incipient Trinidadian nationalism were almost minor considerations.[42]

All the same, *Trinidad* had no future. The finances were manageable, between cash from Mendes and the advertisements that local businessmen took out so as to place themselves in the vicinity of the literary vanguard. But the solicitation, the editing and the writing proved far beyond the means of two intellectuals. Besides, James had already made known his intent to go abroad.

With the end of *Trinidad,* the way cleared for a broader experiment. *Trinidad*'s spiritual descendant, *The Beacon,* with twenty-eight issues from 1931 to 1933, gained a sturdier editorial hand in financer–editor–polemicist Albert Gomes, just returned from a stint in the USA. It also reflected a marked seriousness in its mixture of politics and culture. It took up race consciousness. It devoted a special section to East Indians. It organized short-story competitions. In all these areas, it broke with artificiality and imitation, repeatedly scandalizing Trinidad and the island's middle-class society in particular. James insists that the magazine and the milieu around it dominated literary life, not only in Trinidad, where it had no competition, but in the English-speaking Caribbean, where it had next to none. And not only literary life, but also the maturing sensibility of the Caribbean's historical place within the century and the world. Emerging trade-union activists and nationalist politicians joined the dialogue in *The Beacon,* the first time these

connections had been made. Decades later Mendes recalled:

> *The Beacon* was, of course, the best organ of opinion in Trinidad – and nothing touching it for intelligence, wit, satire, and general excellence has since appeared in Trinidad. Nothing at all. It created a furore of excitement in the island ... and it set people everywhere thinking and talking as they had never talked or thought before. *Those were the days! ... The Beacon* took anything into its maw, anything that was fresh, good, intelligent – stories, articles on politics, race, music – reviews of books, of music recitals, of art exhibitions – controversial letters, stimulating editorial notes written by Gomes.... He had three riproaring years of tearing into every sanctity and pharisaism of the respectable folk. How hurt they were – but how they secretly enjoyed it.[43]

Mendes and James had explained, in the editorial notes to *Trinidad*, No. 2, that literary realism demanded the use of the living material at hand, no matter if presence of ugliness and sexuality might offend the reader.[44] But writers and editors enjoyed themselves too obviously for the sake of mere realism. A new literary continent was in the process of being discovered, a continent closer to the cultural reality of West Indian life than any described hitherto. Whether Trinidad listened or not, the English showed themselves interested.

The proof of the pudding may be found in James's own literary efforts. His first published story and first international literary triumph, 'La Divina Pastora', appeared in the British *Saturday Review* in 1927 and again in *Best Short Stories* of the following year. James constructed his tale deftly, with not a wasted phrase. 'Of my own belief in this story,' he began, 'I shall say nothing. What I have done is to put it down as far as possible just as it was told me, in my own style....' A modern-day folk tale of native life, it examined with sympathy but without sentimentalism the condition of a young girl on a cocoa estate where 'feminine youth and beauty ... fade early in the hard work' for thirty cents per day. The plot concerned her understandable obsession to marry into her own home, and the lackadaisical courtship by her intended. She appeals to the figure of the title, the special saint of Trinidad whose statue is to be found in Siparia, a refuge for pilgrims. Her very absence from her village on the pilgrimage achieves its aim by stirring his enthusiasm. She is happy but somehow wishes she had not sacrificed her only jewellery, a little gold chain she had placed around the neck of the plaster saint. After she returns home from an evening with her beau, the chain reappears miraculously in its old spot on her dresser. This conclusion is firmly in the genre of folkish credulity so much alive in superstitious Trinidad – or just as possibly of O. Henry, a great favourite of the younger James. The form provides a study in lower-class behaviour,

unquestionably ignorant but also quaint and charming.[45]

James's second effort, the picaresque 'Turner's Prosperity', recounts the plight of a clerk overwhelmed by debts. His crime has been to live slightly above his means, attempting at once to maintain a family respectably and to enjoy minor pleasures. At payday he is hounded by merchants demanding the arrears. His Scotch employer, who rails at the improvidence of 'the natives of this colony', nevertheless offers to rescue the poor man with a loan so as to spare himself the irritant of the weekly confrontation. How much does Turner owe? He has never calculated the precise amount. Taking the question home to his wife, he imagines how wonderfully he could get on with a debt twice the current size. What joy he expresses presenting his employer the total! No miracle transpires. Turner is discharged, destined for a fate James does not even suggest. Tragic in fact, the story has the basically comic quality of the ghetto character study in any ethnic genre, Jewish, Italian or Afro-American to name only a few. Indeed, in their foolishness and beauty, the scenes might also appear in Sholom Aleichem's fictional Russian Pale except that they lack all the signs of messianism or (interestingly, for James's evolution) proto-socialism.[46]

'Triumph', James's third and arguably his best short story, offers one of the first published treatments of Trinidadian (or West Indian) slum life *in extremis*, the condition of society's very bottom rung. This is no ghetto phenomenon: every street of Port of Spain, James tells us, had these barrack-yards with rows of rooms no larger than twelve square feet. James's portrayal of conditions is worth quoting at length:

> In one corner of the yard is the hopelessly inadequate water-closet, unmistakable to the nose if not to the eye; sometimes there is a structure with the title of bathroom, a courtesy title, for he or she who would wash in it with decent privacy must cover the person as if bathing on the banks of the Thames; the kitchen happily presents no difficulty; never is there one and each barrack-yarder cooks before her door. In the centre of the yard is a heap of stones. On these the half-laundered clothes are bleached before being spread out to dry on the wire lines which in every yard cross and recross each other in all directions. Not only to Minerva have these stones been dedicated. Time was when they would have had an honoured shrine in a local temple to Mars, for they were the major source of ammunition for the homicidal strife which so often flared up in barrack-yards.[47]

Secrets are virtually unknown here, and not only because of the physical proximity. James reminds us that 'when His Excellency the Governor and his wife have a quarrel the street boys speak of it the day after'.[48] So that friendly advice and aid, gossip and malevolent plotting, conjuration with good and evil intent among the dwellers weave a social fabric as

tight as it is fraught with contradictions. The protagonist, Mamitz ('shortish and fat, voluptuously developed', as Trinidadians loved their women), has lost her man and finds herself utterly destitute. Only the aid of a neighbour – gender alliances count for almost more than the often unreliable male paramours who bring in money and food – permits her to survive. After invoking Obeah, she manages to acquire a stylish Creole as suave as he is unpredictable in his affections. Thriving for the moment, Mamitz 'grew fatter than ever, and when she walked down the road ... she created a sensation among those men who took notice of her'. She meets a butcher who is not handsome but a good provider. Mamitz's rival provides him with the information that she still entertains the Creole, and a fight ensues. But in the end, his love holds strong and Mamitz wins out. With the ultimate ace of money on hand, she offers to take her rival's 'so' foot man' (afflicted with syphilis) along to the seashore. Such is the stroke of the title.[49]

One can say several things about these stories. The first is that James the writer had already made a precocious stamp upon Caribbean literature. He fairly set out the themes of the pioneer generation, foreshadowing in 'Triumph' Mendes's novel *Black Fauns* (1936) and others to follow. It would not be at all far-fetched to compare James with Claude McKay, one of the key figures of the Harlem Renaissance and author of several of the outstanding realistic, sexually avant-garde works about lower-class people in the history of American radical literature. In *Home to Harlem* (1928) McKay's chief protagonist, a deserter from the war, comes back to romance and adventure that add up to a philosophy of life wholly outside middle-class white ways. McKay had himself already been, successively, editor of the Communist-oriented *Liberator* magazine in New York, a delegate and honoured figure at the Comintern in Moscow, a rebel from Communist puritanism and a poet whose defiant works were read from political hall to Jewish synagogue. McKay himself would drift toward conservatism, Catholicism and an early death. But he had shown what the West Indies could do. If he struck one of the highest notes in the Harlem Renaissance, James resounded a literary echo in Trinidad. Soon he would draw the political conclusions, too.[50]

Second, James made his mark initially through the exploration of the female personality. As in Mendes's *Black Fauns* (1934), men appear in the story principally to move the plot along. Women in fact dominate the bottom rungs of working-class life due to the frequent absence, or even more frequent unemployment, of the men. James shows them wilfully independent. 'I ain' want to married [,] the man in the house all the time, you go'n be a perfect slave. I all right as I be,' says one of his characters, indignant at the suggestion that she take her man to keep.[51]

Finally, and at the deepest level, James has almost articulated a political philosophy. Gregory Rigsby calls this theme in all James's writing 'the law of relationship', the need of humanity at large for egalitarian intimacy with fellow beings. At their best, the residents of the barrack-yards can express this beautifully. Possessions they have few, but on good days 'they shared their rum and their joys and troubles ... everything would be peaceful and happy'. Impoverishment stunts their lives. Yet they express, in their best behaviour, the *possibility* of a different kind of world order. Just as important, they express themselves in terms of what Sylvia Wynter calls an 'alternative cosmology', perfectly symbolized in the 'magic baths' taken by Mamitz to rid herself of lucklessness. However irrational in their own light, these methods described an absolute opposition to the perverted rationality of the existing system. As they take their place in the world, the cultures of such people will put reason and feeling back together in a new way rather than merely imitating the existing modes.[52]

James's novel, *Minty Alley*, published in 1936 but written nine years earlier, reassembles these themes one last time, at full length. One is sorely tempted to see James himself in the young, middle-class Black man who arrives in contemporary Port of Spain and takes his life's lessons from the masses. Haynes – the name sounds altogether too close to 'James' for coincidence – has all book-learning abstractions which made the young littérateur a marginal aesthete. He awakens through the simple act of listening in the hallways, talking to individuals about their views and above all their problems; and he awakens through the charged sexuality of the most spontaneous, undefeated character in the novel. James denies the identity of himself and Haynes. But in the broad sense, identity there must be or James would not be James.

As literary scholars have noted, *Minty Alley* gives the reader precious little landscape and still less psychology. James flatly refused to indulge the 'picturesque' literary travelogue-style so familiar to depictions of the region. And he made a conscious choice for the limited-knowledge narrative, in which the reader learns only as much as does the narrator. Thus we find ourselves wholly within the small world of Haynes, and with him we peel layer after layer from our own ignorance about mass life. When a character says, 'I feel you are one of us now,' the crucial transition has been made.[53]

Haynes has not entered this social world for moral or political reasons. Intended by his mother to study abroad, he faces the calamity of her death just before the novel opens, and must make the necessary adjustments of his life. He goes on working in a bookstore for a paltry $10 per week, but can no longer afford to live in his own house. So he must seek boarding. At No. 2 Minty Alley (among 'ordinary people', his

part-time maid warns him) he finds the cast of major characters: Mrs Rouse, the kindly, ageing landlady and sometime professional cook; Philomen, her beloved East Indian assistant; the nurse, a divorced woman who worked at her profession and cared for her young son; Benoit, Mrs Rouse's live-in boyfriend and occasional day-labourer; and Maisie, Mrs Rouse's spunky young niece.

Tne daily struggles of life produce conflicts, sexual and financial, that draw Haynes towards actions and feelings hitherto unknown to him. Benoit, typical roustabout, attempts seductions behind Mrs Rouse's back. Haynes is outraged; but also excited at the sexual intrigue. Benoit – neither young, light-coloured nor particularly handsome, uneducated and given to absurd disquisitions about mysticism – knows, in his own way, much about women. Increasingly confiding in Haynes, he simultaneously justifies himself and gives Haynes the encouragement necessary to take the steps the younger man so urgently desires with Maisie (after which she can only say 'Why did you take so long, Mr Haynes?').[54] But Benoit is trapped in his own desires. After seventeen years, he will leave Mrs Rouse for Nurse, to a personal destruction which mirrors the eclipse of the household.

Mrs Rouse, the victim of Benoit's philandering, gives Haynes another side to Trinidadian life. Every month of the household raises new desperate financial problems. Haynes learns, at last, that sometimes there is only enough food about for him to eat full meals. Benoit, good-for-nothing that he might have been, is the last love of her life. Her tenants begin to leave. An obeah man, warning her that an East Indian is the cause of her troubles, ignites the very-present race feeling in Trinidadian lower society, 'Nigger' against 'Coolie', and deprives her of the work and the attentions of Philomen.

Haynes himself takes charge of the household but to no avail. The novel ends in a Keystone Kops-style explosion of the feud between the pathetic but enraged Mrs Rouse and the impulsive rascal-like Maisie. Hurling each others' clothes out of the windows, creating a neighbourhood spectacle, they bring down No. 2 as surely as if it had been the House of Usher. From the viewpoint of Haynes, no one can be said to be at fault; this is the life of the masses, their joys tainted by sorrow and their collectivity tainted by conflict.

At the novel's last moment, with Benoit dead and Maisie (also the nurse and son) emigrated to America, Haynes passes the resold house almost by accident. In a phrase critics will seize upon, James describes the rise of the Black middle class, the passing of the old ways, and the keen feeling for nostalgia he has nurtured.

The front door and windows were open, and from the street he could see into

the drawing-room. Husband and wife and three children lived there and one of the children was sitting at the piano playing a familiar tune for Hemy's music-book. Over and over she played it, while he stood outside, looking in at the window and thinking of old times.[55]

This is a fascinating sidelight upon the historic social shift taking place, and most of all upon the rising middle class so evidently missing from the novel. Again, as in 'Triumph', James tells us that the golden age of Trinidadian popular life is past (although perhaps also somewhere in the future). In 'Triumph', similarly, he had lamented Trinidad's 'picturesque life of twenty-five years ago' when the carnival in full and unregulated glory encompassed singers and stickmen from dusk until near-dawn. 'Barrack-yard life has lost its savour', and James is offering a few of 'its great moments' that remain.[56]

This element of distancing is characteristic of the entire literary project. C.L.R. James and his colleagues were triply removed from their subjects, by virtue of education, sex and historical perspective. A much older James might have used the notion of literary 'marginality' to explain his own *de facto* strategy. In any case, it could not have been otherwise for intellectuals at the periphery of the empire. They spoke for and about a West Indian culture. But they properly scorned the educated element within it, that is their own philistine middle class. Their attachment to the lower classes could be greater than that almost anywhere else, due to the intimacy of the surroundings. But it also inevitably had a vicarious quality. That was their achievement and their limitation.

James knew the characters of his stories well from strolling the slums near his own dwellings. He was known as 'a great man to listen' to all who chose to talk, about life and love. In return for their stories, he gave them sympathetic attention. In the case of *Minty Alley*, Mrs Rouse very much resembled a real-life Mrs Roach, an uneducated but very proper landlady of his. Her brother, who somewhat resembled Benoit, was a gambling, guitar-playing rascal caught for keeping a brothel. Mrs Roach, as James later related, had answered this threat to propriety with a stream of articulate invective that struck James as extremely poetic. He listened to her, amazed and impressed at her powers of speech.[57]

He had already, by this time, made up his mind as to his own destiny. 'I had been practising writing. And I said, "Enough of this. I shall save 200 [pounds] (a thousand dollars). I shall go to London, and take my chance, come what may." '[58] It was not a choice to leave the subjects of his literature. As a Black writer, he *had* to go abroad to make a literary career. He would take with him the idea for a novel he hoped would become his *magnum opus*, a fictional treatment of his family's history

over three generations. That novel would never be written.[59]

Minty Alley, dedicated to James's mother, is homage to that which he took along in personal memory. Its dedication is also homage to the personal isolation – despite the presence of his circle of colleagues – in which he completed the creative act. His appearance as avant-garde writer gained attention, but also threatened his respectable status. At this critical juncture, 'when things looked pretty black', he recalls, his mother acted again. She had complained, when reading one of his unpublished earlier stories, that he imitated the British rather than setting out his own style. As he published daring and original stories, she carefully collected the material, defending him to the world at large and to his father at home from criticism. Did he write on subjects considered shocking? 'The boy is just reporting, you know,' James recalls her saying defensively, 'he [is] not advocating anything.' Did he fail to prove, as his father would have liked, that money could be made in this field? 'Don't mind that,' James recollects his mother answering: 'The boy is doing well. He chose to go this way and not that way. Let him go this way.'[60]

James mentions that she even managed, out of her meagre household budget, to send him a few dollars. These might perhaps have been crucial to the young writer. But his mother's confidence in him loomed larger than material considerations. With that confidence, he did not need to write what the newspapers wanted to print. He could go his own way. Although she would have shunned the implication, she had fostered a tribute to the predilections of Matthew Bondman, the aesthetic lumpenproletarian, and to all the bondmen and bondwomen who populated the barrack-yards of C.L.R. James's imagination.

James's growing sense of removal from Trinidad can be measured in another way, as the distance from the settled home life that he had grown up to believe essential to personal happiness. By 1927 he had married Juanita, a half-Chinese Trinidadian woman he recalls as highly intelligent if not especially well-read, supportive of his literary and political ideas. Sister of a woman reputed to be the most beautiful in Trinidad, James's wife worked as a typist, expressed herself little in public, and shared his vaguely radical politics. Were they happy? 'She satisfied all my needs, which were few,' he says a little strangely. (He says almost the same thing about Haynes and Maisie: 'They never made love except when they were about to go to bed together. The affair was not altogether what he had expected it would be, but as he wanted no more than Maisie gave, he missed nothing.')[61] He recalls Juanita saying, about a year after they had married: 'The only time you have any pleasure with me is when you are on top of me.' He could understand, as a writer, the existence of a problem. But he could not understand *personally*, let alone deal with, the problem of being a husband. To this day

he expresses a twinge of regret that she remained behind in Trinidad; she might, he believes, have evolved with him through life; here, too, we may find the element of projection as wish-fulfilment for a relationship unmanageable in real life.[62]

His first sustained historical study, nearly completed as he boarded ship for Liverpool in 1932, gives us still another glimpse of the writer as intellectual in transition. *The Life of Captain Cipriani: An Account of British Government in the West Indies* (1932), retitled, slightly condensed and republished the following year as *The Case for West-Indian Self Government*, is an extraordinary document in several ways. In its original form, it had two distinctly different purposes. He sought to make sense of the social movement which gave Trinidad, at long last, a semblance of polity. He interpreted the rise of this movement through the life of the national hero, Cipriani. Second, he sought to capture the logic or illogic of colonialism, the rule of whites over non-whites, by the example he knew intimately well.

The second task has been remembered best, as an important document in the history of the West Indies. By James's precise social interpretation, the colonial administrator had no ability to understand the complexities of the situation, or to appreciate the talents of the native. He left his liberalism and his spirit of fair play behind in England. He acted not only with prejudice, in economic and social matters pertaining to the islands, but with a perversity that crushed all logical moves toward self-rule. He corrupted the fair-skinned native with the false flattery of meaningless participation, and treated the rest with open contempt. 'Solution of the problem there is but one,' James wrote, 'a constitution on democratic lines.' Failing that, the future looked dire for both sides, but especially for the West Indians:

> Even were the Colonial Office officials ideally suited to their posts the situation would not be better, but worse than it is. For the more efficient they are, the more do they act as a blight upon those vigorous and able men whose home is their island and who, in the natural course of events, would rise to power and influence. Governors and governed stand on either side of a gulf which no tinkering will bridge, and political energy is diverted into other channels or simply runs to waste. Britain will hold us down as long as she wishes. Her cruisers and aeroplanes ensure it. But a people like ours should be free to make its own failures and successes, free to gain that political wisdom and political experience which come only from the practice of political affairs. Otherwise, led as we are by a string, we remain without credit abroad and without self-respect at home, a bastard, feckless conglomeration of individuals, inspired by no common purpose, moving to no common end.[63]

James's other task, the portrayal of Cipriani and the movement he

directed, had the feel of a condensed and somewhat uneven biographical
study. At times the details of Cipriani's life seem to overflow the frame-
work; and on the other hand, the psychological portrait of him remains
incomplete at best. James seems to be experimenting, as he did not need
to experiment with fiction, seeking an appropriate form for a national
epic. Most curious is the virtual absence of description of the Trinidad
Workingman's Association that Cipriani guided, the 15,000 who consti-
tuted the core of a labour and socialist force. Focusing upon hearings
which highlighted the confrontation of Cipriani and local devotees of the
Colonial Office, James plainly shortcut history. At novelistic moments
(Cipriani is seen at Council hearings wiping his hair 'with a backward
gesture which usually characterises bald-headed men') he seems to be
grasping for a different object. What takes form, at last, appears at once
a preliminary document of protest, and a personal preparation for a
different kind of biographical–political study.[64]

'Time would pass,' James concluded in *Beyond a Boundary* about his
early Trinidad experiences,

> old empires would fall and new ones take their place, the relations of
> countries and the relations of classes had to change, before I discovered that it
> is not quality of goods and utility which matter, but movement; not where you
> are or what you have, but where you come from, where you are going and the
> rate at which you are getting there.[65]

James would even admit that only in an English art gallery studying the
Negroid facial feature, or again with the living example of Paul
Robeson, did he abandon completely the Anglo-Saxon physical (and, by
extension, psychological) ideal he had learned in the books of his child-
hood. Not until then did he discover, as Robeson articulated it for him,
that Blacks would be fools and worse to go through life as imitation
whites. By that time, 'They are no better than we,' a phrase heard often
in Trinidad about whites and cricket, would take new, nationalist
meaning. The 'mould of nineteenth-century intellectualism', already
cracked, could be decisively broken and a new C.L.R. James emerge
from it.[66]

But surely that awareness had, before James left Trinidad, dawned in
every sense but conscious self-realization. Everything he had done since
the mid-1920s – his literary beginnings in sports journalism and in
fiction, his collaborative editorial work on *Trinidad* and *The Beacon*,
above all the manuscript for *The Life of Captain Cipriani* – pointed to a
break with the negative self-image which the Colonial Office was
infamous for inducing among its charges. In another, deeper sense,

James the young cricketer, the son of a widely respected teacher, and even the reader of Thackeray, had never imbibed the sense of inferiority anyway. But his growth had brought a broadening of pride from family and self to society, high and low.

The young teacher famous for his knowledge of island history and cricket history had already begun his approach to collective self-redemption. England would provide him the contacts to become the West Indian abroad he could not fully realize at home. He would advance not so notably in his direct embrace of Western culture in its homeland as in dialectical acceptance of its accomplishments as a springboard for other works, outside and contrary to the mainstream, which would transcend the West's palpable limitations.

The personal goal of the writer, it is often said, is to reconcile artistically what cannot be reconciled in life. So we might say of James. If we seek the soul of this writer, perhaps we should return to the vitality of past English literature and its curious relation, in the mind of the young artist-to-be, to the unofficial cultural life of Trinidad. As James would argue in *Beyond a Boundary*, something of the full-blooded pre-modern order had passed from one to the other, or at least achieved a relation in his fertile consciousness. Neither Britain in its contemporary decline nor the nascent bourgeoisie of the island could measure up to that combination. But neither could the nationalist politics of Captain Cipriani, without a cultural counterpart.

He would continue to grow through contraries. James, in his literary mind *returning* to England from the physical reality of Trinidad, would nevertheless remain the Caribbean, Trinidadian, descendant of the James family, childhood friend of George Padmore and tutor of Eric Williams, classicist, cricketer, literary comic realist and political rebel. The development of each identity brought new meaning to the category and to the whole. He had a long life ahead to work out the internal logic against the backdrop of a tortured and heroic twentieth century.

It is an odd thought that James felt himself impelled toward the Western metropoles which had long since buried their carnivals in the recesses of historical memory. No one was so well suited as the young Trinidadian to tap that memory and to tease out the meaning of apparently vanished collectivities for the future of the civilization.

2

'The Absurdities of World Revolution'

When James arrived in England in 1932 – he tells the story – he heard that 'the famous George Padmore' would be speaking at Gray's Inn Road. Eager to see all new sorts of things in those days, he arrived in the hall and found the speaker to be none other than his childhood friend, Malcolm Nurse. Could it have been such a great surprise? Ras Makonnen, reading one of Padmore's pamphlets in New York, had a few months earlier guessed the revolutionary's identity and just missed his departure to England, only to join up with Padmore later. Makonnen already had his mind set upon Pan-Africanism and had grown impervious to the appeals of Marxist ideology. James for now remained the naïf. But not for long.

James says that had Padmore asked him to come along in 1932 to Moscow, for Comintern training in African conditions and the African Revolution, he would have gone at once. As luck would have it, Padmore did not ask. Ostensibly accurate, this story also has an apocryphal feel. We cannot imagine James in Stalin's Moscow. But perhaps it is as difficult to imagine just how much of an unconscious Pan-Africanist James had become by the time of his departure from Trinidad. And how political in his mind, although he had not yet begun to work out the details.[1]

The next six years, by far the most eventful in James's life hitherto, ended the naïveté and set him on a path toward Africa (and the West Indies) but directly away from Moscow. As the vast bulk of the organized Western Left absorbed the horror of Nazism, lowered its sights and settled for Socialism in One Country (with capitalist democracy in the others), James and a relative handful of activists moved against the current. Trotskyism in a few countries offered a resilient intellectual opposition to compromise with capitalism and to the internal degeneration of Soviet life. Versions of Black radicalism in the USA and England

drew propagandists and journalists toward the cause of African and – more rarely – West Indian emancipation. With minor possible exceptions such as Trotskyists in Ceylon, only the activity of James himself forcefully joined anti-imperialism and Trotskyism. And only for the brief episode of British political life did they work in equal parts of James's day-to-day activity.

Trinidadian nationalism came first, along with cricket. These two cannot be separated either practically or intellectually in James's introduction to English life. He had come to England ('The British intellectual was going to Britain,' he later put it) to become a writer. Cricket carried the freight costs, and offered him a road into popular English life.

James and Constantine

James had known Learie Constantine somewhat more than casually, through family, friends and cricket circles in Trinidad. (If only he had chosen Shannon rather than Maple, he notes in *Beyond a Boundary*, he would have known Constantine far better.) But James had never, he later testified, discussed more than cricket with the older man. From the moment James set foot on British shore, ostensibly and actually to write Constantine's *Cricket and I*, he became keenly aware of his colour and his West Indian status. Constantine prompted him, and the two prompted each other, to ever higher levels of consciousness. The intellectual-minded athlete and the athletic intellectual working in harness constituted a unique, formidable alliance for genial anti-colonialism. Thereby hangs a tale of international sports history.

Constantine's father, an overseer and international batsman, travelled by Trinidadian public subscription to England in 1906 and at Crystal Palace batted 89 against W.G. Grace. As if that were not enough, Constantine's uncle was the popular slow left-hander, Victor Pascall. Learie Constantine, in short, had been sired for the sporting purple. A regular All West Indies player, he came to England in the later 1920s because he had suffered for his colour in the lack of a government appointment, gone to work in the oil fields, and found cricket the one way forward. Like so many other Black men, he made up his mind to succeed – and the community around him desperately wanted him to succeed. Thus, a few years before James's emigration, Constantine had secured for himself celebrity in the county league cricket of Nelson, Lancashire, 'amidst mingled [West Indian] cheers and regrets at our losing him'. He truly came into his own, playing in England as he had never played in the West Indies and emerging as a true representative of

the Caribbean. Through concentrated effort he earned his English stature, meanwhile eliciting a home-island enthusiasm bordering on adulation.²

Constantine returned periodically to Trinidad, and often spoke with James about cricket, England and the English. When he learned that James was prepared to travel, was in fact vaguely planning some early point of departure in order to become a literary man, Constantine offered to underwrite the young intellectual through thin times.

'For a non-white colonial to adjust his sights to England and not to lose focus is the devil's own job and the devil pays great attention to it,' James reflected in *Beyond a Boundary*.³ Incipient littérateurs tended to get lost in English life, incipient nationalists to get lost in anti-imperial debunking. Constantine supplied the perfect medium for learning about England in a more general way: through cricket circles, he knew working and other classes widely, but concentrated upon (and offered James) experiences rather than abstractions. In his quiet fashion, he was already an ardent nationalist and anti-racist.

Daily life as virtually the only Blacks (along with Constantine's family) in Nelson, Lancashire, made a more vivid awareness of race inevitable. Thus when Constantine opened the door for James to professional sports reportage, he also opened the door to anti-imperialist politics. (Ironically, Constantine would return to Trinidad as one of Dr Eric Williams's major supporters decades later, and James would feel compelled to oppose him as insufficiently watchful of neo-colonialism.) But it was not a politics directed at the surrounding, largely working-class population. English children of this period, but not only children, remained simply ignorant of, and mainly curious about, Blacks. The heroic cricketer of county league play and the affable young writer seemed so utterly unlike the stereotypes of African savages. The word spread from Lancashire outward that Constantine was an interesting speaker on cricket and on the West Indies, at church meetings and other public functions. In an age when mass media had only begun to erode the role of the speech as entertainment, James the former schoolboy debater took the platform first with Constantine, and then alone. 'We were educating thousands, including ourselves,' James recalls.⁴

In a remarkably short time, James became a public figure. (There was even some talk of putting him up for parliament.) The BBC had invited him, almost by accident, as last-minute substitute on a panel and he acquitted himself with such vigour that colonial officials complained and James countered with a detailed reply. He had carefully explained on the centenary of slavery's abolition that West Indians, too, were Westernized and not some primitive peoples. He did not have to rage at the crimes of colonialism. The key idea went straight to the core of imperial

ideology and took it on effectively, as an absence of fair play.

Cricket and I (1932) made the same point still more pleasantly. At once a memoir and a study in cricket, the book served nationalist purposes with a subtlety and impact that no self-avowed political West Indian manifesto could have. 'The first book ever published in England by a world-famous West Indian writing as a West Indian about people and events in the West Indies', as James called it, Cricket and I simply demonstrated the maturity of thought, the forcefulness and also the Englishness of the West Indian.[5] Like the tremendous kindliness that Constantine's presence evoked in the Nelson working-class families, eager to aid their adopted home-town hero, the book dictated by Constantine to James clarified a simple distinction that, in popular discussions of sport, frequently leaps across all previous barriers. Race and race-hostility might prevail in the world; but on the playing-field, heroism and humanness come in all colours.

Meanwhile, Constantine subsidized the publication of The Life of Captain Cipriani (1932), and thus made possible James's first non-fiction literary success in his own name – and in that of the West Indies. The next year, Leonard and Virginia Woolf's Hogarth Press published a shortened version with a more straightforward title, The Case for West-Indian Self-Government, politely received in England. Lacking any conscious plan, James and Constantine had in only a few years made considerable progress toward a statement of West Indianhood. In a few years, James hit upon a further project of West Indian history: the Haitian uprising and its hero, Toussaint L'Ouverture.

A turning point approached for James in several different ways. The Caribbean scholar Robert Hill has suggested that documenting and interpreting 'the most outstanding event in the history of the West Indies' prepared James's intellectual turn to the Left. He soon found himself immersed in radical French historiography, simply in order to grasp the French Revolution and its relationship with the San Domingo events. This was an education in itself, at the root of a modern social history decades ahead of its Anglo-Saxon counterparts. Later he would locate an especially important intellectual companion working through the French Revolution itself, the independently wealthy, brilliant, somewhat unorthodox Trotskyist Daniel Guerin. The knowledge of each other's work, and political connections, strengthened the resolve of both. Seen in another light, James's research also constituted a preliminary approach to international Black history, hardly even a concept at that point. In the same years that James pursued his researches, veteran Black political–intellectual leader W.E.B. DuBois, foremost sponsor of Pan-African gatherings, had begun consolidating the studies leading to his book Black Reconstruction. The relative youngster (and political

neophyte) James, and the distinguished DuBois evolved simultaneously toward Marxism, on history's account. They could solve the intellectual problems before them in no other manner.[6]

But if DuBois remained in the élite Black milieu, hostile to Marxist politics for almost another two decades (or until capitalism had proven its stubborn unwillingness to reform relations with the non-white world), James surrounded himself with a British working-class radicalism which led him on another path altogether. He took seriously the kindly criticisms of his developing ideas by local Labour Party members. But he kept reading his books, with a thirst for knowledge unprecedented in his life.

Meanwhile, another reality intervened. How could he finance his time to do intellectual work? Constantine once more came to the rescue, through a recommendation to a friend, premier cricket journalist Neville Cardus. A poor boy from Manchester, largely self-educated to literature and music, Cardus had simultaneously made his way upward through minor publications to the *Manchester Guardian* and sloughed off his youthful socialism. 'The MG', as he wrote in his 1947 autobiography – more than a little like *Beyond a Boundary* – made its young writers painfully conscious of style. It also made them famous. Cardus fell into cricket reportage accidentally, as a replacement. He made a great name for himself there because he so loved the game and the players that he brought his full critical attentions (with allusions to music and literature aplenty) into his sports commentary. He had been at it more than a decade at James's appearance.[7]

James needed only a chance to prove his potential as a popular sports writer. Overnight he became the first West Indian, the first man of colour, to serve as cricket reporter for the *Guardian*. Soon he would add *The Glasgow Herald* and a few other periodicals to his list. He had, as his editors and readers soon recognized, taken on more than a job. It was a labour of love, the passion of his Trinidad correspondence days now realized in the spotlight of world journalism. Cricket not only provided a means of living. The fulfilment of earlier, barely conscious aspirations gave James a rootedness in British life and culture that few native revolutionaries could claim. Indeed, the distance established between him and England by his birth, colour and circumstances permitted him an unashamed attachment to contemporary popular culture from which British (as American) theoretical Marxism almost invariably found itself alienated.

Cricket Reporter

Most of James's early cricket writing involved county matches, to which he brought both a sense of sports tradition bordering upon sentimentalism (but crossing that border quite less often than Cardus), and a sense of collective British accomplishment which an unabashed patriot could embrace. The county pitch, which from Trinidad he had anticipated to be a small and endangered spot of green amid the industrial grey, he found delightful – 'beautiful as it seems only the English countryside can be beautiful'.[8] The habitat and the game, as respite from commercial life, suggested a substitute for all that had begun to vanish from urban reality. It also offered, James hinted, a sign of what possibilities for a better British life lay ahead.

To read James on the fifty-nine year-old S.F. Barnes is to understand the accumulated dignity of cricket – and the appreciation of that dignity by the crowd – as if in a novel. The bones of the old sportsman creaked and the noble countenance showed 'a man who has seen as much of the world as he wants to see'. Barnes the bowler confronted Constantine the batsman and, as 'a case of the boa constrictor and the rabbits', disposed of him in under seventy runs. The hometown Nelson crowd applauded him roundly. Then the circumstances reversed and Barnes, older than Constantine's father, faced the young West Indian's fast bowling with pride and with team results. 'In the years to come,' James concluded, 'it will be something to say that we have seen him.' No cricket fan with a heart could object.[9]

Still more remarkable in the combination of sports and social themes was James's commentary upon the visiting West Indian team. Here, he had no competition even from the likes of Cardus. James treated readers of *The Cricketer* to a short education in the material conditions of the game in the Caribbean: paucity of equipment reinforced by a paucity of good, steady competition, but offset by favourable weather and by sheer popular enthusiasm. He analysed the strong and weak points characteristic of this milieu: talented but inconsistent batting, and fast bowling let down by poor slip-fielding. Only with proper handling could West Indian cricket become great. But such handling, he seemed to suggest, demanded an end to the colour line and to colonialism at large. West Indians had proved themselves, as individuals, when given the chance. Now they were waiting for the chance to prove themselves as a people, James hinted. It was 'only cricket' for the British to recognize the reality at long last.

On assignment after assignment, James the journalist discussed the essentially fine points that a junior reporter should. In even the most average columns, a tone of self-confidence and seriousness comes

through, a drawing of implications without pretension but with a deep respect for the players and spectators. Here and there, almost as a surprise sprung upon the ordinary sports reader, he injected an altogether stunning phrase. Once he imagined that an Athenian, used to gazing upon the Olympic Games, were suddenly transported to the Lancashire pitch:

> What would an Athenian have thought of the day's play? Probably that the white-flannelled actors moving so sedately from place to place were performing the funeral rites over the corpse of a hero buried between the wickets. Watson and Iddon, from their garb and movements, he would have supposed to be priests waving the sacrificial wands with solemn dignity.[10]

It was a characteristic touch. Within a year James had made his reputation as cricket reporter. A less confident or less political man might well have cleaved to it, or added it to a repertoire of theatre and music criticism as Cardus did, and as publishers pleaded with James to do in order to fill out his critic's vocation. His rich personal life around the theatre, his fanatic devotion to Shakespeare performed with British precision and feeling, his personal attractiveness and wit would have made him a distinguished figure indeed.

That was neither James's proclivity nor his limit. According to Eric Williams, who arrived in England only a few months after his former tutor but who kept nose to academic grindstone in order to reach (successfully) for a First in History, James might easily have become a more distinguished scholar and forefather of West Indian nationhood. He might, that is, if only he had not abandoned all for 'the absurdities of world revolution'.[11] Williams misunderstood James fundamentally. Although the political particulars of world revolution might intrude severely upon time, aspirations and intellectual training made James at once scholar and Trinidad's greatest cultural nationalist. Cricket afforded one sort of public fulfilment for the West Indian in Britain, Marxism another. James described his new thinking as the result of a conversion experience from which he could not imagine turning back: 'Something came into my life and altered its whole course. Everything previous seemed only preparation.'[12]

One might almost say that the society of British Marxists provided for James the complementary opposite to the world of cricket. What one included, the other excluded, and vice versa. Each was international in its way, but the two led (in the eyes of any other observer, at any rate) to very different visions of the good life. Both celebrated man the tool-using animal. But the machine and the bat or mitt implied contrasting historical and aesthetic phases of civilization, as James would articulate

decades later in *Beyond a Boundary*. The first (according to most Marxists of the time) depended upon the raw exertion of collective power and the second (according to the friends of cricket) upon muscled finesse. Each had, moreover, its own ambiguous relation to the British working class, shifting with time and place. While one aspired to revolution as a culminating, even eschatological event, 'revolution' (had the word been used) to the other would have been a full circle: a return to beginnings. One tended, in Levi-Strauss's phrase, to bury Being in Meaning, sensuous experience into ideological definition; while in the other, Being held Meaning at bay and threatened to disguise the larger significance altogether.

From the day C.L.R. James picked up his first socialist text, he had already entered the eccentric British Marxist world, small and relatively isolated by continental standards. Its special contours fitted his needs, making accessible a supporting cadre which educated him in industrial working-class life and honoured his efforts without, however, dominating his entire political attention (as would American Marxism later). Its very weaknesses served, for his era of personal transition, as sources of growth. British Trotskyism, hardly large enough to be described as a movement, effectively introduced him to the wide vistas of Marxist internationalism.

One of the sources for this rich interaction can be traced straight back to the West Indies and to an earlier version of the *emigre* revolutionary, Curaçao-born Daniel DeLeon. The British DeLeonists, following the doctrines that the Socialist leader set out in America, had broken away from the Hyndman-dominated Social Democratic Federation (SDF) at the turn of the century. They proceeded thereafter upon a purist course apart from the main current, the British Socialist Party (BSP), which also grew out of the SDF among other sources. No more than a thousand in number to the BSP's considerably greater following, the DeLeonist Socialist Labour party (SLP) might have been a mere footnote in British Left history except for two considerations. Like its American counterpart, the British SLP became deeply involved for a period in the radical wing of the industrial union movement, especially in Scotland. Unlike its American counterpart, it sunk roots deeply enough in the working class to become a prime source for early recruits to the British Communist Party.[13]

The mass strike movement beginning in 1910, and the world war four years later transformed the British Marxist scene in several important ways. The shop steward movement grew up as an alternative to stagnant official labour (including Labour Party) leadership, and carried with it an arguably proto-revolutionary, but at least fervently syndicalistic momentum. New entities, such as the Plebs Leagues (named for a

phrase in DeLeon's classic *Two Pages from Roman History*), the Workers Socialist Federation and the South Wales Socialist Society emerged alongside the shop stewards, emboldening anti-war sections of the Independent Labour Party (ILP) and raising hopes for a new, national coordination.

The Russian Revolution, and to a lesser degree Leninist doctrine, filled the vacuums of an organizing centre and a cohesive doctrine. The resulting Communist Party of Great Britain (CPGB) dominated native Marxism more successfully, until the time of James's immigration, than in either most of continental Europe (where the Second International parties hung on and, to an extent, revived) or the USA (where a combination of 'Right' and 'Left' deviations, IWWs, ethnic socialists and others gave the pre-Popular Front Communist Party a difficult time). This is not to say that British Communists, in this early period, had any special success; but between the CPGB, the reformist Labour Party and the ethical ILP, the available political slots on the left had been filled.

The CPGB had also managed to adapt itself to British turf in one very important way. Concentrated in the mining districts of South Wales, the factories and shipworks on the Scottish Clyde and a few other places, the few thousand members represented a proletarian tradition (especially outside England proper). That tradition, according to Stuart MacIntyre, can be correlated with the pride of the skilled worker in the relatively recent, but thoroughly working-class, community. He (with rare exceptions, she) spent limited leisure hours in union activities and self-improvement – especially study. This was especially appealing in districts where the autodidact tradition had already been strong, and where a recent displacement of religion by secularism had evidently left a gap in 'faith'. The disciples were men who took pride in being at once a part of, but not limited to, the lives of their fellow workers. In America, outside the all-important ethnic communities, they might have grasped at upward mobility; in England, education and politics became a compulsion.[14]

Communism offered this ambience a decided mixed bag, varying quite as much with the district as with the shifting international line. It gave them, in Moscow, a Mecca for world revolution, and an increasingly dense set of documents which fructified their instinctive faith in science. The first appealed mostly to militants, but the second touched English labour traditions deeply. Marxism of the SLP or BSP variety had emphasized purity of doctrine, but also helped to precipitate the rise of a class feeling ('class hatred' might not be too strong a term) wholly outside the labourist, parliamentary tradition. The eclipse of immediate revolution from the horizon after 1921 posed a problem for credible strategic perspectives. But it re-emphasized the very tradition of

education which meant so much to the working-class cadre.

Over the course of the 1920s and early 1930s, the Communist Party and several commercial publishers therefore added dramatically to the stock of Marxist literature. Cheap, readily available writings by Marx, Engels, Lenin, Bukharin and (especially at the end of the period) Stalin, among others, were circulated vigorously. Veteran Marxists poured new wine into old bottles, the familiar emphasis upon the printed word altered only by a change in text, wall charts detailing evolution refitted with new terms. Until the 1930s, as McIntyre emphasizes, the process remained a proletarian concern generally, with middle-class teachers no more prominent than erstwhile autodidacts.

All this began to change fundamentally toward the end of the 1920s. Defeat of the General Strike shrank British Communism to a world of its own, especially as Communists deepened their isolation through fits of sectarian rage. In a more structural sense, the greater availability of secondary education to the 'gifted' child of the working class had already begun to erode the source of Marxist autodidacts. The displacement of the workers' educational centre as source of entertainment and edification by the picture-house and the radio also took a heavy toll. The upper levels of the Party, especially its educational posts, began to be taken over by middle-class intellectuals. This development coincided with, then reinforced, the displacement of theoretical expertise from the local autodidact to the office of the Party's high priest.

Leninism's faith in the Vanguard already tilted the emphasis toward this direction before Stalin tightened his grip upon the Comintern. The 'unity of theory and practice' *as determined by the Party* eclipsed, once and for all, what might be called the 'era of Joseph Dietzgen', the cult of the self-taught philosopher. As universally in this era, Moscow's perspective rendered the ultimate source of change at once both the cosmos (which decreed dialectics throughout the material stuff of the universe) and Party (which, although subject to the 'Laws of History', also somehow altered them). How the two interacted, and what implications followed, remained a mystery to be unravelled by Communist publications and leaders. In some periods, the Labour Party might be seen to have been created and sustained for the precise reason of holding back the workers; in other periods, it appeared to be a wrong-headed but genuinely proletarian movement which needed to be entered and transformed (or at least its active cadre recruited).

The rationale varied with the period, but the distance between the intellectuals and the constituency remained set in place. And, of course, so did the primacy of Moscow in all theoretical as well as practical matters. As the syllogism went, Leninism was the only Marxism of the day, the Communist Party the only valid representative of Leninism.

This seemed plausible to many of the World War I-era militants, or at least better than anything else available. The relative lack of Communism's political progress might be attributed to the empiricist woodenheadedness of the British people, or to the corrupting influence of Empire, or to competing political forces. Whatever the reason, men like Willie Gallacher, Tom Bell and T.A. Jackson stayed and stayed until the end of their long careers. Intellectuals such as Palme Dutt and Harry Pollitt articulated sweeping doctrines. Younger people, drawn in through the unemployed movement on the one hand or campus appeal of the Popular Front on the other, had no way to understand what had been lost along the way either to Stalinism or to commercial culture or both.

But other political radicals did understand, and it was to these that C.L.R. James owed his christening in Marxist practice. The ILP, still ten thousand strong at the beginning of the Depression, was probably closer than Marxists of any kind to real British working-class traditions of egalitarianism and nonconformity, with a touch of pacifism as well. The presence of the CPGB reinforced the ILP's tendency toward the middle-class rebel, but the potentiality of consistent work within the Labour Party (until 1931) held real appeal for many a working-class militant. The decision to leave the Labour Party led, in a half-dozen years or so, to the virtual disintegration of the ILP. But in the widely held perspective of capitalism's 'final collapse', governed over by Labour Party leaders' class betrayal and met incompetently by an isolated and ineffective Communist Party, this end was by no means apparent. Rather, the ILP and the CPGB both moved along in the national crisis as little churches both anticipating some vast, sudden growth (including a triumph over the other) not far ahead. ILP eclecticism encompassed the old educational spirit as well as a variety of older and newer forms of appeal, including fractions of Leninist sympathizers or infiltrators Stalinist and otherwise. ILP leaders attempted a balancing act between the competing forces of attraction. By 1934, when the ILP broke off protracted negotiations with the Comintern, Trotsky himself was invited to contribute to the pages of the influential weekly, *The New Leader*.

This offered an opening that Trotskyism badly needed. But as Brockway himself espoused Trotskyist-like criticisms of Comintern tactics, the ILP threatened to overwhelm or co-opt the perceived need for a distinct vanguard force. British Trotskyists had no serious alternative to offer. Trotsky's hopeful formulations of winning over 'the revolutionary proletarians' in the ILP strained credulity severely. With a mere handful of disciples, they had virtually nowhere else to go anyway. Compared, for example with the USA – where the Communist Party heresy-hunt of purported Trotskyist sympathizers managed to exclude an important

labour bloc in Minneapolis in the late 1920s and to alienate a group of prominent intellectuals in the early 1930s – British Trotskyism had slim pickings. No prominent leader of James P. Cannon's previous national stature, no important youth leaders such as Max Shachtman could be corralled, despite widespread disaffection with Party practices.

When James moved toward Trotskyism, based upon his own reading and via a discussion group which met at the home of a noted cancer researcher in Hampstead Garden Suburb, he found his prospective comrades less well read in the Marxist classics than himself, the neophyte! With his writings in *The New Leader*, his public speeches and his influence on the ILP, British Trotskyism literally came of age. Amassing a mere 40–50 members in various ILP branches, they could dominate in Liverpool and London, and heavily influence others.[15]

The grizzled veterans of British Communism's early days, Harry Wicks and Henry Sara among others, brought more to the match than mere enthusiasm. British Trotskyism's working-class cadre, small as it was, had the ring of proletarian authenticity. The hard-bitten autodidacts, disappointed in what they found of Communist Party-style Leninism, had been expelled or gone searching. James later recalled warmly their sense of political and human experience in the working-class movement at large, an experience rare to the younger generation of Trotskyists recruited largely from college or middle-class circles. They were, the oldtimers at any rate, arguably the crafted traditionalist cricketers of Marxist politics. Appeals to celebrity based upon manipulation of public opinion, as the Communists were to arrange most effectively during the Popular Front era, went beyond them and beneath them. Time and the school of hard knocks had taught them the rules of discussion and debate. They could not treat the vision of a now-imaginary Soviet democracy seriously. And they could not return in kind the slander that Stalinists like Harry Pollitt poured across them. It wasn't cricket.

They had come a decade late or several decades early for the successful espousal of these views. With the unemployed movement, Spain and the Popular Front, the Communists consolidated a hold upon activism. At the end of the decade, they had neatly reversed the proportions of Left activists held by the ILP and CPGB. Fenner Brockway's personal appeal notwithstanding, the ILP had in the meantime been very largely reduced to a pacifist–socialist movement on the model of former Protestant minister Norman Thomas's US Socialist Party following, likewise dwindling perilously toward virtual collapse. As in America, the Popular Front alliance with capitalism and allegiance with Russia precluded other possibilities.

There had been moments of higher hopes. The Communists' earlier

abandonment of the ILP, and latter abandonment of revolutionary perspectives in favour of the Popular Front, temporarily cleared spaces on the Left. Although some British Trotskyists shifted their attack to the leaders of the ILP, Trotsky himself earnestly sought to win the movement over. What he had in mind, however, was some eventual enrolment into the Fourth International, precisely the sort of entangling alliance that ILP leaders had feared in the shape of the Comintern. This difference, more than any of the important strategic–tactical differences (such as the Trotskyist condemnation of pacifism) set the stage for a showdown. James, taking principled Trotskyist positions in general, not only sought to avoid a final rupture but remained in the ILP after nearly all the rest of the Trotskyist circle had gone off on their own, and thence into the Labour Party.[16]

To seek the logic in this political–personal puzzle, the most single important moment of Trotskyist–ILP practical activity must be glimpsed at close range: the Abyssinian crisis. When the Soviet Union rushed to send oil to Italy, rather than leading the struggle against imperialism, James became the outstanding spokesman within England and certainly within the Marxist movements for the Ethiopian plight. 'Let us fight,' he proposed, 'against not only Italian Imperialism, but the other robbers and oppressors, French and British Imperialism. Workers of Britain, peasants and workers of Africa, get closer for this and other fights.' With his encouragement, the ILP urged British workers to refuse to handle munitions, war materials and oil. When pacifists, supported by Communist sympathizers, rescinded this resolution, James pressed the point in what was called 'a typically torrential speech'. Somewhat fancifully speaking as a 'Black Worker', he appealed movingly for help to Ethiopian Blacks.[17]

The stature of James rose, but the prospects of Trotskyism fell. An entire issue of the *Controversy*, the ILP internal bulletin, continued the discussion, with James outlining the revolutionary position and warning that failure on the question would mark the ILP's downhill course. Despite Brockway's support on this particular, the pressure against the Trotskyists mounted. Not only did the parliamentary faction win a referendum vote for pacifist non-interference, but the Marxist Group was forced to dissolve officially in order for Trotskyists to continue as individuals within the ILP. In international discussions, James persisted in describing the ILP as 'the only independent working-class party in Britain', and in ruling out unnecessary desertion.[18] There was no evidence, he averred, for the hardline Trotskyist claim that the ILP was about to collapse; Trotsky's prediction of the Spanish POUM's disintegration had been altogether mistaken. The differences became academic, in any case, when the publication of *Fight*, the new tabloid of

the Trotskyists edited by James, was declared by ILP leaders to be a hostile act. James himself moved the resolution for collective withdrawal.

Neither he nor the other Trotskyists found a medium equal to the ILP. The Marxist Group, attempting to make a fight for an independent Fourth International entity, rapidly lost steam. Many of the British Trotskyists had already made up their minds to enter the Labour party *en bloc*, while others including James opposed the move. Subsequent divisions among such small numbers meant virtual disintegration. Some rejoined the ILP. James himself occasionally spoke at ILP branches and wrote for *Controversy*. As the ILP itself disintegrated, it became a somewhat more firm supporter or at least publicist of the colonial revolution. Meanwhile, the Trotskyists continued quarrelling among themselves, merging and splitting in succession. For the next few years, the Trotskyists would gain their main influence among Labour Party youth, and find that influence ably combatted by Communist supporters. James the magnificent public speaker could still rally a crowd, and frequently did, in street meetings. He could effectively denounce Stalin and the Comintern. But he had no taste for the Labour Party. And he had no viable alternative.

James's least original major work, researched in part by the Marxist Group (and dedicated to them) must be placed in this context. Through a connection Brockway had made for James and other anti-Stalinists, Fredric Warburg published *World Revolution* in 1938, despite Warburg's own genial scepticism. It was the first comprehensive anti-Stalinist study of the Comintern and the only one, for many years, not based in a comfortable reassurance of capitalism's many virtues. It was chiefly an expansion on, and a small-scale correction of, Trotsky's own internationalist polemics. 'So far as individuals personify movements, Trotsky personifies the principles of Marxism, Stalin the degradation of the Third International,' James wrote in a phrase he would repudiate within a few years. 'The bourgeois world realizes day by day that the banner of world revolution has passed from the Third International of Stalin to the Fourth International of Trotsky....' This was wholesale fantasy, but an inevitable conclusion to such a work.[19]

Actually, James brought Trotsky and Trotskyism up short on a few points, especially in regard to the ostensibly unimpeachable Vanguard Party. He had seen just how easily that vanguard might ignore or abuse the principles of internationalism when it came to colonized societies, and he had an inkling of how poorly the vanguard concept embraced the historical particulars of the West's own working classes. 'There is more involved in this than right or wrong ...' he warned:

Centralism is a dangerous tool for a party which aims at Socialism, and can ruin as well as build. Lenin was a man big enough to forge this weapon fearlessly, use it to the utmost limit and yet realize its limits. He was a dialectician and knew that democratic centralism was very near to democracy at one time and equally near to pure centralism at another. Yet it would be idle to deny that all through his association with the party he dominated it.... Yet despite his authority he was more than once the prisoner of the conceptions he had so rigidly instilled.... From the Russian party it spread to the whole International. Centralism which helped to create the International helped to ruin it.... It is perhaps the greatest of the many bows that the revolutionary Ulysses will have to bend.[20]

Trotsky himself was unlikely to accede to this formulation. While he seemed to encourage democratic discussion in contrast to Stalin's diktats, in fact he took criticism of himself badly and outright disagreements still worse. He could not have liked the comment that Trotsky 'either could not or dared not bring the masses' into the opposition of Stalin, as Lenin surely would have done in his place.[21] He definitely did not like James's portrayal of Comintern degeneration as having begun, notably in Germany, *before* Trotsky's exodus from influence.

With such minor exceptions, *World Revolution* hewed to the Trotskyist line of blaming all failures upon Stalinism and then upon Stalin personally. Nor did he take Trotsky to task for Kronstadt (where the great military strategist of the Civil War ordered, albeit with a heavy heart, the repression of the striking sailors). Taking congnizance of the essential role peasants had played in Russia and again in China, James declined to note the indifference Trotsky showed toward the particular peasant modes.

'If anything will emerge from this book,' James wrote oddly at the close of an early chapter, 'it is not only the strength of principles but the power of leadership. The first helps the second. The party of international Socialism rose with Lenin and died with him.'[22] In this largely negative sense, *World Revolution* had the virtues of its faults. The critique of Stalin as the conscious and unconscious soul of the bureaucracy – not only in Russia but worldwide – confounded the purely subjective interpretations spread by Communists and Trotskyists alike. Not only the unwillingness but the congenital *inability* to choose rising masses over a Party bureaucracy becomes the foremost feature of Russian foreign policy. 'This unique combination of economic and political ignorance and stupidity, Tammany Hall ability and ruthless determination' had *succeeded*, in its own malign way, in consolidating itself and its grip upon world forces after 1934.[23] That truth was one Trotsky could only understand as an aberration, and James as a temporary fact of political life. The road out seemingly led back to the Fourth

International. But not in England, where at least in the foreseeable future the outlook for Trotskyism was unpromising to say the least.

James's translation of Boris Souvarine's *Stalin*, published by Warburg on the eve of the Hitler–Stalin Pact, became a hot-selling work precisely because it dealt at closer range with the personality. It was the first and last major translation work of his career. The book's merit could be found in degree to which it shed light upon the qualitative changes in Russian society and the difficulties of Marxism encompassing them. James's personal consultations with Souvarine, in Paris, gave him more food for thought on the history of Bolshevism. But *Stalin*, first and last a polemical work, also bore the dogmatic weaknesses of *World Revolution* in which Stalinism had become the *deus ex machina* for the failure of world revolution. Somewhere inside himself James struggled to get past this limit. He could do so only through personal life and via other arenas of political–intellectual work. Pan-Africanism, a broadening upon his West Indian nationalism, offered the way out.

Pan-Africanism

By the time James arrived in England, the older Pan-African movement in its various manifestations had nearly run its course. From the middle of the nineteenth century, individual theorists put forward versions of race pride, the return of Africa in particular to its historically distant place of glory, and the contribution of Black labour to build a Western prosperity it did not share. The struggle for Indian independence offered one model of anti-colonialist rhetoric and direct-action strategies. African nationalism summoned up very different notions of massive repatriation, international support, scientific study and so forth, all with a single underlying purpose: the redemption of the race.

The newer Pan-African movement had its origins in the collaboration of W.E.B. DuBois and Trinidadian Henry Sylvester Williams, who together launched the first Pan-African Conference in London in 1900. Revived by DuBois in 1919 as the Pan-African Congress, it provided a forum of educated Black opinion on the threat of racism and the import- ance of race dignity. As early as the first years of the century, theorists began to put forward the concept of Africa's primitive communism as a source for development and a lesson for the world. The 'Cult of the African personality' provided the mirror image of the vastly more powerful colonialists' myth of Black savagery. But 'African socialism', of which the world would hear much, had already been born.

The Congresses may be said to have reached their climax in 1921 in London, with a host of Black educated luminaries and a handful of

noted English liberals. True to the Wilsonian promises of America's wartime 'world crusade' for democracy, it sought to legitimize Black autonomous states, past, present and future.[24]

Less respectable but more influential, Marcus Garvey's 'Back to Africa' movement precipitated a mass political and cultural force such as Black America had not seen since Populism. For the first time, Black Nationalism became, moreover, a widespread, international phenomenon. Descendant of Jamaican Maroons, Garvey had arisen as an agitator and newspaper editor, speaker at London's Hyde Park and frequent visitor to the British House of Commons. Launching a nationalist movement from Jamaica, he arrived in America in 1916, and within several years had made Harlem a centre of international agitation. Joined by prominent Black socialists, he led protests against race rioting, published from 1918 a popular weekly and impressed many observers with the charismatic influence he possessed over Black audiences. Building a Universal Negro Improvement Association (UNIA) of more than eight hundred branches, founding a score of small businesses, he became what Garvey scholar Tony Martin has rightly called 'unquestionably the leader of the largest organization of its type in the history of the race'.[25]

Garvey convened a world gathering at Madison Square Garden in New York, throughout the month of August 1920, with some 25,000 international representatives and thousands outside who could not be seated. By that time, opposition from all sides, DuBois to the US State Department, had converged to unseat him from authority. Relentlessly pursued by American authorities, victim of near-successful assassination attempts, he was convicted of mail fraud in 1923. Garvey was eventually sent to prison and then deported. Yet he and the UNIA remained influential well into the 1930s, especially in the West Indies, albeit never to the old degree. The images Garveyism had raised, of Blacks who conducted their own economic affairs where possible and fought back physically where necessary, nevertheless made an immense impression in an age of rising nationalisms.[26]

The movement for Indian home rule had pioneered the anti-imperialist movement in England and by the time of James's appearance created a formidable anti-colonial lobby. Krishna Menon, destined to become a fast friend and honoured colleague of James's, had taken it upon himself during the 1920s to transform independence agitation from a polite parliamentary effort into a dynamic educational mechanism. Establishing his influence at once in India and England, he offered a model of what one agitator could do. Backed by the continual and often violent agitation at home, Menon impressed upon the English the seriousness of the anti-colonial mission.[27]

The general decline of Garveyism, meanwhile, allowed new Pan-African movements to emerge, their intellectual and political leadership mainly centred in London. The West African Students Union (WASU), founded in 1925, most clearly followed old models in its rallying of present and future élites on behalf of Africa as a whole. The League of Coloured Peoples (LCP), launched by Jamaican Harold Arundel Moody in 1931, sought to build a British movement through opposing discrimination and taking up the case of Black British seamen in particular. Moody's stern Christian fundamentalism, however, had little appeal to the radicalized, rising generation of African intellectuals. Here, James's childhood comrade stepped into the gap. George Padmore's foray into Comintern politics created a paper, *The Negro Worker*, also in 1931, and a much-circulated pamphlet, *Life and Struggles of Negro Toilers* (1932). The Comintern shift toward the Popular Front de-emphasis upon British and French colonialism ended this style of agitation and forced Padmore into independence. The Abyssinian Crisis brought Padmore, and a score of other talented activists, together with C.L.R. James.[28]

Abyssinia (or Ethiopia) was the veritable symbol of Africa's past greatness, its emperor Haile Selassie a unique monarch upon a throne older and more secure than that of many European constitutional monarchs. When the International African Friends of Abyssinia (IAFA, later renamed IAFE for Ethiopia) formed in August 1935, James served as chairman, with distinguished others including Jomo Kenyatta and Amy Ashwood Garvey in harness, and Padmore soon to join the crew. When in 1936 Selassie and his family arrived to exile in England, James wrote: 'Every succeeding day shows exactly the real motives which move Imperialism in its contact with Africa....'[29] According to IAFE activist T. Ras Makonnen (born George Thomas Nathaniel Griffith in British Guiana), the outpouring of Black support for Ethiopia, from West Africa to the USA, allowed Blacks to understand their own emerging equivalents to Lenin, Trotsky or Sun-Yat Sen. Moreover, Blacks working for their own emancipation were no tools of the Communists, but the agents of their own freedom. Aid they surely sought from Whites, but not leadership. The IAFE disbanded as other more prominent figures took up the cause. James himself wrote frequently on Ethiopia for *The Keys*, journal of the LCP. In Robert Hill's considered view, the vigorousness of the response marked the decisive turning point in the rise of a new Pan-Africanism.[30]

In an organizational sense, this last point is surely valid. Frustrated by the unwillingness of the League of Nations to take serious moves against Mussolini, former IAFE members formed the International African Service Bureau (IASB). Its monthly journal *International African*

Opinion, edited by James from July to October 1938, vowed to 'assist by all means in [our] power the unco-ordinated struggle of Africans and people of African descent against oppression which they suffer in every country'. It helped lead protest meetings condemning colonial brutality against striking workers in the West Indies, it urged democratization of the colonies and legalization of unions as a step toward decolonization. For these aims, James and Padmore worked in tandem, the first as writer–theoretician and the second as agitator.[31]

Seen from the inside, the IASB was a considerably more casual association. As Makonnen recalls, it served for many African students in London as a coffee-klatch, a perambulating discussion of perhaps thirty intellectuals – about the size of James's Trotskyist groups, but much less intense – around a hot stove. It did a great deal of work simply helping individuals at loose ends. Its propaganda efforts grew piecemeal. At first, James and Padmore engaged in heckling at Garvey's public addresses, attempting to siphon off a part of the crowd for a more radical message. Soon they realized they had made a political and personal blunder in this approach. Padmore took to peddling copies of *International African Opinion* outside leftwing political events and in Hyde Park (where a Black racehorse-tipster would rouse a crowd with his verbal antics, in preparation for Padmore's serious address). Padmore, even more than James, kept the larger questions of colonial liberation public, even when the Ethiopian incident had passed. Given the small size of the constituency, the IASB could not be much more.

One remarkable quality of James's participation, from a political viewpoint, is how little the normal conflicts interfered with cooperation on Pan-African issues. According to Makonnen, James gave ground to the pacifist spirit of ILP on the issue of Abyssinia, urging the shipment of arms less vigorously than he would have otherwise. (James, looking back fifty years, denies it.) But even if so, he gained the valuable assistance of Fenner Brockway on colonial issues well after James's own break with the ILP. On the Left, he managed valuable alliances involving non-Marxist anti-colonialists, such as Makonnen, without apparent rancour or prejudice from any element.[32]

James's personal, artistic and political relations with Paul Robeson also fall into this category. He met Robeson almost immediately after disembarking, and shared some social encounters with the now-famous athlete, singer and film star. When James wrote an agitational play, *Toussaint L'Ouverture*, a production of it at the Stage Society was offered on the condition that Robeson would play the lead role. That production constituted a triumph for the IAFE. *Toussaint L'Ouverture*, which opened at London's Westminster Theatre in 1936, suffered badly, however, from overburdening dialogue. Robeson saved the play and

might have gone on to give it a commercial performance (as the two imagined, James himself alternating with Robeson in the Toussaint and Dessalines roles!) had not Robeson's inclinations towards Communism and James's toward Trotskyism interfered. And yet – here is the remarkable thing – the public conditions that made this attenuation necessary had no effect upon their personal bearing with each other. Most uncharacteristic political foes, they continued to recognize in each other an enmity to imperialism and all it represented. James for his part records an admiration for Robeson's devotion, however misconceived its Stalinist object. Robeson without the Communist connections, James believed, could and should have returned to America to lead a Garvey-like nationalist movement more sweeping and clear-minded. Only in the sphere of anti-colonialism, it is safe to say, could such *détente* be reached, and only between personalities who had independent standing within their respective movements.[33]

From another standpoint, the impossibility of James and Robeson collaborating directly and continuously marked the limits of Pan-African politics in that age. James could go no further in Pan-African practice for the time being. His greatest contribution lay in his comparative studies and their Pan-African synthesis. Unlike most other West Indians, who came to England thinking Africans to be savages, James insists, he had been prepared to see them as other oppressed but intelligent, capable peoples. His foremost contribution lay in historical study. *A History of Negro Revolt* (1938) put together the material he had gathered on Toussaint and the Haitian revolution with assorted developments across the Black world. 'The Negro was no docile animal', James stressed throughout. In the mid-nineteenth century the Black runaways had changed the physiognomy of US politics, almost emancipating themselves as a race (but prevented by the repeated unwillingness of America's emerging industrialists to sanction Black seizure of Southern lands). Of subsequent African revolt, James later testified, he found more than he could have imagined when beginning his research. The 'definite Communist tendencies' lacked the 'combination of workers in the towns and the peasants in the interior', and also forceful international support, to advance. One day it surely would have both.[34]

Much of this Padmore had already advanced, in his *Life and Struggles of Negro Toilers* (1932). James's conceptual breakthrough could be found in his chapter on Garveyism, its very traditions despised by the Comintern and indeed mocked by Black Marxists of all kinds. James, more than any previous writer, addressed from a Marxist viewpoint the psychology of the American Black:

All Negroes are aware of the mass of lies on which the prejudice is built, of

the propaganda which is designed to cover the naked economic exploitation. But the Negro and his white friends have little chance to stem the propaganda. The main organs of publicity are in the hands of the whites. The millions who watch the films always see Negroes shining shoes or doing menial work, singing or dancing. Of the thousands of Negro professional men, of the nearly two hundred Negro universities and colleges in America which give degrees in every branch of learning, and are run predominantly by Negro professors, of this the American capitalist takes good care that nothing appears on the screen.

Thus the American Negro, literate, Westernized, an American almost from the foundation of America, suffers from his humiliations and discriminations to a degree that few whites and even many non-American Negroes can ever understand. The jazz and gaiety of the American Negro are a semi-conscious reaction to the fundamental sorrow of the race.[35]

It may be noted how closely this observation follows upon James's earlier fictional treatment of fantastic symbols and cultural messages in the lives of his slum characters. They, like the Trinidad cricket audience fanatically devoted to their favourites, unconsciously strugged to erect alternative symbols of dignity and confidence. Garvey's proclaimed plan to return Blacks to Africa was indeed 'pitiable rubbish', but the charismatic leader truly understood the militant psychology of the audience. Though confused about socialism, and more fascist than socialist in his forms of organization, Garvey unquestionably 'made the American Negro conscious of his African origin and created for the first time a feeling of international solidarity among Africans and people of African descent'.[36]

In the conclusion to *A History of Negro Revolt* James noted significantly that Africans used the Seventh-Day Adventist symbol, The Watch Tower, to proclaim that the blessed ones were about to inherit the earth from the wicked rulers (Whites). It seemed absurd on the face of things, but hardly inexplicable given the resources at hand. 'If Toussaint wrote in the language of '89', opined James, 'the grotesquerie of the Watch Tower primitively approximates to the dialectic of Marx and Lenin.' Haitian insurrectionists maintained the momentum of the French Revolution, and Black American slaves won the Civil War; today, Africa along with Europe would change the world. 'The African bruises and breaks himself against his bars in the interest of freedoms wider than his own.'[37]

The Black Jacobins: Toussaint L'Ouverture and the San Domingo Revolution, published the same year, 1938, applied the dynamic conception of Blacks as lever to world history to the immense detail of the first and only successful slave revolt in the modern world. It is, before Christopher Hill's works on the English Revolution and E.P.

Thompson's *The Making of the English Working Class* (1963), unquestionably the classic social history in the English language, and – along with Trotsky's *History of the Russian Revolution* (1935) – the outstanding interpretation of mass and leadership of revolution. It shared with these works a dramatic advance over previous Marxist histories, based not upon original (especially, archival) research but upon a rewriting of standard sources. Its truest counterpart is W.E.B. DuBois's *Black Reconstruction*, a work based largely upon secondary scholarship and shackled to a questionable terminology, but with James's work the most important Black historical study of the twentieth century. As Robert Hill has said, *The Black Jacobins* revolutionized historical scholarship simply by discrediting the history of abolition as pure philanthropy (Eric Williams's *Capitalism and Slavery*, an expansion upon one of James's chapters, took the final step in that direction). For the future of Third World historiography it did something more. Not only did it show beyond disproof that Blacks had not been passive in world events. It offered a model of historical study intertwined with the struggle itself, whose character the scholarship helps to define. Its methodological success also cast fresh light on what James had first attempted at small scale in *The Life of Captain Cipriani* but lacked both the drive and the sufficient historic event to bring to life.[38]

The Black Jacobins

Apart from all these considerations, and from a strictly literary viewpoint, *The Black Jacobins* is itself an extraordinary synthesis of novelistic narrative and meticulous factual reconstruction. So successful is the book that it hardly reads like a history at all. The story seems more straightforward to us now than it did at its original publication. For that time, the careful portrait of Central African life before the slave trade, with a peasantry 'in many respects superior to the serfs in large areas of Europe', was a revelation.[39] So, too, was the careful economic analysis which placed slavery and its profits at the very centre of world capitalist expansion. James did not at all deny the repression of Black culture which took place, nor the splendour of European culture, but he insisted upon clarity about the ultimate sources of both social–economic development and intense suffering.

The protagonist, Toussaint, belonged to the small and privileged class of houseslaves, but his heart yearned for freedom. Those who thought like him had to await propitious circumstances, the 'objective conditions' that James would lay out so carefully:

Men make their own history, and the black Jacobins of San Domingo were to make history which would alter the fate of millions of men and shift the economic currents of three continents. But if they could seize opportunity they could not create it. The slave-trade and slavery were woven tight into the economics of the eighteenth century. Three forces, the proprietors of San Domingo, the French bourgeoisie and the British bourgeoisie, throve on this devastation of a continent and on the brutal exploitation of millions. As long as these maintained an equilibrium the infernal traffic would go on, and for that matter would have gone on until the present day. But nothing, however profitable, goes on for ever. From the very momentum of their own development, colonial planters, French and British bourgeois, were generating internal stresses and intensifying external rivalries, moving blindly to explosions and conflicts which would shatter the basis of their dominance and create the possibility of emancipation.[40]

So it was to happen. One side were the increasingly decadent white colonists, living an unreal life of bloated luxury, less capable with each generation of handling the many tasks of plantation society. In a short time, the agrarian plantocracy, the traders and the colonial bureaucracy had sired an intermediate class of Mulattos proscribed from white privileges of position (including, by law, the paternal name), despite the steady accumulation of wealth, a condition which grew steadily worse in the decades before the French Revolution. On the other side were the Blacks, fundamental source of the vast profits in cane sugar.

The stage-by-stage, almost moment-by-moment narration of revolutionary events in *The Black Jacobins* immediately brings to mind Trotsky's *The Russian Revolution*. James would shortly praise Trotsky's volumes as among the greatest any historians had ever produced from the time of Thucydides forward. But every premise of Trotsky's work rested upon the backwardness of Russia, while every premise of James's rested upon obverse modernity of San Domingo. In each case, major developments in production had placed an ostensibly peripheral society in the midst of the world market. In each case, the successful insurrection found itself faced with multiple external enemies and with a mass population too illiterate to manage, suddenly, all affairs that fell upon it. In each case, the revolutionary government felt required to utilize the remnants of the old bureaucracy – at great risk of alienating the masses.

If only Trotsky had been able to learn from James as James learned from Trotsky! *The Russian Revolution* shifts from a study of mass uprising to a study of Party rule (with the peasantry as virtual ciphers), showing only hostility toward the revolutionary contributions of anarchists and other political forces. *The Black Jacobins* stays similarly close to Toussaint, but counts precisely the cost to the Revolution of the great leader's own inability to communicate with the masses. *The Russian*

Revolution brushed the Kronstadt Commune aside as a mere incident (James treated it differently, in a passing observation, as a tragic movement for which Lenin instantly compensated with the declaration of the New Economic Policy, NEP) but *The Black Jacobins* treated Toussaint L'Ouverture's condemnation of the zealous Black nationalist Moise (done in order to protect needed white allies) as a catastrophic disconnection between Toussaint and the masses. Not that revolution might not be required to commit such deeds; but failure to explain them carefully to the population signified to James a decisive inability to grasp the revolutionary process.

The contrast of the two books can be usefully extended to the internal decay of the revolutions. Lenin dies; Toussaint gives himself over willingly to Napoleon Bonaparte, whose imprisonment of him brings death. The barbarian Stalin triumphs in Russia, the barbarian Dessalines in San Domingo, and they both rule through terror. Here, both narratives fail in a sense. James ends *The Black Jacobins* with a fateful comparison of imperialist and revolutionary violence, and with the projection of African struggle ahead for the twentieth century. Trotsky closes in a paroxysm of rage at Stalin. The first seems remote, abstract; the second, overly subjective, obsessed with the details at the expense of the larger picture.

But there is something else, something more important, that *The Black Jacobins* shares with *The Russian Revolution*. Unlike the social history to come, which concerned itself largely with the reality of working-class (or Black, or female) life in the national specifics and in the absence of revolutionary activity, both works are rooted firmly in a continuity of historical process from the English and French revolutions to the contemporary scene. Trotsky and James, that is to say, belonged to the classic (some would say, golden) age of Marxist historicism with its internationalist assumptions full blown.[41]

'It was in method, and not in principle,' James wrote in a phrase that would become rightly famous,

> that Toussaint failed. The race question is subsidiary to the class question in politics, and to think of imperialism in terms of race is disastrous. But to neglect the racial factor as merely incidental [is] an error only less grave than to make it fundamental. There were Jacobin workmen in Paris who would have fought for the blacks against Bonaparte's troops. But the international movement was not then what [it is] to-day, and there were none in San Domingo.[42]

By James's calculation, European revolutionism in the midst of its own struggles might very well require the success of the anti-colonial revolt

for final, international success. Then the dynamic of the white and Black Jacobins would become the central epic of the human race. This assumed a continuing succession of stages which, in view of the post-World War II disappointments of the Western Left, lost credibility. Stalin and even more the leaders of the Western working classes brought out the worst prospects of neo-colonial counter-revolution, but the worst had to be present for betrayers to bring it out.

An Englishman Emigrates

James had reached very nearly the end of his stay in England. He had already tasted something of a different political climate during his mid-1930s research in France for *The Black Jacobins.* Living in Paris and then Marseilles (through the financial help of Harry and Elizabeth Spencer, his friends from Nelson), James met with exiled German and with French Trotskyist intellectuals, watched with great interest the stirrings of French workers constrained by the Popular Front, learned second-hand about the horrors of Nazism and took in the ambience of a culture less repressive than that the middle-class West Indies or England had to offer.

With the oncoming conflict, the other reasons for staying in England dwindled. *The History of Negro Revolt* and *The Black Jacobins* aroused little interest, as the Left placed anti-imperialism on the backburner. James himself never quite got over the feeling that, as he expressed a few years later, the British genuinely *liked* Blacks but did not take their striving for national independence as seriously as the Indians'. Much of the Pan-African crowd in London dispersed, some facing harassment for their lack of patriotism, most simply facing isolation. Padmore managed to keep issues alive, but just barely. After World War II they would rebound, but that was far away in 1938. Trotskyist groupuscule activity, meanwhile, could be safely pursued by others, so far as it could successfully be pursued at all. The Trotskyist position on war, 'Revolutionary Defeatism', had scant prospect in a Britain about to be nearly overwhelmed by Nazi bombs, and the issues of the immediate post-war years called young militants like Edward Thompson (along with the rest of a circle of outstanding social historians-to-be) to a last round of Communist Party agitation.[43]

In 1938 a visiting James P. Cannon invited James to America, a motion seconded by British Trotskyist sections which, in typical groupuscule fashion, had sought to remove an oddball 'troublemaker' who was merely their deepest thinker and most popular public figure. James therefore arranged a 'transfer' (it would be attributing too much

to the Fourth International's internal discipline to put it just that way) to the USA, assumedly between cricket seasons, for the ostensible purpose of speaking on Europe, the war and the 'Negro Question'. He would not actually return until forced to do so, and then with his Trotskyist experience far behind.[44]

What sort of person had James become? With this striking sketch, his publisher captured the irony of James the engaging politico in dubious battle:

> Despite the atmosphere of hate and arid dispute in his writings, James himself was one of the most delightful and easy-going personalities I have known, colourful in more senses than one. A dark-skinned West Indian Negro from Trinidad, he stood six feet three inches in his socks and was noticeably good-looking. His memory was extraordinary. He could quote, not only passages from the Marxist classics but long extracts from Shakespeare, in a soft lilting English which was a delight to hear. Immensely amiable, he loved the flesh-pots of capitalism, fine cooking, fine clothes, fine furniture and beautiful women, without a trace of the guilty remorse to be expected from a seasoned warrior of the class war. He was brave. Night after night he would address meetings in London and the provinces, denouncing the crimes of the blood-thirsty Stalin until he was hoarse and his wonderful voice a mere croaking in the throat. The communists who heckled him would have torn him limb from limb, had it not been for the ubiquity of the police.
>
> If politics was his religion and Marx his god, if literature was his passion and Shakespeare his prince among writers, cricket was his beloved activity.... Sometimes he came for the week-end to our cottage near West Hoathly in Sussex and turned out for the local team. He was a demon bowler, and a powerful if erratic batsman. The village loved him, referring to him affection-ately as 'the black bastard'. In Sussex politics were forgotten. Instead, I can hear today the opening words of *Twelfth Night* delivered beautifully from his full sensitive lips: 'If music be the food of love, play on; give me excess of it.' Excess, perhaps, was James' crime, an excess of words whose relevance to the contemporary tragedy was less than he supposed.[45]

Warburg was hardly fair to James's vision of Trotskyism. But he offers a glimpse into the changes that six years had wrought. Novelist George Lamming calls the James of the 1930s a 'peasant by recent origin, a colonial by education, a Victorian with the rebel seed', and he asks what the connection might be between the James who knew Thackeray by heart and the James who 'wrote the history of Caliban's resurrection [the San Domingo revolution] from the natural prison of Prospero's regard' [colonization]. The answer is not simple, and emphatically not impersonal.[46]

For one thing, James had become a Pan-Caribbean and a Pan-African, in line with the rule that West Indians transcend their island

identity only when they go into exile. It was not contradictory for him also to say, 'I remain obstinately British in my personal standards, ideas and tastes,' as he wrote privately in the middle 1940s; 'I still am and in many things will always be I expect.' England had made it possible for him to recognize himself in his multiple identities, and that attainment would survive wherever further he went.[47]

He has recalled one precious incident from private life which speaks volumes. He knew his Trinidad relationship had definitively come to a close. And he spotted a woman who regularly passed him in the street, dancing at a Left social event. Evidently beautiful, 'she was much in demand'. He asked to come see her in her apartment, she readily agreed, and when they shook hands 'we never let go'. On James's insistence, he sought to have a discussion with the husband, who declined to see him. James asked her to marry, and *she* declined. Life had already become too precarious for intellectuals in the 1930s, and the colonial Black intellectual offered no solution. James retains the precious memory of her ('It is over forty years but I still think that we shall meet one day. She would have put on a little weight, and she would be a little grey but she will be as she was on that Monday morning, a human being made to order for another human being ...') but little sense of how a settled life might have developed out of such a liaison. He had, unconsciously, chosen another way.[48]

Hence, in part, came his ability to pick up and leave England with a vastly greater sense of abandon than other intellectuals who left behind darkened Middle Europe for the new world. They would also bring, along with their many intellectual tools, a longing for the textured intellectual life of their home, and a veritable dread for the popular life of America from the Hudson River westward. James, having nourished himself upon the fruits of popular culture, would now find himself more at home than ever before at the tree from which those fruits came most plentifully.

At the same time, we need to see the limitations upon James's sense of personal freedom. To anticipate an interrogation in the following chapters, we may cite Lamming's insistence upon James, against all his protestations, as Ishmael of *Moby Dick*. 'For the simple reason that he has never been, either by work or education, a renegade or a castaway.' Neither revolutionary outlaw nor hapless refugee, despite his heartful association with those victims of history, James placed himself in relation to Toussaint, the Ahab of the West Indian sojourn. And in like relation to Lenin, we might add. And even to Trotsky, although always with reservations. To leave the literary life firmly behind, he had hitched his wagon to a Leninist star. He came to America with that perspective firmly in mind.[49]

When he left, he recalls, Constantine called him in and asked if he had funds for a proper wardrobe. No, of course not. The older man once more and for the last time staked out the younger. Not only from a personal debt or friendship. James was still the West Indian representative, now to a far greater land of international politics and culture. It would not do to have him ill-kempt in America.[50]

3

American Bolshevik, 1938–53

For fifteen years in America, James the self-interpreted Leninist gave his full attention to the revolutionary movement. He made no public forays beyond the usual left-wing party-sponsored lecture series or a rare university address. His work appeared in no popular journals, not even those (like Dwight Macdonald's *Politics*) with a decidedly like-minded political cast. Writing under a half-dozen pseudonyms, living the somewhat shadowy life of the small Marxist group leader, he firmly abandoned the semi-celebrity status he had achieved in Britain as a cricket journalist and prominent Trotskyist spokesman. It is a measure of his seriousness that this personal eclipse disturbed him not in the least.

For one thing, he had a rich and complex, if sometimes deeply disturbing, private life. Despite his commitments, many of his personal friends – among them Richard Wright, James T. Farrell, Carl Van Vechten, Ralph Ellison, Meyer Schapiro and even Norman Mailer – were artists or critics rather than politicos. He devoted his free time to absorbing the popular culture of films, Harlem entertainment and the detective novel. He wrote a play for the Black actress Ethel Waters. He courted for almost a decade, and finally won, a woman of extraordinary beauty, who bore his only child. And he experienced the intensity of unsettled romantic affairs, as if his precocious theoretical perspectives on modern women's emancipation merely added to the explosive quality of private liaisons. His followers, similarly, might be seen as a self-conscious combination of the political and the personal, people who found in the ambience he encouraged a chance for making revolution in society and simultaneously in their own lives.

All this constituted a full existence, especially compared with the generally narrow lives of fellow Marxist intellectuals and contemporary Left political leaders. He left it behind, perhaps at the appropriate politi-

cal moment, only under extraordinary protest. No part of his biography has remained so obscure. But equally, none has seemed to him so full of intellectual accomplishment, or of personal satisfaction. For this one moment, he attained the multiplication factor of enduring radical comradeship at the very centre of advanced capitalism. He authored his most formidable political and theoretical (as opposed to historical or cultural) works – however small the immediate audience. He has believed, ever since, that had he stayed, he would have been able to act with considerable influence upon coming American events (such as Black Power) which reshaped world revolutionary forces. That very influence, ironically, would have been incongruous to the movement he was forced to abandon in America. He later reached across the decades toward the New Left, but mostly with assumptions and language that made his message difficult for ordinary radical youngsters to imbibe. He would need to be rediscovered.

More than James realized, the unresolvable paradox of intellectual success in apparent political failure and political failure in apparent theoretical success rested upon the general status of the American Left. That Left had always been, in its more self-consciously Marxist elements, an immigrant movement – first- and second-generation – obscure to the wider public. It operated with occasional wide impact by acting through and upon the outbursts of workers, likewise through and upon the deeply cultural currents of native reform. It interpreted change around it, often brilliantly, and it acted with influence vastly beyond its numbers. But it consolidated nothing, and slipped away once more into isolation, to be revived only by a later generation. James, and all his immediate political work, fell within this pattern even at a critical turning point of the Left's Americanization. To an extent that the avid anti-Stalinist James could never fully grasp, the entire Left grew, flourished and disintegrated as one. The ideological fine points, which mattered so much to intellectuals of all factions, struck no chord with America at large. James's group, determined to abandon the dogmas of Left organization for the richness of popular life, nevertheless sunk with the rest of the Left movement.

James the Trinidadian had the special advantages of classical training, Pan-Africanism and a modern eye for the meeting points of economics and culture. But tragically, he emerged in an era of mostly Left-wing defeat and reformism. The question of socialism, which he might have been able to raise in a creative fashion, had all but disappeared from the public agenda even for those who sought to overthrow capitalism. He had no way and – until his last days in America, fighting against his expulsion – no real compulsion to reach directly the popular audience that might have made better use of James's wisdom. He found himself

trapped by the very intensity of the small-group activity which supported him. Literary projects of real potential and creative value for himself went unrealized. Time ran out on alternatives. James departed America on terms different from Trotsky or Bukharin, thirty years earlier returning to a revolution, and equally unlike his friend Richard Wright fleeing racism. He was a fond sojourner driven from what had *become* his would-be adopted land.

Exile from America would in fact be the remaking of his public literary and Pan-Africanist political career, almost as he had left off in an earlier life and a different Europe. How the American experience made that later success possible is a subtext developed behind James's own fertile consciousness.

Encountering US Trotskyism

Of James the immigrant in 1938, ostensibly visiting on a six-month visa between cricket seasons, American Trotskyism had never seen the like. Despite Trotsky's political predilections, the 'Negro Question' remained a mystery suitable to discuss only in relation to Communist errors. Of culture, Trotskyist-inclined intellectuals around the *Partisan Review*, for instance, knew plenty but they had already begun a phased withdrawal into aesthetics. Popular culture they viewed as did the old Bolsheviks (including Trotsky himself): a mere diversion of the masses from political consciousness. In Trotskyism singularly, among American Marxists, one likewise found an open attack upon Marxism's Hegelian philosophical underpinnings, premises which James would come to defend with fresh readings of the masters. Trotskyists, bitterly split among themselves, united only in their hatred for Stalinism and in their utter faith in the concept of the vanguard which James would spend his best efforts attacking. No wonder his factional foes regarded James as a 'stratospherist', mystic, a maker of hyperbole and a bit of a charlatan. At first glance, he was to American Trotskyism as chalk to cheese.

In human terms, however, one must imagine a mini-movement, barely a few hundred members with a trail of factional wars in their past, freshly reorganized and expectant for new forces. Trotskyists had taken a national leader or two out of the American Communist movement in 1928, led some important strikes, and had begun to publish a respectable journal. But every success had turned into its virtual opposite. Amalgamation with a group of homegrown Marxists (led by the socialist minister and later pacifist luminary, A.J. Muste) in 1934–5 barely added to Trotskyism's forces, so numerous were the defections and so flagrant the internal quarrels. A foray into the Socialist Party – faithful to

Trotsky's own vision of a 'French Turn' by Trotskyists into the major centrist socialist movements of the day – 'captured' an energetic youth component. Meanwhile, the organization of the CIO (as American Trotskyism's foremost leader put it) 'pass[ed] over our heads'. They had been locked out of the most decisive institutional event in the generation, confined to the unorganized peripheries of agricultural workers and to the AFL stronghold of the teamsters. They poised themselves for a comeback. But they began the game, with the new Socialist Workers Party of 1938, immeasurably far behind the Communists.[1]

In this situation, James must have seemed to Trotskyists almost as DeLeon had to the fumbling and isolated Socialist Labor Party of 1890: a phenomenal asset. Educated Americans had already heard of the author of *The Black Jacobins* and of *World Revolution*, reviewed favourably in the *New York Times* and in *Time Magazine*. American Trotskyists had by no means expected, however, a Black man who had a better grasp of classical history, of European culture and, above all, of the Black role in American life than any among them. ('I constituted the Third World in the Trotskyite party,' James has written in his unpublished memoirs.) With due respect to the remarkable array of self- and college-educated thinkers, he was a true cosmopolite among abstract cosmopolitans. He recalled later his first US public engagement, speaking at length in New York about the European situation, without notes, quoting extensive statistics from memory. The Trotskyists set him out immediately upon a national speaking tour, at once an education for him in American conditions and a rare opportunity for Trotskyists to reach beyond their limited numbers to a public crowd in a church or hall. Who else in their ranks, save Trotsky himself, would have been invited to debate Bertrand Russell and (by vote of the audience) have defeated that famed logician in political logic?

Constance Webb, a Los Angeles teenage political activist entranced by his ideas and bearing, recalled later encountering the speaker as a figure of physical grace and the veritable symbol of revolutionary promise:

> His ... neck curved forward like that of a racehorse in the slip.... But, as with highly trained athletes, the tension was concentrated and tuned, so that he gave the impression of enormous ease The impact of his first sentence was astonishing.... He was our captive and we were a captivated audience.... Towards the end of his speech, the Blacks in the audience began to respond, their voices punctuating each telling point. The words met half-buried ideas, which had been struggling to emerge. Here was the broad, wide world of imagination and heart. Here was an international movement.

And here was a compelling, personal understanding of the race

problem eating away the heart of American democracy. James seemed to her, and he certainly seemed to others, a man poised to articulate what had been in the minds of Black and of white listeners pondering the significance of the race dilemma. To them, therefore, this anomalous West Indian Briton 'understood more about the American scene than any of the American comrades'.[2]

Here, almost immediately, James struck his first and most memorable political chord in America. He met with anti-Communist Black intellectuals critical of the New Deal, such as the editors of the influential weekly *Pittsburgh Courier*. He quickly learned, from readers of *The Black Jacobins* in Harlem, that the Trotskyists had become known as the single Left organization which had *no* apparent position on Blacks. Valuable time had already been lost. The earlier insistence of Communists upon a 'Black Belt' nation had never been a realistic position. The broad Popular Front shift, muting of Communist criticism on the British and French empires and away from colonial events altogether, had disillusioned many. But only Black nationalism in its especially raw, antisemitic form, had been able to benefit. The fading Socialist Party, even where it had exceptional contacts in the south, had long since placed its hopes in the labour bureaucracy. Positions to the Left of the Communist Party remained vacant. James already shaped his alternative: Blacks themselves would act upon American democracy, and in the process *they would transform the prospects for socialism.*

Trotsky, who had privately come to the conclusion that without a forceful answer to the Black question his American followers would wither away, hastened to summon James to his exile residence of Coyoacan. It was, very likely, the first time since leaving Moscow that Trotsky met with a self-confident political equal. James was certainly the first non-white Marxist of such stature whom he had known since Comintern days with the Indian leader M.N. Roy. James venerated Trotsky's contributions, but he gave no ground. (Nevertheless he was charmed by the almost aristocratic appearance and manners of Trotsky and Natalia, by the former Red Army leader's facility with languages and his fearlessness about the known prospects of assassination.)

Blacks, James insisted in his prepared document for the summit meeting, had become by experience and condition more motivated for anti-capitalism than any other American sector. However their trajectory demanded agitation for democratic rights before agitation for socialism. Above all, it demanded a movement in their own and not in some Left party's name. On that basis, the dialectical relations between Black nationalism and Black class-consciousness could be mediated. Trotsky, who had previously framed the Black Question as if it were a problem of some national minority in Russia, grasped the importance of

James's formulation – but not its full implications. He could not shake the essentialism of the vanguard: Blacks (and whites speaking to Blacks) who would propose the immediate agenda to the masses and declare, with one voice, 'We are the Fourth International.' It was a characteristic difference, destined to grow in time.[3]

And yet it is remarkable how much the two agreed upon. James insisted that Leninism in the United States (although to this point mainly in the Communist Party) had added something new to the political equation by treating the Black as a comrade rather than a stranger. As Lenin had observed in regard to colonial workers, 'no concession can ever be made' by Marxists to racial prejudice. The Comintern of Trotsky's day, although hardly in debt to Trotsky himself on the question, had already made this serious contribution. Second, as James and his comrades had showed in the International African Service Bureau and especially in their manifesto against the Munich Pact, support of revolutionary struggle for African independence would be critical for any future English-language movement. A weekly paper and pamphlets of a Black organization, a truly international monthly edition of *International African Opinion*, initial agitational efforts in specific sectors (domestic service, agricultural workers and industrial unions with Black membership) and on given questions (unemployment, discrimination, rents, etc.) – all these projects Trotsky supported or did not oppose.[4]

The two shared, with different weights upon various aspects of a 'Transitional Program', the conception of international and US capitalism so devastated that democratic and economist struggles for specific aims would snap a weak link. How else could an organization of less than a thousand members imagine sweeping over and past a Communist Party of 55,000 cadre and a following of a quarter-million more, past a Democratic Party of traditional working-class loyalty with the eroded but stubbornly rooted charisma of Franklin Roosevelt as its centrepiece?

James had *begun* to doubt the efficacy of the Trotskyist model: to his question of how the French Trotskyist movement could flounder while the working-class upsurge continued, Trotsky offered what seemed to him all-too-pat assurances of inevitable political development. These reservations were political not personal. After the great leader's assassination, James would pen a formidable tribute to the man he considered one of the great historians of modern times and a strategic mind second in rank only to Cromwell and Lenin. But James had one strategic agenda which Trotsky only partly shared: Bolshevism as a wedge for Pan-African uprising, rather than vice versa.

Perhaps the plans set out for a Black radicalism with Trotskyist influence might indeed have sparked a great flame in a few years, amid the

rise of the Black industrial worker and race relations to central significance. Surely, the Black movement and Black population could have utilized an alternative to the Communist Party, growingly popular but mainly among Harlem's cultural elite, on the basis of a middle-class-oriented integrationism. Perhaps, on the other hand, Trotskyists might have failed in hundreds of little ways (as did Communists) to persuade ordinary Blacks of their good intentions and of their strength to change American society. Certainly, they never approached the numbers required for a mass movement. The imagined Black movement might in that sense be compared to the international artists' organization FIARI, launched with great optimism in 1939 by surrealist leader André Breton and adhered to by such notable non-Communist US Marxists as Bertram D. Wolfe. FIARI, too, would have organized (or rather, encouraged the organization of) artists in their own behalf, with Trotskyist support and ideological assistance. The artists' movement died with the Second World War and the collapse of independent Left perspectives.

In 1939, the clouds overhanging revolutionary prospects did not look so dark to the Trotskyist faithful. They had, as a political party, after all just begun. The Socialist Workers Party convention of that year, after severe internal discussion, duly affirmed the necessity for a Black movement, not subservient to the SWP but participated in by Trotskyists. Blacks were, according to a convention resolution, destined 'by their whole historical past to be, under adequate leadership, the very vanguard of the proletarian revolution'. (James called it 'one of the high points in the history of our American revolutionary movement, this decision of our recent convention'.)[5] The Party duly established a Department of Negro Work. As 'J.R. Johnson', James himself wrote a weekly column in the official *Socialist Appeal*, a new departure in Trotskyist history.

He wrote both for the Party faithful and for the wider readership of the *Appeal*. To the former especially, he placed the question of Black struggle at the centre of US Marxist movements' intellectual and political maturation. The chauvinism of society infected the radical movement. Until Trotskyists themselves could see that 'the majority of Negroes will fight for a new society with a vigor and endurance that will be surpassed by no other section of the American workers or farmers', no political progress could be made reaching ordinary Blacks.[6] The Communist Party had only belatedly, under international pressure, set out a programme for Blacks; their half-heartedness and the political stultification of the CP made that effort a tail on the kite of Moscow's needs. Trotskyists likewise had delayed an approach until directed to do so by international leaders. Now they faced a supreme challenge:

[H]aving broken with bourgois ideas[,] we must vigorously create our own, for if we do not, bourgeois corruption will come pouring in on us again. So conscious and complete a break with American bourgeois ideas about Negroes has never been made in America before.... Only a Marxist party can even attempt it.[7]

Seemingly for the wider Trotskyist following, he savaged the Communists' manipulation of liberal opinion (as in the CP's vigorous protests against the film *Gone With the Wind*), he urged Blacks to oppose world war and he discussed Southern lynchings and Black sharecroppers. He wove together labour and colour themes in a basic statement of SWP policy, describing the Russian Revolution as the great event in the world history because it posed the prospect of worldwide emancipation from colonialism.[8]

In short, James emerged as one of the foremost Trotskyist theoreticians, a veritable guide to districts where the movement had never gone before. Within a year came a disastrous split in Trotskyism, the assassination of Trotsky and the outbreak of war. From those blows, the organizational aims of Trotskyist agitation among Blacks never recovered.

James's criticisms of the SWP, circulated in mimeographed form, foreshadowed both the division and James's line-up within it. Trotskyists waited for workers, and Blacks, to join them, as if 'agreement with Lenin's principles' had ceased to be a principle of action and became an end in itself. The SWP, already slipping backward in membership from 1,000 to barely 800, might be the second party in the world built along Bolshevik ideological lines, but it 'is not composed of Bolsheviks like those Lenin led.... There is a limit to ideological victory over material conditions.' James was not seeking to be negative. But the American triumphs of Trotskyism seemed to have consisted mostly of factional forays among the Socialists 'and the pounding of political opponents into a proper docility'. The working-class cadre, such as it existed, 'operated more like trade unionists in the party than party members in trade unions', reinforcing membership passivity and leadership bureaucracy. Concrete investigations of the anticipated American working-class constituency had never actually taken place. Foreign-born workers, a key segment, tended to be seen as if stripped of identity, the Ukrainian-born worker more interesting if he stayed in Russia (where he would still be part of the intellectually absorbing 'Ukrainian Question') than in Detroit. 'We have to break out of this,' James concluded seventeen closely-written pages, 'or be condemned to forever eating up each other or pounding each other in the name of "principled" Bolshevism.'[9]

James had already begun his project of Americanizing Bolshevism, first of all himself. His unsettled plans, to return to England to stay on in

America, had been changed by Raya Dunayevskaya (party name, 'Freddie Forest'). Ten years his junior, a veteran of the Communist movement (and its earliest Black interventions) in the 1920s, she had participated widely but remained an unrecognized intellectual talent within Trotskyism. As a childhood immigrant from Russia, she knew the language well. Even before she met James, she had fixed her ideas about Stalin's society as a form of state capitalism – no mere 'bureaucratic society' as liberals, socialists and former Trotskyists had begun to argue – subject to the class conflict and economic crisis characteristic of capitalism. Compared to this position, all other Trotskyist critiques amounted to a waiting game, waiting for Stalin and his bureaucracy to fall or to be thrust out by some loyal descendant of the old Bolshevik Party. A dynamic revolutionary view had to place inevitable crises at the centre of 'state capitalism' as well as capitalism proper.

Dunayevskaya convinced James that such a position helped make sense of capitalism's shifts in the West, toward a more bureaucratic society inside the labour movement and outside. Together, she and James would work out the ramifications. They would form a group or 'tendency' within Trotskyism to argue out their position. It was the cue he had subconsciously awaited. A few years later, he would write privately, with pride, 'I have a few close collaborators. They are doing magnificent work. They are young and full of enthusiasm....'[10]

What did it mean, psychologically, for James to choose America? He recalled his first visit south, where in New Orleans white women unabashedly eyed him 'like some sort of movie star', prompting one kind of nervousness, and up through the segregated cities where he slowly and with some danger learned the victim's etiquette of racism – another form of anxiety. H.L. Mitchell, the redoubtable leader of the Southern Tenant Farmers Union, likewise remembers James in deeply racist Mobile, Alabama, riding at the front of the public bus, asking the driver directions 'just as if he belonged there'. Numerous personal observers, whites, Blacks and Asians alike, would remark to James that he *did not act like a Negro*. That was a weakness in the long run, in many ways: he could not put himself fully in the mind of the Afro-American. But it was a great advantage in the short run, for he could share vicariously in the greatest popular Black upsurge since the days of Populism – this time expressed in popular music and dance as much as in politics – without the nagging recollections of past defeats American Blacks held in their collective memory. He could project his fantasies of American freedom (and, above all, women's freedom) into the personality of the woman he loved and into his relationship with her. He could carry himself as the foremost Black Marxist in a time when Harlem had become a world centre for Black culture. England had nothing to compare.[11]

A handful of young Trotskyists sensed all this. Flexibility toward Black culture overlapped with a flexibility in cultural and personal matters in a Left which had generally treated them with formulae when it treated them at all. Interviews with Trotskyists young in the late 1930s suggest the depth of the personal and social-cultural influences that drew individuals toward the directions James was taking them. Among those who would cleave closely to him in particular, the struggle for self-development, a life of politics and art, is especially striking. Many had passed through the Young People's Socialist League either via family connections or from an instinctive rejection of Stalinism's youth and student movements. They flaunted a mild bohemianism, even as they gave their energies to workers and to unions eager for aid. They craved creative self-expression even as they pronounced themselves, a little uneasily, to be true American Bolsheviks.

Leah Grant-Dillon, niece of a prominent Yiddish poet and herself a modern dancer, describes her youthful identity as one of the 'evil trio', three young women a little notorious among their political circle for their artistic inclinations and their sardonic sense of humour. Like so many other Jewish youngsters of lower-class origin, reared in neighbourhoods where boys dreamed of being another Heifitz and girls of playing piano like Artur Rubinstein, she was amused to be told by Trotskyist leaders to 'industrialize'. Her family had never, until her generation, had the option of *leaving* industry. Marxist movements of all kinds typically offered a mixture of private artistic inclinations and public workerist philistinism, interwoven through the friendships of the time. Trotsky's personal interest in art meant surprisingly little in political practice. James provided a lifeline of sorts, through his dialogues and his personal encouragements.[12]

Constance Webb, his almost constant correspondent and wife-to-be, had the most extraordinary experience of all with him. Young Trotskyist, distinguished model, Hollywood *ingénue* and starlet, stage actress, intimate of Richard Wright, she sought to make her own creative life both through and against the particular urgings of James. Encouraged by him to literary analysis, she finally produced the first biography of Wright. She also gave up a promising film career, and never lost the sense of opposition from other leaders of the political group. As his letters detail, the questions of artistic expression permeated James's own thoughts even (perhaps in an odd way, especially) when a combination of political and personal problems seemed most overwhelming.[13]

Stan Weir, an intimate admirer if never a member of James's group, offers an obverse example of the West Indian's appeal. Son of a seamstress-maid at a Hollywood mogul's mansion (herself later remarried to a prominent Black jazz musician), Weir grew up on another fringe of

working-class and Bohemian life. Coming of age in 1940, deeply drawn to literature and increasingly radical, he left UCLA to join the Merchant Marine. There he met old Wobblies and syndicalist-minded Trotskyists who educated him to working-class resistance and to the history of the Left. Trotskyists he remembered as 'the guys who read the best novels': *Man's Fate, Fontamara, Les Javanais*, Gide and Rilke. Orthodox Trotskyism seemed to him fatally compromised on the war issue, in part as an arrangement with sympathetic union leaders, but also simply uninterested in culture. With James, uniquely, Weir would be able to talk class struggle in a new key.

The *telos* of working- and lower middle-class people who had absorbed the highest capacity for cultural advance he and James found refracted, if not in literary interests then in the blue-collar affinities such as popular film and jazz dance. To a Stan Weir – fictionalized as uncompromising protagonist of Harvey Swados's *On the Line*, and working-class hero of the same author's *Standing Fast* – James personally signified the potentiality of self-development.[14]

James as Political Leader

James's talent for leadership received its first test within a year after he personally opted for America. The Hitler–Stalin Pact and the approach of world war brought a Russian invasion first of Poland and then of Finland. American Communists suffered an unprecedented blow to influence in the Eastern European communities most directly affected (notably, those very Ukrainian–Americans James viewed as an ignored case in point, also Poles and, more obviously telling to Party prestige, the all-important Jewish–Americans). Trotskyism, tutored on Trotsky's own defence of 'deformed' but apparently still authentic socialism in Russia, came apart on the question of those hapless districts the Red Army invaded. Had these also become 'socialist' societies, simply because private property had been confiscated by the Russian state and its clients? Or did the plainly authoritarian character of such societies, heir not simply to betrayed revolution and revolutionary party, throw in doubt Trotsky's basic categories? James felt drawn to organize around an answer.

Behind this central theoretical controversy lay others more subtly developed. The internal life of Trotskyism, always uneasy, had also come apart on the class question eternally endemic to American radicalism. By the late 1930s, the Communist Party had very nearly become a middle-class movement, especially in its most public manifestations. To be sure, CP control or influence in a dozen important industrial unions

was its fundamental strength. But it recruited and held on to relatively few ordinary unionists. Other factory militants remained (up to this point at least) personally respectful of Communists who brought them unionization, but somewhat sceptical on larger political questions. Membership leaped ahead in New York state and California, where the party had penetrated the political mainstream whether through an American Labor Party or the Democratic Party. Around *The New Masses* and through the lower rungs of the New Deal, Communists rallied intellectual opponents of Fascism to their own circles. Trotskyists considered themselves immune to the politics of the Popular Front, but they were hardly immune to similar developments in other forms.

Trotskyist influence upon the industrial working class, outside the Twin Cities (Minneapolis–St Paul) in general and the Teamsters in particular, had always been scattered. The main source of expanded influence among workers came from the 'colonizers', predominantly Eastern, middle-class youth who headed outward to the factories. The foray into the Socialist Party (an organization which, an early Trotskyist infiltrator noted, had more YMCA workers than industrial workers) netted more of the same type, often the children of former Communists or Socialists who had advanced themselves into small business or the professions.[15]

At the first outbreak of dissension, whether theoretical or practical, the leadership of the Trotskyist movement blamed the SWP's troubles upon petty-bourgeois anxiety. Eventually, the working class cadre would arrive; until then, faithfulness to Trotsky's own programme guaranteed the necessary continuity. But James, among many others, never accepted this wisdom. 'Engels and Lenin insisted,' James had written in 1939,

> that Marx deduced the inevitability of socialism not from the negation of the negation, but by an observation of socio-economic phenomena. Few of us go any further, and it is a crime to encourage the membership to pretence and hypocrisy.
>
> This, says Trotsky, is Bolshevism. His advice is: Whatever the errors and mistakes, follow [SWP leader James P.] Cannon.
>
> The answer is No. Unequivocal, undiluted and without reservation. Agreement with Lenin's politics did not make anyone ipso facto into a Bolshevik. Incompetent politics can be defended only by bureaucratic rudeness and disloyalty.... On the 'organizational quest' a turn is necessary. We shall make it. In loyal collaboration with the majority, or without them. But made it shall be.[16]

James had, he testified, initially been drawn to that grouping and its followers, *outside* New York in the industrial centres which taught 'the

things that cannot be learnt in books'. Experience had taught him other-wise. In short, and in practical terms, the class question *within the movement* could no longer be allowed to determine the status and future of the movement. If creative Trotskyists had to begin with an unlikely crew in order to become an American revolutionary movement – James did not quite say, but quite obviously implied – then so it would be. (I asked him forty years later if the odd homogeneity of the Workers Party, almost entirely petty-bourgois and Jewish, had not seemed to him a daunting obstacle. He replied: with all the other obstacles, we could not even take the question up.) Race and race sympathies, he might have added, had helped show the way forward already.

In 1940, James and the great majority of youth recruited earlier from the Socialist Party now split from Trotsky and the Socialist Workers Party on the questions of the war and the nature of the Soviet Union. They would henceforth appeal for, and play (with their sister tendencies abroad, most of which barely existed) a central role in creating a 'Third Camp' opposed to capitalism and Stalinism. Their outstanding leader, Max Shachtman, and his lieutenant, Martin Abern, had themselves come from the upper echelons of the 1920s' Communist Party youth. Now they led what amounted to a Children's Crusade into the new Workers Party.

Shachtman and his lieutenants had fostered a movement *against* Stalinism more than for another clearly articulated position. They hoped ('expected' would be the correct word) to *restore* the purity of Bolshev-ism in a place where it had never truly existed, where its steadfast supporters by 1940 were basically a mixture of ageing immigrants (still in the Communist Party) and politically green intellectuals. Surprised by the pace of the Russian Revolution, Lenin had nevertheless at his dispo-sal a Bolshevik party and against him a tottering dynasty. American Trotskyists faced a New Deal fading but still vital, with widespread support including sections of the Left, and a capitalism (with all its current problems) the most powerful single force in the world.

And yet, America held promise. As James and others read the Bolshevik experience, the key had been the Soviets workers' councils. Nowhere in the world did those seem more likely to recur, in some form, than in the United States with its ultra-advanced industry and its still-young CIO. True, the labour leadership (including Communists) had begun drifting rightward with their very accession to power. At the very core of democratic unionism, the United Auto Workers, Communist local presidents and shop stewards set themselves upon the problem of learning how to 'stop strikes', so as to effect a disciplined response and to coalesce influence around their own candidates for leadership. Other industries, where the Left had greater or less influence, experienced the

same development. Already, the democratic uprising had become, where not successfully stifled, rebellious toward the consolidation of bureaucracy. The approach of war and the prospective imposition of government controls threatened to put into place a tripartite arrangement of government, industry and union leadership against working-class self-expression.

Up to 1940, the Trotskyist militants had been able to do little more than 'suffer like hell', in the words of a sympathetic Detroit observer, and air their complaints bitterly – sometimes with the unideological support of ordinary workers and sometimes not. Here and there they might lead a small-scale action. Occasionally, even outside Minneapolis and the Teamsters (as in the syndicalist-minded, if also patently racist, Seaman's Union of the Pacific, an AFL competitor to the Communist-controlled West Coast CIO-dominated sea trades) they became central to the administration of a particular international. Generally, they stood on the outside looking in.[17]

But the war that the Trotskyists had so vigorously opposed none the less opened possibilities hitherto only imagined. For one thing, anyone not drafted could get an industrial job. The Communist Party, shortly after Hitler's invasion of Russia placing itself utterly against industrial conflict, opened the door wide to competition. By this time, no substantial non-Trotskyist competition even existed: the Socialist Party barely survived, and the 'Right Communists, led by Jay Lovestone, formally dissolved. Erstwhile militant labour leaders, suddenly become 'industrial statesmen', rose from modest origins to heights from which they would not return. The new workforce had little reason to view them with adulation, and good reason to cock an ear towards a different kind of labour radical.

The depth of popular anti-war sentiment, voiced by traditional Congressional conservatives, pacifists like Norman Thomas and by the Communists in 1939–40, had long been deep and widespread. Based in part upon revelations of war-profiteering twenty years earlier, in part upon a residual feminism (Jeanette Rankin, congresswoman of Wyoming, voted against entry into both world wars), and in part upon the American distrust of Big Government, the feeling persisted despite rising patriotism. To cite only one prominent example: America's foremost historian, Charles Beard, suspicious of Roosevelt's manoeuvring and the government's suspension of many civil rights – whether demands upon business, labour or hapless minorities such as the Japanese–Americans – denounced the system. Overnight, Beard received press and academic slander predicting the Cold War efforts by such noted liberal historians as Arthur Schlesinger, Jr, to finish off his reputation. But not all dissent could be intimidated away as Nazi sympathizing.

Likewise industrial unrest, which continued on through the late 1930s and actually expanded in the war years. The replacement workforce of migrant Southern Blacks and whites, women and others knew little of the earlier informal work groups established in the CIO's first years. But as such units regrouped, the spirit of resistance against unchecked employer prerogative caught fire and even spread to sectors previously unorganized. Industrial actions offered a particular benefit to Blacks and to women, long treated as second-class workers. The strike pattern nevertheless posed an ambiguous phenomenon for any interpreter. UAW workers in particular tended to vote patriotically for contracts banning strikes, and then to engage in them anyway. The education of a new industrial species and generation to class struggle proceeded, for the most part, willy-nilly. From 1942 onward, strikes mounted in raw numbers, workers involved and hours lost; by 1944, strikes had reached an all-time level.[18]

Beyond all these considerations, the wartime society steadily embraced a democratic (and even sexually and racially egalitarian, to an unprecedented if still limited degree) rhetoric of world crusade. Radicalism, as so often in America, now consisted in the popular demands to bring reality in line with rhetoric. Even a small group could react with volatile effect upon such prospects.

React they did. The miniscule Workers Party published a weekly newspaper with a claimed 50,000 circulation, including a special West Coast edition of 10,000, and another 10,000 in Buffalo, New York. The paper agitated around issues the Communist Party had abandoned for the duration – wage-freeze, inflated local prices, organized racism – and against the general bureaucratization of CIO unions that the Communists often viewed as a positive development. This proved to be American Trotskyism's most hopeful moment.

In retrospect, the ambitious collection of youngsters also constituted a germ of future neo-conservatism. Its intellectuals included Irving Howe (who edited the weekly *Labor Action* for a time), later novelist Harvey Swados, *Fortune* magazine journalist Dwight Macdonald, art critic Lionel Abel, philosopher James Burnham and numerous later-notable others. By the end of the 1940s, through its peripheries would pass Saul Bellow, Gertrude Himmelfarb, Richard Hofstadter and Clement Greenberg, among a crowd of brilliant young Jews. James recalled the frequency of psychoanalysis among the daily topics of casual conversation, and the prevalence of Brahms on the record-players. A more unlikely, unproletarian group could hardly have been invented. Its most celebrated outcome represented, in retrospect, a movement away from Marxism, assaulting American liberalism first from the Left and then from the Right, moving toward a rationalist and Jewish equivalent of

Catholic humanism with a secure hierarchy (this time of intellect rather than position and property) holding off the threat of the masses – especially the non-white masses. Its least celebrated (left-wing, that is) outcome represented the opposite, the dissolution of Leninism into a renewed syndicalism, radical race-consciousness and cultural anarchism directed against the bureaucratic State in its various capitalist and Stalinist incarnations.[19]

James stood astride these centripetal tendencies, true to Leninism but a Leninism successively reinterpreted. To the fears and anxieties aroused by the German conquest of France, James argued forcefully that Hitler could not win. An issue of the *New International,* written wholly by James, detailed his revolutionary predictions. The Nazis he saw as the acme of statification already apparent in Bismarck, the famous blitzkrieg an old Prussian technique perfected by modern technology. Collapse of the bourgeoisie, and calculated destruction of the working class, made possible a renewed German nationalism with unprecedented state orchestration. Demoralization of the working class in France, Holland, Spain and elsewhere – with the assistance of the Communists – rendered any internationalist, revolutionary alternative, with its own style of military resistance against Hitlerism, an impossibility. But internationalism would rise again, James argued, because no alternatives existed for civilization.

> Capitalism after climbing great heights came to a standstill and has now slipped from its foundations. Great states crash, communities of millions are torn up by the roots; shocks, catastrophes, sudden reversals and annihilations, drawn-out agonies, events unpredicted and unpredictable flow and will follow each other with bewildering speed. As we look at the film of history it seems that the operator has gone mad. But through it all the general line is clear, the objective hopelessness of the profit system, the statification of production by the imperialist state, the reduction of the living standards of the people, political and social servitude The crisis grows deeper every day. War is only one manifestation of it.[20]

These were the ideas by which the Workers Party members at least initially urged themselves forward during the war, and the prism through which James wrote in *The New International.* Without doubt, it was first of all his range of knowledge which set him off from even the bright youngsters around him (and likely inspired the lifelong resentment against him by Irving Howe and others). The martyred Trotsky he viewed in the succession of Gibbon and Michelet, the unfolding events of the war in the mirror of four hundred years' European conflict, the potential socialist unity as realization of ideals put forward (albeit in religious and sectarian forms) in the Crusades. No one else in American

Trotskyism or indeed in the American Marxist movements could write or speak with this scope. *The New International*, thanks largely to James, shortly rose from the Trotsky cheering section it had previously been to become the outstanding Left journal in the USA. Secondly, James kept an eye toward Africa and Asia; as the War promised the end of the British Empire, it raised prospects of revolt, previously quelled with resources no longer available to colonialism. Still an international figure of sorts, James also remained on the executive of the International African Service Bureau, and helped to plan the Fifth Pan-African Congress in 1945, which set out the pro-independence political agenda. James also planned with Richard Wright and others the publication of a Black monthly opinion magazine which, despite elaborate plans, never saw the light.[21]

He also contributed, in 1940, an extraordinary pamphlet to the rising anti-war sentiment of Black Americans. In '*MY FRIENDS': A Fireside Chat on the War,* he borrowed both the form of Franklin Roosevelt's informal talks, and the immanent critique Richard Wright made of American society, to speak in the voice of a self-educated worker. Most extraordinarily, this worker's wife, 'Leonora, who is a Red' (and presumably in line with the Communist Party's current isolationism), is credited with the most pungent criticisms. In a literary style that rang with vernacular, James's protagonist baited Roosevelt:

> My friends, who does the President want us to fight? He and all the writers in the papers say that it is to defend our democracy. Our democracy! My friends, when I heard that I laughed for ten minutes. Yes. Laughed. I'll tell you why. It was because I was so damned mad that if I didn't laugh I would have broken the radio. And the radio cost me $4 in the pawn shop and I didn't want to break it....
>
> My friends, the President warns us about the fifth column. I understand that this is the new name for the enemies of democracy. Where have the President's eyes been all this time? If he wants to find out who these fifth column people are, he just has to ask the Negroes. We know them. We spend our lives fighting against them. If the President sends a reporter to me, with a large notebook, I guarantee that between sunrise and sundown tomorrow I'll point out to him more fifth column enemies of democracy then [sic] he can find room for in all the jails of this country ... beginning with the Vice-President of the United States, Jack Garner....
>
> I went to the last war. I was treated like a dog before I went. I was treated like a dog while I was there. I was treated like a dog when I returned. I have been played for a sucker before, and I am not going to be played again.[22]

As a pamphleteer, James had limitless potential. To test his talent for political leadership and his unusual views of the peasantry, James volun-

teered to go to south-eastern Missouri in 1941, where he almost immediately became embroiled in the struggles of sharecroppers. Not that James turned agitator; Workers Party members on the scene suggest he spent most of his time in St Louis with only occasional forays into the countryside, essentially to encourage their incipient strike, listen to their story and incorporate it into a second Workers Party pamphlet. But he proved himself a good listener and an able scribe of another Black vernacular, that of the rural region still virtually untouched by big-city secularization:

> All the preachers must get their flock together and preach to them about the union and solidarity in the struggle.... That is the voice of scripture. Also the laborer is worthy of his hire. That is scripture also ... Solidarity in the union, that is the way to get the Kingdom of Heaven upon Earth.[23]

The sharecroppers won their strike, although their subsequent experience in the Communist-dominated Union of Canning, Agricultural, Packing and Allied Workers (UCAPAWA) would be disappointing for the reason that non-wage employees never fitted into the CIO structure. Yet a victory had been scored, by rural Blacks in wartime, with the aid of white CIO workers in St Louis and under the ostensible guidance of a Trotskyist. Not only was this a signal triumph, it was also unique; it would not happen in the rural south again soon.

Meanwhile, James and Dunayevskaya had moved toward forming a 'total' faction, with its own ideas and support network, inside the Workers Party. It was, to begin with, an enlarged study group composed largely of remarkable women around James intellectually and around a household turned into a kind of radical salon. There, at the residence of Fredy Drake Paine and of her husband and fellow political enthusiast, prominent architect Lyman Paine, James came and went with his own key, frequently led group discussions on subjects ranging from movies to economics, and generally held court. The Paines not only hosted the group, but also provided James's financial sustenance (as they would continue to do for almost a quarter-century). With their help, he could rally intellectual energies without imposing an iron-clad dogma upon the comrades and the allies who came and went through this milieu. As a disciplined political cadre, it lacked substance as well as numbers. But as a collective mind, at once intently serious and also creatively playful, it suited perfectly the era of new conceptual problems facing the Left.

By 1943, James could write to Constance Webb that despite an operation upon an ulcer,

> these three years have been wonderful for me. I have at last got hold of

Marxism, economic (Capital) and philosophical (Hegelian dialectic). I don't know all I want to know but I have covered the ground, and not only in theory but as a result of it, in my daily work, [I] really can see that I am in command of things. These three years have been the most exciting intellectually of my life and if I could have studied only because I was ill so much[,] I don't think I would have regretted it.... There have been great battles and some of it has been wearing but that is politics ... on the whole [I] am satisfied with the past and very confident of the future.[24]

It was a heady experience for others in the group as well. A typical young woman, fresh from factories and college on the West Coast, served along with others as a research aid for James, and remembers the flush of excitement in the demands of doctrinal debate, even when she had no particularly strong favourites among the debaters. She had become a 'Johnsonite' (following James's American *nom de plume*) or 'Johnson–Forest' follower largely because James alone among Trotskyist intellectuals had made provision for her to do useful work and to grow with the effort. James seemed to her, as he must have seemed to others, overly talmudic, also practically obsessed with the possibility of short-range dramatic change in America, but with all that still a charismatic theorist who inspired (or enthralled) devotees.

Grace Lee, soon to be the third member of the group's leadership, similarly views the Johnson–Forest Tendency as a completion of her education and the initiation into a lifelong involvement with serious political theory. Daughter of a prominent Chinese–American restauranteur, Bryn Mawr philosophy PhD (with a thesis on George Herbert Mead), Lee had first been swept up into politics during the excitement around the aborted March On Washington movement led by A. Philip Randolph. She had contacted the Workers Party almost by accident, through a small milieu around the University of Chicago submerged by Communist Party influence. The enthusiasm of Chicago Blacks, and her intellectual enthusiasm at C.L.R. James, led her to Left politics. Study classes of Marx, in the light of political developments, made Lee (and her competence in German) an indispensable addition to the group.[25]

Quite apart from James proper, the role model of Marxist woman theorist provided by Raya Dunayevskaya had its own definite effect. Every Trotskyist had read Rosa Luxemburg; they practically claimed her as one of their own. The aspiration for anything like Luxemburgian theoretical status by an American Marxist woman met, however, with jeers. (In the Communist Party, women had been celebrated principally as heroic rank-and-filers, or 'mother' to the workers, a status which the redoubtable Elizabeth Gurley Flynn stoutly resisted but not with complete success.) Dunayevskaya was, arguably, the first to achieve and

maintain her top-rank status. Grace Lee could be described in a more restricted sense as the second and possibly the last until the rise of such female political veterans and Marxist academics as James-influenced historian and women's movement spokesperson Linda Gordon, in the 1960s-70s.

Practice joined theory. For Lee, it was retrospectively 'a marvellous time for going into the plant', and no less marvellous a time to study Marxism. Optimism measured the course of the Left at large. Orthodox Trotskyists - observing the rightward political trend to a Republican Congress in 1942, the railroading of Socialist Workers Party leaders into jail on a patently absurd charge of sedition, and the concurrent loss of their teamster influence - did not particularly anticipate a silver lining. Buffeted by repression, the SWP settled down to survive the military interregnum. The Communist Party, for its part, entered its own final Golden Age, flush with the pro-Russian tilt of US war policy and with the emergence of an impressive female enrolment (a majority of the party's 1943 peak of 80,000 members) at shop and community levels.[26]

Utterly opposed to Stalinism and repelled at its open abandonment of a proletarian teleology, the little Johnson-Forest group actually shared with the Communists some similar sources for political hope - more than the Workers Party at large. Changes in the status of women, of Blacks and of industrial society at large filled them both with eager anticiption. The difference between the Johnsonites and Communists, apart from vast scale of one to a thousand, was that the Communists had moved decisively away from the 'revolutionary defeatist' formulae of anticipated revolutionary outburst, to the vision of a world ruled by liberal America and Communist Russia in peaceful alliance; the Johnson-Forest perspective refashioned the traditional Leninist strategic wisdom, by reference to new stages of mass production and mass culture, to fit the current situation.

The great and calamitous events, war abroad and uncertainty at home, encouraged Johnson-Forest followers. James could write privately in 1943: 'I live at present in daily expectation of the beginning of an upheaval ... marking the beginning of the socialist revolution. I think of that many hours every day. It keeps me alive.'[27] On the negative side, as a 1940 resolution the Workers Party proclaimed, the fascist state had 'deeper economic roots' than Marxists had hitherto acknowledged. The breakdown of classic capitalism had catapulted the state into command of economic forces, from which height it could become a vehicle for barbarism. The choices had therefore narrowed: only the emancipation of labour could forestall barbarism. James himself, writing in 1945 after the atomic warfare against Japan and the revelations of German genocide against the Jews and others had revealed the new

situation, reformulated this idea as 'socialism and barbarism' *simultaneously* coming to fruition.[28]

On the positive side, James and his comrades greeted such various events as the 1943 Harlem riot, the wartime strikes and the voting strength of the CIO's Political Action Committee as potential mass mobilizations against the state's version of social peace. Abroad, he saw the rise of European liberation forces as proletarian revolution in nuclei, substituting themselves for broken national bourgeoisies. These tendencies were actually accelerated by the capitulation of the middling national forces to Communism (the power of the Red Army) on the one hand, and the concurrent rise of intellectualized versions of Fascism (now designated clerical 'Humanism') on the other. As he had predicted in 1940, one by one the alternatives had all but run out.

Workers Party intellectuals and factory cadre, at once more trade-unionist in their practical approach and also more traditionally Trotskyist in their separation of theoretical discussion from mass agitation, found less and less common ground with the likes of James. The Holocaust, arousing as it did a deep guilt in the minds of Jews who had been less than enthusiastic in supporting the American war effort, confirmed a creeping despondence. Theses on 'Historical Retrogression', circulated by German Trotskyists, captured the mood: capitalism had fallen apart, the Russians advanced and European society increasingly resembled that of the Dark Ages. The task of revolutionaries had become essentially one of *restoring* society from the verge of barbarism to a pre-socialism transition stage. If James believed that the degradation of the productive forces 'socializes labour' and 'drives it to revolt', the prevailing perspective held that degradation meant the end of all immediate revolutionary hopes.

Indeed it did for the Workers Party, which slid steadily downward after the war and dissolved into a propaganda group in 1949. Its foremost leader, Max Shachtman, himself drifted rightward to become architect of the AFL–CIO's hawkish Vietnam policy. Shachtman carried with him a stratum which embodied the extreme ideologues of Cold War labour leadership, instructing a younger generation of former socialists in the fine arts of subverting radical labour movements abroad and discrediting dissident radical (or merely democratic trade union) tendencies at home. Within a quarter-century, they had become all that they had accused the Communists of being, except that they embraced the American version of the leviathan state. Other individuals of the old Shachtmanite movement went on to distinguish themselves within just those sorts of dissident labour and social movements persecuted by their former comrades now in power. A handful of Workers Party alumnae also played an invaluable role of bridging the political gap, at least for

individuals, between the Old and the New Left. The overwhelming majority came to the view, one way or the other, that the classical Trotskyism (or Bolshevism) of the 1915–45 period had indeed decisively come to an end, leaving its heirs in limbo.[29]

It would be too much to say that the philosophical and political differences among those moving in opposite directions consisted in approaches to the race and colonial questions. But these differences, along with an unstated but unmistakable gender tilt, seem to underline the radical break Johnson–Forest made with the Workers Party on ostensibly Leninist grounds in 1947. A young Italian–American woman from no political background drew close to James from her observation that he lectured (as her mother, a *sui generis* Pentecostal Christian, had earlier preached) about the 'backward ones' destined to rule over the world society. One of the 'backward ones' herself, she could feel a stirring throughout American society. James's ultimate disproof of 'retrogression', though hardly stated at the time, was the nationalist uprising in the Third World that he had anticipated and helped to orient. A corollary, more clearly stated, was the increasingly Black character of working-class restiveness in the USA. The Right-leaning defectors would come to view these developments with alarm, and come to associate them with the 'retrogression' which threatened Western civilization. The Left defectors would sometimes celebrate what their erstwhile comrades despised.[30]

This political logic, barely identified at the time, carried the Johnson–Forest group into the mainstream Trotskyist orthodox Socialist Workers Party from which the group had departed in 1940. Just then enjoying an upswing of influence similar in character and duration to the Workers Party wartime boomlet, the outnumbered orthodox Trotskyists essentially filled the gap left by a declining Communist Party the best they knew how: assailing the retreat of union leaders from earlier class militancy; appealing over the heads of Black and labour organizations for direct-action tactics; and hailing the possibility of the breakthrough that no one else on the Left seemed any longer to view as realistic. They had not changed their views on the character of the Soviet Union, nor (formally or informally) on the Woman Question, nor on the general role of the vanguard leading American workers in old-style Bolshevik fashion. But they attracted new blood. In their own eyes, their time had come. Their lively cadre from the indigenous working class (augmented, to be sure, by 'colonizers') had persisted with promising results. Especially among semi-politicized Black workers they seemed to get a hearing. Veteran leader James Cannon, buoyed with optimism, proclaimed his hopes in a pamphlet, *The Coming American Revolution.*[31]

Johnson–Forest and the SWP entered a marriage of convenience, with James's group retaining their internal coherence and discipline. The SWP, utterly delighted to get the outstanding Trotskyist theorist on Blacks, accepted the rest of the group with equanimity. (As a bonus, it acquired a handful of valuable activists, such as the Johnsonite who put the weekly *Militant* to bed.) Assigned a column on the Negro Question – as if the plans of 1939 now recontinued almost a decade later – James did his task as well as his growingly difficult personal situation allowed. Local Johnsonites vowed not to fight over insoluble theoretical differences, striving instead to work on common issues. Here and there, they found themselves engaged with industrial militants, whether with miners in West Virginia, steelworkers in Chicago, or even running for office on the Oakland, California, SWP local ticket. Wherever possible they had tried to raise the possibility of mass mobilization, and of a truly Americanized version of Marxist politics, within this framework.

James sought to underpin the political development with a strategic understanding of the gap between the SWP's modest means and the real radical potential. He called an occasional contribution to the *Militant* 'The Elemental Urge to Socialism', meaning the mass desire that existed regardless of political guidance or its absence. 'Any theory of party building or party organization which is not based on the needs and desires and experiences of workers,' he warned, would come to no good. Indeed,

> Bolshevism ... conscious of its roots, is constantly on the alert to examine and ponder over the slightest reactions of genuine proletarians to the concept of the party, the theory of the party, the experiences of the party, *whether those experiences are favorable or not.*[32]

As half a dozen years earlier in the Workers Party, James appealed for a willingness to believe in the potential subjects of the revolution 'more than they believe in themselves' and for the courage to Americanize and update their international heritage to the prospects upon the horizon.[33]

This final dream by James of Trotskyism's revival drew swiftly to an end. By 1949–50, the Cold War and the successful implementation of factory discipline (with union leaders' ardent assistance) left potential activists from the rank and file both discouraged and increasingly fearful of repression. While the remaining activists of the disintegrating Workers Party tended to go over to the anti-Communist unionists (especially auto leader Walter Reuther), the floundering Socialist Workers Party cadre now struggled to defend critically the Communist-led progressive blocs. In some cases, again that of the United Auto Workers, they actually became the spokespersons of these blocs so long

as the following could be maintained. But the grounds for agitation constantly dwindled. According to some complainants, the factory Blacks recruited into the SWP found actual comradeship (including such touchy questions as Black Nationalism, and the social engagement of Black men with white women) considerably less than in the Communist Party milieu. Whatever the reason, most of the new sympathizers soon departed, leaving little behind. The return to 1930s-style class struggle never materialized, while the widening Civil Rights movement of the 1950s would bear many traces of past Marxist influence but no organic links with the Left.

Struggles against the onset of the Cold War and its various repressions increasingly dominated the reserve energy remaining. Campus activism briefly spread around the 1948 presidential campaign of Henry Wallace. Communists sank all their energy and hopes into the effort, alienating key trade-union supporters (who remained in the Harry Truman camp) and bringing on the Progressive Party charges of disloyalty. The SWP, like the collapsed Socialist Party, ran its own candidates in total isolation. Working-class issues in their own right virtually disappeared. As the Workers Party (dissolved in 1949 into an avowed propaganda group) drifted rightward on world issues, the SWP Trotskyists increasingly attached themselves to fantasies of heretical Communist régimes (such as Tito's in Yugoslavia) becoming favourable toward the Fourth International.[34]

All this, for James and his followers, seemed either blundering or downright anathema. They had no further reason for remaining within such a current. But how to set out a wholly new course, in accordance with their undying faith in working-class capacity and their hopes for emerging racial dynamics? The strain between evolving, post-vanguardist views and the stubborn faith of loyal Trotskyists snapped the links. Surprising even some of its less centrally-connected sympathizers, the group withdrew suddenly from the SWP in 1950. James now led his following into the political wilderness – or out of the wilderness of the insular Left into the valley of promise, somewhere in American life.

Beyond Trotskyism

Organizationally, in terms of numbers let alone public influence, the Johnson–Forest group had made no particular progress in its pilgrimage through Trotskyism. But from a theoretical standpoint it had been an immensely rich several years. The flow of materials, pamphlets and books surpassed any other period of James's own life in particular. It was also the most inherently collective intellectual work he would ever undertake.

One measure could be found in pamphlets published, during the interim period between Trotskyist organizations and just after final secession, about the lives of ordinary workers. A similar effort had been made repeatedly, since the founding of American Marxism, to capture the ambience both faithfully and optimistically. Perhaps the most successful results had come in the unpretentious Yiddish literature written by real workers or slum-dwellers, or in the later reportage by such straightforward commentators as Ruth McKenney (her *Industrial Valley*, a 1939 look at Akron, Ohio). Most, if by no means all, of the Communist fiction had been marked by narrow didacticism and unrealistic political conclusions. Trotskyist intellectuals, so far as they interested themselves in fiction rather than criticism, had (again with exceptions) moved steadily away from class to aesthetic experiments. Only in the closing years of the 1940s and early 1950s did a handful of varied and personally disconnected Communists, Trotskyists and independents succeed in moving beyond literary pamphleteering to careful literary realism. James's group collectively sought a parallel path in non-fiction, workers revealing through an intellectual amanuensis their inner world of observations, frustrations and dreams.[35]

The Johnsonites published most of their texts in two waves: during the 'interim period' of 1947, between the Workers and the Socialist Workers Parties, and after the split from the SWP in 1951–2. *The American Worker* (1947) by 'Paul Romano and Ria Stone' (pseudonyms for a worker who told his story, and Grace Lee who both wrote it down and added a commentary) offered a snapshot of the factory and a chiselled analysis of blue-collar psychology. *Indignant Heart* (1952) supplied the book-length life story of 'Matthew Ward' (as told, in effect, to Constance Webb), a Black worker who had migrated from the South to Detroit, worked in the auto plants and been progressively discouraged from both the Communists and Trotskyists – but not from the promise of radicalism. Lee's translation of passages from Marx's *1844 Economic–Philosophical Manuscripts*, focusing upon the ineradicable alienation of wage-labour, illuminated the very empirical points raised by daily life. No one else, inside the Left or outside it, went so far in either direction.[36]

James, Dunayevskaya and Lee meanwhile wrestled with world events in the light of their theories. A substantial pamphlet, *The Invading Socialist Society* (1947), established the extraordinary insight, for the time, that Communist parties around the world were not *mere* 'tools of the Kremlin' (as Trotskyist theory of all kinds claimed), but rather were 'an organic product of the mode of capitalism at this stage'. In short, the State's growth had become an inevitable (and the only possible) bulwark against socialism; the decadent Second International and the Stalinist Third International parties could not and would not disabuse their

followers of the illusion that state property equalled socialism. Each viewed the collapse of capitalism from this standpoint, although awaiting different kinds of liberators. The Johnsonites, on the contrary, called for revolutionaries 'to drive as clear a line between bourgeois nationalization and proletarian nationalization as the revolutionary Third International drove between bourgeois democracy and proletarian democracy'. The slogan The Socialist United States of Europe carried forward the necessity of abolishing existing national boundaries as a necessary step in true reconstruction. Engels's own formulation, 'the invading socialist society', had foreshadowed and predicted the transition from statification to socialism.[37]

State Capitalism and World Revolution (1950) brought this critique almost to full book length. Argued as in the earlier pamphlet with logic extremely internal to contemporary Trotskyism, the document savaged in particular the Trotskyist adaptation to heretical Communists in power. Such an adaptation, James and his collaborators argued, meant the acceptance of nationalization (rationalized as 'national unity' against foreign domination) as the virtual accomplishment of Socialism. Trotskyists had in effect substituted the bureaucracy in state power for class struggle against that bureaucracy (and every other kind of ruling elite). They had exchanged visions of intra-bureaucratic power-struggles for the old dream of proletarian emancipation. According to the Johnsonite analysis, Tito merely wavered between Cold War camps; he did not begin to approach socialism any more than the competing superpowers did. Purporting to defend the revolutionary traditions of Trotskyism, the authors proposed to disabuse themselves of Trotsky's own key methodological errors.

The heart of their analysis linked modern capitalism to Russian 'state capitalism': the bureaucratic Plan, the logic of the experts, i.e. Rationalism in power, was the essence of updated exploitation. James's perceptual penetration of the CIO struggle, his analysis of the Communists' support for bureaucratic tendencies within the labour movement, extended this insight into the processes of revolutionary transformation and the limitations of conventional Marxist wisdom. James and his collaborators argued that American workers, however unwilling they might have been historically to join socialist parties in European standard, were not backward in the most important sense. The instinctual grasping for the Universal – no mere change in the form of property, but rather in the social relations of production – could be seen in the actions of 1940s workers urgently seeking the negation of existing relations. The CIO, 'more political party than trade union', had embodied the initial phase of their striving. Stripped of its bureaucracy, it might embody once more the greatest challenge that the exploited had ever set before

modern capitalism. Or workers would find their own forms to do what had to be done.

In any case the challenge had to come, as a *necessary* response to the level of contradiction already reached within American capitalism. The system of sweated labour pioneered by Ford threatened to become a comprehensive totalitarianism. Scientifically rationalized production with the State as mediator marked the culmination of the industrial and political evolution which had been centuries in the making. Triumphant, it would signify the subordination of every democratic possibility to the demands of capital. Concurrent with that development at every step, however, were elements of resistance from the weavers of the medieval 'free' cities to the British Levellers and Diggers to the Paris Communards and, finally, the members of the Russian Soviets.[38] James argued, in a separate document, that the *idea* of Freedom had been rendered successively more concrete throughout Western history, despite calamitous defeats suffered along the way. (He noted that when the slaves of antiquity made their claim upon freedom for all in God and equality in Heaven they also made their claim upon an abstract freedom. Unlike his mostly Jewish opposite numbers still in the Workers Party, he did not view the triumph of Christianity or its role in medieval times as proof of the Dark Ages.) From era to era, the struggle had continued. The prospects inherent in ordinary modern workers and their mutual relations to each other would fill in the abstraction long present: such was the promise of socialism.[39]

The difficulty of seeing this outcome at the very moment of civilized collapse – the shambles left from modern warfare – offered James proof positive of the need for reviving the *methods* of the dialectic against the false reality of Rationalism. From this point, James advanced to his prime philosophical document, *Notes on Dialectics*. Rarely, at least until the structuralist documents of the 1970s, has so difficult a text been presented to the American Marxist reader. Never before or since has it been presented in the framework of interpreting proletarian action through the guidance of Hegelian logic.

The document came together at a strangely significant personal moment. Almost since his arrival in America, he had written impassioned letters to Constance Webb. He had expressed in private the artistic intuitions that he repressed from his public writings, his excitement at American culture (especially American cinema), his sense of personal insecurity at earning a living or even remaining safely in the country on an outdated visa. He had agonized, not at his advancing age in itself, but at his inability to secure a stable relationship alongside his political life. At last, after the refusal of US authorities to accept a divorce from his Trinidadian wife, he went through a variety of legal stratagems to marry

Webb. To free himself formally, James had to risk exposure and deport-
ation; taking all risks in hand, he set out for the divorce-mill of Reno,
Nevada, working uncharacteristically as a gardener–handyman. There
he set down in a series of letters the political–philosophical conclusions
he had reached by turning repeatedly from text to contemporary politi-
cal life. Just as an imagined life with Constance Webb seemingly symbo-
lized for James a successfully completed Americanization, so his
intellectual work on Hegel meant the fruition of a decade's Marxist
study and observation.[40]

He intended to work through, in philosophical detail, the theoretical
steps taken already. Hegel's *Logic* provided, he insisted, an 'algebra in
constant movement', suitable for any dialectical process but especially
suited for the great social transformations then at hand.

Fundamentally, James categorized all the old perspectives, Second
International and Trotskyist, as frozen in the realm of 'Understanding'.
These had seized upon a historical development, the nineteenth- and
early twentieth-century workers' struggle against private property, and
set themselves upon the goal of state ownership. Understanding could
not be underrated or done without. But falling short of Reason by want
of a *leap* (in the spirit that Lenin wrote 'LEAP LEAP LEAP' in his
notebooks on Hegel), it failed in the first instance to comprehend the
role of *subject*, real living subjects.[41]

Trotskyism therefore failed to transcend the categories of Lenin's
1903–23 era. Trotsky had been unable to conceive that the Russian
Revolution, the highest stage reached in revolutionary struggle, had
succumbed to state capitalism. Faced with the transformation of the
world Communist movement to Popular Frontism, he could only
conclude that Stalinists had 'supple spines', or could prove themselves
capable of anything. James returned to the lance he had split with
Trotsky in 1939, and the conclusion Trotsky should have drawn about
the German catastrophe: 'the policy in Germany as far back as 1930
should have been governed by the idea that the workers at all costs
should act over the heads of their organizations.'

'True reality', James quoted Hegel as saying, 'is merely this process
of re-instating self-identity, of reflecting into its own self in and from its
other.' That was the key to the alternative view: the labour movement at
each stage 'degenerates but splits to re-instate its self-identity, its unity,
but ... this unity comes from divisions within its own self'. Stalinism, like
Bernsteinism before it, *was part of the historical process.*[42]

What could the new stage be? James insisted that the Paris Commune
and the Soviets had shown the way forward, in the dissolution of
economics and politics into each other at the moment of revolutionary
transformation. That had been Lenin's struggle after 1920, to bring the

Russian people into the governing of the state and the replacement of the bureaucracy. (Decades later, a still more philosophical James would credit Mao Zedong, despite his own bureaucratic origins, with similar intentions in the Cultural Revolution.) The secret of the Soviets was the *possibility* of such a transformation; the tragedy of Russia was the impossibility under conditions of revived world capitalism. 'The revolutionary concept of 1917 was, for Lenin, the soviet and what it means to the people ... not nationalized property, but the soviet plus nationalized property ... electrification *plus* the soviets.'[43]

Lenin, James insisted, had never viewed his role as the originator of the Party concept. Combining in himself the culmination of a process from Kant's insistence upon human thought as source of cognition (and Hegel's insistence upon thought as definition of humanness) and of Marx's insistence upon man as a labour-using animal, Lenin had added that 'proletarian man is revolutionary or he is nothing'. The Party was a mere means to this end, the proletariat's way of knowing itself, *i.e.*, its mission. Each great thought belonged to a particular age. Another concept, another step in the great evolution, would be required for the mid-twentieth century.

Put differently, James saw the progression from Cromwell and the French Revolution to the Commune and Soviets as the successive development and degeneration of the petty-bourgeoisie, first triumphant and then caught between the ruling classes above and the working class below. It carried through the French Revolution, but only on the condition that the mass movement be subordinated to itself. In substituting itself for the Revolution, the intermediate class supplied the first great clue to state capitalism. It could not suppress the masses, its own social weapon, but neither could it permit them to take power in their own name and to dissolve the State into themselves.

Much had changed in the intervening period. But the petty bourgeoisie had remained an intermediate class, the stuff of which Socialist and Communist Party leadership was made. Labour leadership (accompanied by an anarchist petty bourgeoisie) seemingly succeeded it, in the struggles that developed from the mid-nineteenth century to the first years of the twentieth, but actually grew into its likeness, embodied in the Mensheviks and later Stalinists. *Through* the labour leadership, they blunted the proletarian thrust in the name of socialism itself. Rather than small property owners, they were the technical administrators of capital (and state capital). In that capacity they would rule – or ruin. *This* petty bourgeoisie, Menshevik or Stalinist, would *not* defend private property. But it would murder a class, destroy a society if necessary, to prevent the abolition of itself as a guiding force.[44]

Notes on Dialectics revealed how far James had travelled to the study

of counter-revolution within the revolution. He had observed how much hostility workers, especially American workers, felt toward the bureaucratic obstacle – however unconscious they remained of the significance – and he closed with a dread portrait of possibilities:

> The world moves to civil war and imperialist war or imperialist civil war. They are being prepared openly before the people.... Year by year for thirty years, this is the course bourgeois society has taken. Since 1933, fifteen years ago, it has gone downward without a pause. It has been worthwhile writing this if only to settle for ourselves why, when we propose that the Fourth International orient itself around telling the workers that they alone, in every country, have the power to alter this and that only by their independent power – our most violent opponents are not workers but the trotskyists themselves. As I have been writing this, one thing keeps popping into my mind and I cannot drive it out. Their organizations stagnant and dwindling, they stand impregnable, ready to go down with the proletariat on the basis of their analysis that the workers are not ready. I think of the stalinists in Germany in 1933 and in Spain in 1938. They too explain that their treacherous compromises are due to the fact that the workers are not ready. Dialectic explains their difference and their identity.[45]

Notes on Dialectics summed up, perhaps, the dangers of historical generalization and also of political hyperbole. The attribution of all revolutionary failures to the malfeasance of the petty bourgeoisie failed, at the very least, to perceive that all non-spontaneous American radical movements, from Abolitionism and Woman's Rights to the First International onward, owed their formation and intellectuals to the same class. The very craft worker whose artisanal legacy stretched backward in time and whose gradual loss of status lay behind Marx's support in England, Germany and elsewhere, had (as Thorstein Veblen pointed out) a 'small property' holding in his head and hands. Neither Marx nor Lenin nor Trotsky nor the various American Marxist intellectuals, with few exceptions, could make any other claim for themselves as individuals. Indeed, more descended, like Engels, from some wing of the *large* bourgeoisie than from the downcast proletariat.

James's views offered an insight into the revolutionary process, but by cathartic gesture aimed all the energy of defeat away from the internal structures of the working class. The proletariat therefore ceased, despite all James's theoretical efforts, to be the subject of history and became object once more, the 'giant in chains' somehow always betrayed by leadership. A more Trotskyist view, broadened from the critique of Stalinism outward, could not have been formulated.

But James, even straining at his own logic, had all the virtues of his faults. This micro-argument of *Notes on Dialectics* stood within a theor-

etical context which provided a corrective. The larger interpretation made elsewhere, of the alienating division between mental and manual labour under capitalism, showed the disintegration of society and the mobilization of capital 'for the suppression of its own creation – the need for social expression that the modern productive forces instils into every living human being'.[46] Marxism, he argued, consisted in the recognition that the resulting explosion (and not some moral appeal, or for that matter the State's seizure of productive facilities) would make the Revolution. James and his colleagues had discovered a hidden Marx, long before anyone else in the United States, because the stresses and strains upon the working class and the entire population made that discovery theoretically obligatory, and because the Johnsonites had the intellectual energy to make the connection.

In another sense, James had acted within a context in which arguments for the 'backwardness' of workers and ordinary people in general had become more common coin in the Left than official publications would admit. The decline of the Communist, Trotskyist and Socialist movements alike, the absence of a revolutionary breakthrough in the wake of the Second World War, made all but the most hardened cadre begin to doubt the subjects of their own devotion. James insisted upon a revolutionary way out because all other avenues had been blocked. Or again: he insisted upon the potentially revolutionary energy of an emerging generation which felt sickened by world events and the stream of propaganda lies from East to West, but which had by and large lost the old-fashioned urge to read about socialism and to put their ideas into political action. *This* proletariat, and middle class, was indeed spontaneous in its actions – or it was nothing, nothing to socialism in the immediate future anyway.

James's Trotskyist critics, if they read the philosophical theses at all, would surely have cited James's fondness for Hegel's claims that apparent mysticism actually hid 'speculative truth'. Independently of Hegel's claims, they had long seen James as a mystic. His mid-1940s challenge for anyone to *disprove* the *possibility* of the workers uprising within a few years provided much fruit for satire in the disintegrating Workers Party. (It goes almost without saying that in the factional hot-house atmosphere of Trotskyism, opponents viewed the Johnson–Forest group as a personality cult held together by James's mesmeric machinations.) He had similarly, by 1946, come to the point of suggesting that the post-war Italian Communist Party, of many millions, had nearly itself substituted mass for party, abolishing the contradiction – raising the possibility that, in a crisis situation, even Stalinism might become its opposite.[47]

Ten years later, amid the Hungarian Revolution, he would find his vindication in the substitution of the mass for the party of any kind;

another fifteen years and he would insist, against the background of Poland, that *Notes on Dialectics* had become his most valuable work.

Where had James come in the little over a decade since his entry into the United States? The struggle for adaptation, perhaps, goes back to the initial object of Trotsky's inquiry, the Negro Question. One could draw a straight line from James's observations about Garveyism in *A History of Negro Revolt* to the culmination of his decade-long wrangling with American Trotskyists on this question in the ground-breaking 1948 conference document, *The Revolutionary Answer to the Negro Problem in the US*. James based the high estimation of Garvey's impact not on formal Back-to-Africa politics but rather on the sense of pride, racial and international solidarity against centuries of oppression that Garvey aroused. He had learned much from the Black Nationalism he initially opposed. What James called the familiar 'social service attitude' of the left could never stoke the 'fires that smoulder in the Negro world', but showed themselves vividly in social life:

> Let us not forget that in the Negro people there sleep and are now awaken-
> ing passions of a violence exceeding, perhaps, as far as these things can be
> compared, anything among the tremendous forces that capitalism has created.
> Anyone who knows them, who knows their history, is able to talk to them
> intimately, watches them in their churches, reads their press with a discerning
> eye, must recognize that although their social force may not be able to
> compare with the social force of a corresponding number of organized
> workers, the hatred of bourgeois society and the readiness to destroy it when
> the opportunity should present itself, rests among them to a degree greater
> than in any other section of the population in the United States.[48]

Through that perception, moreover, James could follow and extend DuBois in turning the concept of American history around. Blacks had, with their allies the white Abolitionists, forced the bourgeoisie toward Civil War. Only by their emancipation could that struggle have been won and the South be truly reconstructed. Only through their success could a Populist movement have restrained the relentless march of an advancing capitalism. And only by their actual advance could the CIO come into its own. With broadening, deepening relevance to the revolutionary prospect, the independent Black movement *precipitated* the political development of American socialism.

No American radical, not even the Black nationalist intellectuals sometimes in alliance with the Communist Party, had gone so far. None would carry these ideas further until the Black Power phase of the 1960s. That James's views became gospel for the later orthodox Trotskyist movement is a minor (although interesting) concern, with indirect

links to white Left recognition of Malcolm X and the Socialist
Workers Party's eager support of his tentative socialism just prior to his
assassination. More important, James had set himself against Commun-
ist fundamentals in a precise fashion, without renouncing the Leninist
legacy of direct political involvement.[49]

It may well be wondered whether James's definition of the shop floor
struggle as 'Socialism ... the only Socialism' could possibly encompass
his concurrent observations on Afro-American community life.
Likewise, he had little appreciation for the ways in which the contradic-
tions he observed bore fruit *within* the Communist Party, the important
unions and the pro-Black organizations that it led. The observers who
had declared him 'no Negro' had not been far wrong. But perhaps only
from the outside, and with the terms of the argument somewhat simpli-
fied, could James have seen so clearly how the weight of institutions
hung over the proletarian quest. Only from the outside could James
particularize that insight to the rebellious response of Black workers,
who identified least with the emerging 'new men of power' (as C. Wright
Mills would identify the labour leadership).[50]

True to Marx, James saw the proletariat as the embodiment of the
revolutionary prospect. Even his San Domingo slaves of the nineteenth
century 'working and living together in gangs of hundreds on the huge
sugar-factories ... were closer to a modern proletariat than any group of
workers in existence at that time, and [their] rising was, therefore, a
thoroughly prepared and organized movement'. Not prepared by some
external agent, but by the conditions of life and work, with a natural
leadership thrown up in self-conscious striving for a better life. The
modern class struggle pressed home the ultimate proletarian goals,
abolition of hierarchies invested through the division of mental and
manual labour.[51]

Better than the contemporary sociologists, James saw measures like
dues check-off as proof that emerging labour leaders (Communist or
anti-Communist) who thought in terms of industrial rationalization and
international consumer marketing (thus assuming their rightful place
alongside their corporate opposite numbers) constituted the 'American
bureaucracy carried to its ultimate and logical conclusion'. He could see,
as ordinary Socialists, Communists and Trotskyists could not, the signif-
icance of state-capitalist functionaries-in-progress willingly compromis-
ing the integrity of the proletarian impulse, not for personal gain (as the
Trotskyists ordinarily charged) but according to a higher logic. They had
repudiated private capitalism without believing that the classic proletar-
iat of Karl Marx could in the foreseeable future rule itself. The mobiliz-
ation and freed expression by the proletarian millions of their
world-historic universality, no longer empirical but completely self-

conscious would entail the total mobilization of all forces in society. 'That and nothing else can rebuild the vast wreck which is the modern world.'[52]

Johnson–Forest lacked, in retrospect, the human forces to do much more than nurture a theoretical approach and a laboratory practice of an alternative to Trotskyism. It came to view itself as such an alternative only by the early 1950s, a decade after its appearance. As James later recalled, the clinging on to old forms reflected Bolshevik mentality:

> The idea was that if you had the correct policies then you were able to play [plan?] the correct party, and by means of the correct party ultimately you would lead the revolution to success. There was a great deal of misunderstanding of the struggles that Lenin had made in Russia to get his party right, but the general opinion was that you fought for the correct line of the party however small you were; you fought against those who were not prepared to accept your line, and through your success, along these rather narrow and limiting efforts, you would in time rise to being the dominant political party and lead the hundreds of millions of people in the United States. It may seem now that I am speaking about it with irony. But I had more or less the same ideas and rather more than less. All of us had it at the time.[53]

Having committed himself to the life of the vanguard, James saw it through to the end. Beyond that lay his recovery of the culture critique.

4

Artist Again, in Spite
of Himself

By the early 1960s, exiled from America and self-exiled from newly-independent Trinidad, James re-emerged out of politics (with a cultural sideline) into cultural criticism with a razor-sharp political edge. It was a symptomatic move, long in the works. He had travelled from the 1930s–40s dominions of proletarian class struggle and the 1950s national independence movements to an age which found these standards incomplete and in that sense outdated. In a few more years, 'Culture' would occupy a self-conscious role previously inconceivable in the Left, encompassing developments from the Black Power rage of Frantz Fanon to the sexual utopianism of Herbert Marcuse to (in name at least) the 'Cultural Revolution' of Mao's China. Only in recent days has the heretofore unacknowledged centrality of culture in every significant social movement of the past become apparent to scholars of radicalism. By that standard, James was a pioneer in the unfolding vision.

James, arguably the finest sports historian in the English language, had arrived at the common meeting point earliest because he had wrestled with the conceptual problems since his intellectual beginnings. In *Beyond a Boundary*, he recuperated and reinterpreted his own West Indian childhood, his decades of participating in and observing cricket, as part of the sports saga which explained himself and also something vastly bigger. 'Large areas of human existence' had never been accounted for by economics, history or politics, either of the bourgeois or Marxist variety.[1] James the classicist could identify, on the modern playing-field, the spectre of the Acropolis, an ideal of grace and expression as real as that of the Greek theatre. James the cricketer and amateur historian of cricket could see the same ideals, of audience and players, around himself. He could not escape their role in the common striving for West Indian selfhood.

Other critics of the 1940s–1950s – one thinks of the American

literary scholar Leslie Fiedler, for instance – certainly recognized philoso-
phical consequences of the manic arms race that followed the invention of
atomic weapons. Despair (a Fiedler volume bore the title *Waiting for the
End*) drove them into varieties of aestheticism. Refuting the terms of the
argument, James went to the core of the matter. *Rationalism*, the system
of organizing life so as to separate 'work' and 'art', and to restrict the
latter to high culture aesthetics, *had failed miserably*. No matter whether
those dichotomies had been canonized in bourgeois or Marxist terms.
Cricket, sports generally, popular culture everywhere and always at its
best, summed up that unutilized human genius of the lower classes. So
obvious in primordial societies where the differentiations had not fully
taken place, this affect had become hidden within advancing capitalism.
As working people's own role in producing commodities had grown
mysteriously alienated from themselves, so their effort to refashion a
philosophy and practice outside the workplace remained all but invisible
to official society. Humans had from the earliest evolutionary days been
more than tool-using animals. Education, leisure and personal growth
created ever greater possibilities and psychological requirements for self-
expression.

Contrary to revolutionary aesthete Leon Trotsky, contrary to all the
old Marxism in which culture was considered mere handmaid to politics,
and contrary to the vision of socialism as abstraction, James's organic
vision found its reality already present in daily life. The greatest change
in human history demanded of the revolutionaries themselves a return to
mundane sources of subjectivity where the truth could be found. 'The
intellectual consciousness of the mass society rests with the great mass,'
he wrote in a private letter, and 'the more conscious they become, the
safer the great values of civilization are.' Not only their sense of destiny
and responsibility, but their intimate private lives, their sexuality and
their personalities became the crucial element in any view of possible
futures.[2]

Here lay James's accomplishment, won at a dear price. As his cricket
study went to press, he stood politically almost alone, limited to personal
contacts in various spots of the world. Intellectually, in the academic
terms of the emerging culture critique, he was even more isolated. (As
isolated, indeed, as an ageing Russian, Mikhail Bakhtin, with whom
James shared so much, trapped obscurely in Soviet intellectual life and
destined for international appreciation only after death.) Lacking the
formal apparatus of semiotics or the concept of the post-modern, James
had already detached the aesthetic object from its apparent roots in
productivist society and thereby plucked details out of a narrow historic-
ism, placing them into a flow that extended from the bushman to
Garfield Sobers. Novelist, Pan-Africanist and quirky Marxist, he had

come home to himself more fully than when he touched ground in Trinidad again.

From another angle, the architectonic text *Beyond A Boundary* is unimaginable separate from James's activities which carried his political work and his thought from continent to continent, working class to peasant villager to woman oppressed. Seen retrospectively, his insights fell into place one after the other. His search was no mere aesthetic philosophizing but the almost desperate effort to replace the fragmenting principles of Marxist economism (even, albeit unconsciously, his own Marxist economism) with more appropriate ones. The renascent artist in C.L.R. James of the 1950s–60s invites, then, a study in the search for new grounds, as daring as his philosophical–intellectual rebellion during the 1940s from Marxism's traditions. James conceived and carried out the newer tasks differently, facing different obstacles along the way.

Post-Bolshevik Culture

A Johnson–Forest activist, in an internal communication of 1947, recalled proudly that 'we were made to look at the smallest signs, as well as at large actions, among the workers and were taught to interpret them in terms of Marxism. We were made to learn the importance of reading the fundamental writings of our movement and interpret them in our day to day activity.'[3] That command captured a working-class reality proto-political in times of high mobilization, but increasingly cultural during times of demobilization. While continually raising the *possibility* of a sudden transformation, James and his followers spoke increasingly of the day-to-day life which made the redemption of Cold War society ultimately inevitable. They dressed the culture critique in economism, but they had definitely placed it upon the theoretical agenda.

This was by no means a singular gesture. Indeed, a generation of radical intellectuals in the USA and elsewhere used culture as the means to advance their aims and to provide themselves a forum for expression (also, in many cases, to manage a personal livelihood). One wing of erstwhile American Trotskyists became the philosophical guides of a revived literary gentility, by way of the *Partisan Review* and the college English Departments. A parallel sector of Communists, ensconced in the film industry until the Hollywood Blacklist, managed to leave their impression upon liberal cinema and even upon social-minded television. But it is hard to imagine how James, had he not been excluded from America, could have taken either part.

His indirect work remained, instead, tied to his political entity. His

Johnson–Forest Tendency, repudiating the concept of the political vanguard but searching no less fervently for an equivalent strategic conception, plunged into its own publication and mass work at a most unpropitious moment: 1951. Labour bureaucratization had been firmly secured, in ostensibly democratic unions (such as the United Auto Workers) no less than blatantly undemocratic ones like the United Steel Workers. The persecution of Communists by deportations, firings and massive infiltration itself soon became popular culture in the television series *I Led Three Lives* (for the FBI). The Korean War proved unpopular, but protesters faced physical threats from the government 'investigation', harassment and (for immigrants) potential deportation. Radicalism on any grounds, Communist or non-Communist, had become a risky proposition.

Moreover, and perhaps more important, the consumer economy had apparently stabilized. Not until 1957 would recession strike again; restrained by military Keynesianism, the much-feared slump of the economy to depression levels never arrived. Fred Wright, American labour's foremost cartoonist, put away the muscled proletarians and the benighted Henry Dubbs (symbol of the anti-union ignoramus) for the ordinary Joe living an ordinary life tortured by machines gone out of human control and by a boss increasing surplus value incrementally. Harvey Swados, after a tour of work in a factory, wrote *On the Line*, with the protagonist based on James's confidant, autodidact–radical–craftsman Stan Weir, labelled the 'Vanishing American'.

At the same time, the 1950s could be an era of personal fulfilment and individual creativity for blue collar, especially white Americans. Pay was good and steady, the countryside still untouched by the debauched standard of later decades and yet accessible via an ordinary family's automobile. Culturally, new hobbies such as photography moved in alongside such surviving ethnic predilections as the polka or Yiddish Broadway. Five or fifteen years later, the suburbanization and homogenization of an upward-bound new generation would badly erode the class character of experience; for now, a balance remained. Even television, the ultimate homogenizer, featured important blue-collar and ethnic themes, especially on sitcoms but also in creative drama (such as *Marty*) through the late 1950s. Class tensions had, in essence, been translated into culture.

By the middle 1950s, the intellectuals' dissident slogan of the day had become 'alienation', and if French Existentialists philosophized about it, the American educated masses seemed to make it almost faddishly desirable. The victim, unlike the starveling of the 1930s or the exploited worker of the 1940s, was the white-collar employee materially comfortable but spiritually at loose ends. From the outside, atomic weapons

made all life, all versions of the future, inherently insecure. Intellectuals invented new phrases for the psycho-cultural threat from within, but its significance remained elusive and its cure even more so.

James struggled with all his energies, if ultimately without political success, to reconcile in theory and in practice the contradictions of such a psychological climate. The transition in his ideas did not seem apparent at first. He does not, to this day, recognize any clear turning point. Only in retrospect can we see it clearly.

He had first of all, in a negative sense, no interest in the literary circles around the *Partisan Review*, even in the magazine's salad days. An intellectual based in New York he fancied himself, but not a 'New York Intellectual' in the ambient Jewish upwardly-mobile sense. Neither did he have, in the Trotskyist political press as such, the encouragement for sustained cultural observations. By the mid-1940s, in Manhattan and the Bronx, he lived almost a double life (by no means uncommon on the Left) of *participating* in culture with no direct political application. He devoted much private time to conversation about popular culture, no small amount of it urging his followers to take the subject more seriously.

He expressed this yearning best, or at least left behind the best evidence, through his romantic pursuit of Constance Webb. In letters running many pages, James sought to guide the young woman's appreciation of art – from the theatre to films to music – and to interpret his own commitments. He had made up his own mind to be political, and felt no recriminations: 'A fine sight I would have been,' he wrote, 'with two or three books or a play or two to my credit and hanging around the political world, as these other writers do, treating as amateurs, what is the most serious business in the world today.' But that decision did not mean any less commitment to a cultural viewpoint. 'The crudeness and coarseness of the Stalinists' in divining art by its immediate political expression he viewed as having 'wrought an incalculable amount of harm'.[4] A reactionary actor could, in a given instance, make Shakespeare come more alive than could a less skilled radical because of the very complexity of the enterprise. Lines of poetry, especially Shakespeare, he quoted to her as evidence both of creative energy and expression of a certain feeling in a certain age. For himself, he could go on watching Shakespeare, even when (as in a current production in New York with Paul Robeson as Othello) the acting seemed too self-consciously theatrical and so unlike the British ease at making the Bard come alive again. But he did not exclude the popular arts, which he regarded as a major element of his initiation into American life. In Europe, he treasured René Claire; in New York, *The Glass Key*, Dashiell Hammett's novel brought to the screen with Alan Ladd as the

detective, seemed to him more vital and more fascinating. He spent endless hours at the movies, as a release from his own intense intellectual work.[5]

He found another mode of artistic expression in the sly sense of humour which played a role in his fiction but almost never reappeared in his prose. Looking back upon his philosophical struggles, he recalled his 'first break with rationalism' in Bergson, who used as his example of the non-rational the widespread popular desire to see 'a well-dressed man slipping on a banana peel', which is to say, to see 'the snob and aristocrat humbled'.[6] Humour had the power of evoking deeply-held popular emotion, and James fairly worshipped Charlie Chaplin for the ability to express universal feelings through the antics of the Little Tramp. According to his second wife, James even had his own Chaplinesque mannerisms. One day he came across a plastic gold-coloured ring, the kind from Crackerjack boxes, and wore it for weeks, praising it the more as his political comrades pointed out how ugly it was. He had a simple point to make about popular life, and even self-caricature could make it.[7]

Only at one point did he seriously consider re-entering the art world proper. He sketched out, in his correspondence, a historical drama he hoped to write for Black actress Ethel Waters, about Abolitionism and nineteenth-century society. Her character would express the sexual and political tension about to tear America apart in the Civil War. With the encouragement of his friend, Carl Van Vechten (author of the 1920s classic, *Nigger Heaven*), James carried his sixty-page outline to a theatrical agent. The agency wanted a finished play and nothing came of the matter.[8]

James meanwhile found himself drawn to a Harlem far more the mixing point of Black and white than it would be later. He spent time in the famous Apollo Theatre on 125th Street, watching and listening to performer and audience and the nonchalant mixing of races on stage. In this popular art, if not yet in social life, racial-ethnic detente could be reached. He went to dances, not participating himself but watching and listening sharply. He would even attend church, fascinated by the passion of the choral singing. He revelled in the spontaneity of musical expression, the interrelationship here, too, between performer and audience.

For him it posed a serious political question. 'I know that I said on one or two occasions, all the power is hidden in them there, it's waiting to come out, and the day when it comes out and takes a political form, it is going to shake this nation as nothing before has shaken it,' he recalled. It brought to mind DuBois's famous phrase about the Black surge toward equality: 'this is the last great battle of the West'.[9] James's effort with

Richard Wright and a circle of other prominent Black intellectuals to launch a publication was no accident. He lacked the means, but he sought urgently some grounds for political intervention.

The same James would just as easily (although not the same degree of pleasure) stop off for coffee in the New School with Theodor Adorno and the Frankfurt School exiles. They hardly knew what to make of the Black man who shared their enthusiasm for Hegel. He found them interesting, but by no means compelling. They dwelt upon the collapse of the West. James sought the fragments of redemption.

Mariners, Renegades and Castaways: The Story of Herman Melville and the World We Live In (1953) was the only fruit of this rumination to reach public consumption, and not much public consumption at that. By the early 1950s James faced imminent expulsion from the United States, charged with passport violations, and he used public lectures on the subject to establish his claim to legitimacy. Out of the lectures and his larger studies grew the book. Published in a small edition (most of the copies reclaimed by the printer for non-payment), it went out to every Congressman but to scarcely anyone else. For the first time in more than a decade, he had written for an audience outside Trotskyism. But paradoxically *Mariners, Renegades and Castaways*, with its odd psychological contours and political shadings, may be in some ways the least representative of his major works.

Mariners argued most successfully (and uniquely, for decades of future Melville scholarship) that the greatest of American authors had seen the industrial revolution in nucleus, from the bulkhead to the topsail. The whaleship hides a factory, James tells us, and Melville's key purpose has been to present a panorama of labour down through the ages – while showing us very concretely what modern industry does. *Moby Dick* turns on this point because here 'everyone is shown for what he is'. At first glance, the workplace is a hell hole, 'symbolization of men turned into devils, of an industrial civilization on fire and plunging blindly into darkness' – the world of Pittsburgh and Hiroshima that the industrial-autocratic Ahabs will either successfully bring under control, or seek to destroy. At second glance, the crew is collectively (as a class) 'indestructible', laughing at their terrible fate like some characters in a Bruce Springsteen–New Jersey post-industrial recollection.[10]

Here, then, we also see class struggle in nucleus, with all the cultural-psychological sidelights and with all the potentials for mutual destruction which the nineteenth-century Marxists did not foresee as accurately as the novelist. No one but Melville, James emphasizes, anticipated that the executives of the ruling class would themselves go mad. Ahab represents the now well-documented crisis which the damaged vessel of civilization brings upon its self-proud captains. Himself struck by lightning,

symbolizing the power of the emerging mechanical order, Ahab has lost the old faith in deity-blessed 'progress', and has come to view the universe as a mere reflection of his empty self. (Thirty years later, Wilson Harris would comment that James had also seen the racial dimension, the racist self-obsession which blinds the bearer to the subordinate, non-white Other.)[11] In a fine phrase, James calls the emptiness 'abstract intellect ... abstract technology, ... blank, serving no human purpose but merely the abstract purpose'. Ahab cannot possibly see the solution in the social relations of ordinary people, least of all the ones he commands. He can only imagine himself corrupting and manipulating the 'manufactured men' who serve him.[12]

When he suffers some terrible shock, James says, Ahab is going to throw aside all the restraints civilization has imposed upon the race. The white whale precipitates the personal crisis and completes the Ahab character who James considers the foremost literary creation of the nineteenth century. We might today quibble with this conclusion. Female protagonists of contemporary gender-conscious novels, not just of literary classics but of the pulps also, can be just as predictive for modern society and just as real in themselves. James indeed allows in the preface to the 1985 edition that feminist critics have opened his eyes to seeing literature afresh.

Against the civilized monsters, James places the crew, a veritable Anacharsis Clootz (a name Melville took from a particularly fervent egalitarian figure in the French Revolution) deputation of Third World proletarians. They are Melville's own chief source of understanding about the world ('a whaleship was my Yale college and my Harvard'): he learned life in Nature and life in society through them and their rough ways. Like the South Sea islanders who provide Melville with ammunition to attack corrupt American capitalism, they act with apparently spontaneous grace. But the crewmen have already entered history, they understand instinctively the emerging industrial order that neither Quaker capitalist nor radical critics can perceive in the same way. If the essence of Marxism is the self-conscious awareness of the socialization of labour, they are (though James doesn't put it this way) the nation's first proto-Marxists.

The analysis so far would have made Melville the chief proto-socialist critic and far-sighted intellectual of an America which has always wanted to assimilate him as seafaring existentialist. After analysing *Moby Dick*, James shows the author struggling with political material and artistic themes, seeking to make real sense of the great social changes at hand. Other contemporary observers saw the malaise, and wondered that a democratic republic could promote such widespread disaffection. James's Melville lacked solutions, but he saw the problem

intimately. The very physicality of sports critic James's reading continues to stand out against interpretations which make out Ahab as Melville in disguise, the grand glorious figure defying the gods, and the ship's journey no more than a metaphysical phantom. The economic observation, made in the light of the CIO, banishes aesthete abstraction.[13]

But the strains of the early 1950s showed peculiarly in James's analysis. He obviously had to deal with Ishmael, the intellectual of the novel. If James's recognition of Stalinism as an objective phenomenon was one side to his critique of corrupted Marxism, his understanding of the Communist intellectual was the other and far less adequate side. Although he had written little on the subject of psychology earlier, James had been struck by the neurosis of the Left intellectual – so apparently unlike his own organically developed self. As a sidelight to the main story, he interpreted the fate of *Pierre's* protagonist as the collapse of the American cerebral type who suddenly recognizes himself as alone and terrified in a society lacking guidelines. Pierre predicts, for James, the modern psychoanalytic patient (in private James tended to consider *all* politicized American intellectuals he met as potential neurotics: on meeting them, he recalls that he used to ask who their analyst was, which greeting would either expose their basic insecurity or get past the formalities to the beginning of a lasting friendship) who cannot comprehend the consequences of the social changes around him.

He saw this phenomenon from a strange standpoint. A Black, Americanized Marxist intellectual, he had never himself become 'Black', in the American cultural sense, nor anything like an American intellectual. He often reflected, in private letters, that American thinkers had failed terribly to convey the spirit of the masses, and the proletarian movement would have to create culture for itself and for society. From his limited perspective, the Communist movement had only intensified the problem, corrupting and confusing the frail alternatives to aesthete and upper-class culture.[14]

James had, then, little empathy and less appreciation of the Left-leaning intellectuals and artists from the early years of the century until his day. Socialists Jack London, Theodore Dreiser, Upton Sinclair and Floyd Dell, to name only a few, or Communists or near-Communists like Dashiell Hammett, Clifford Odets, Woody Guthrie, Moses Asch (father of Folkways Records) and Nelson Algren among a multitude of folksingers, playwrights, screenwriters and others – these James seemingly brushed aside as unworthy of the tasks at hand. In so doing, he ignored the specific history of creative effort and, more important, the complexity of the problems that destroyed most of them politically or artistically after flashes of brilliance. A man mature in life, James wrote like a young ultra-radical intellectual who had just discovered the

ignominy of American Marxist history, and who believed he and his co-thinkers could, if permitted, easily make things right.

From another and less intellectual perspective, James also missed the pathos of contemporary Left politics. The ordinary American Communist, working-class immigrant or lower-middle-class child of immigrants, suffered humiliation in American society akin in character if not quality to the humiliation of Afro-Americans. He or she found in Communism (as did notable Black trade unionists, intellectuals and creative artists) a psychological compensation. Like religion, it gave the bearer solace and strength. Moreover, such individuals had by the early 1950s made very real gains for their groups through activities in and around the Left. Now mostly in middle life, they endured the harsh charges of disloyalty, and they confronted in political life the dread charisma of American military men such as General Douglas MacArthur and the witch-hunting political supporters of Senator Joseph McCarthy. Meanwhile, a mini-generation of young radicals, terrified by the spectre of the Cold War, had mostly rallied on campuses to the Henry Wallace campaign, thence into civil rights or cultural activities. Few of them remained within the Communist movement, but many carried positive traces of their political socialization into lifetimes of creativity and commitment.

James, the very private Bolshevik, had great trouble with his own legal status – he suffered continual harassment from the FBI in the last months before his confinement to Ellis Island. Not even this level of unpleasantness equalled the climate experienced by Communists driven from jobs, spotlighted in the press, and called before Congressional Committees. James had been targeted as an undesirable alien and not a potential Russian spy. From a day-to-day standpoint, Trotskyism and the small group activity permitted him to live the American revolution for the most part vicariously, without contacting any but the smallest fraction of the activists. He had a clear but almost impersonal, artistic view of socialism and American life.

Thus James's strange view of Ishmael. For James, this dissatisfied intellectual predicted the twentieth-century Pierre, making an existential decision to join the working class but without losing his fundamental internal alienation. Rebellious son of the middle class launched upon his own personal avant-garde adventure – like so many real Marxist intellectuals of the twentieth century – Ishmael becomes for James the proto-totalitarian of a generic kind, Nazi or Stalinist. Isolated and bitter as Ahab, he is forced to choose between the masses and the mad bureaucrat. But he is unable to make the right choice. Lost in fruitless abstractions, he fails to grasp the significance of the apparently simple acts by the workmen around him. He chooses instead to disappear, personally,

into the Leader. For James, as for many other observers in 1952, this sort of analysis framed the discussion of the 'authoritarian personality' and of 'totalitarianism' in general. Uniquely for the Left, James located nineteenth-century, Melvillian roots to the phenomenon.

Unlike other more celebrated (and overwhelmingly Jewish) anti-Stalinist cultural critics of the time, James forcefully rejected the Freudian interpretation. Indeed, *Mariners, Renegades and Castaways* contains such an indictment of psychoanalysis that one can hardly understand James's privately expressed respect for psychological investigation. Clearly, the contemporary Freudian cult rubbed him raw. 'What Freud discovered at the turn of the century and thought was eternal human nature,' James says, 'was in reality the reaction of the crisis which now has mankind by the throat upon the middle classes and the intellectuals.'[15] At the time, and even now, this rejoinder must seem reductive of the complexities at hand. But like Mikhail Bakhtin with his polemical *Freudianism: a Marxist Critique*, James sought to offer an all-encompassing alternative which would explain the same level of complexity in other terms. In Bakhtin's world as in James's, the Unconscious is essentially mythic, an unrealized element in consciousness which threatens to claim eternal status for its projections. Id and ego refract social dynamics in the patient's own terms; but only by acting upon the world can he free himself from externally and self-imposed limitations. Better: if Jacques Lacan has improved upon Freud by positing a dialogue between inner and outer self, but describing that dialogue as a source of agony, Bakhtin and James would have said that the *inarticulateness* (along with the real social status of the subject) is the true source of pain. James did not in fact flesh out the argument in *Mariners, Renegades and Castaways*. He probably lacked the conceptual tools. But his writer's instinct took him in the direction of a Bakhtinite view of culture and personality.[16]

In a bizarre conclusion to the original edition, James described his time on Ellis Island, thrust by the authorities into a cell with five American Communist detainees. One of them, a Russian-born Jew, becomes official spokesman for the victimized prisoners, political and apolitical, of the entire jail, intervening to protect young men against abuse and literally salvaging James from the ravages of an ulcer brought on by prison food. James implies that this man, by his apparently benevolent acts, demonstrates the dangers of Communism and the inability of time-serving American government officials to combat it. A part of James's appeal for freedom and citizenship is based, he says, upon his grasp of this very significance.[17]

In this condemnation of an individual, and defence of American society against such individuals, he more nearly approached an apologia for social life under capitalism than at any other time before or since. At

the very least, some element of political logic seems altogether missing here. Could the reckless US accumulation of nuclear weapons in the elusive pursuit of world military superiority *not* be the key contemporary sign under which modern Ahab and Ishmael laboured? Critics of nuclear 'exterminism' and of its machinations at the centre of every American administration since 1945 have subsequently shown what James might have easily pointed out: the most dangerous intellectuals never rebelled at all, never seriously doubted the equation of proliferating weapons with the boom economy and with the perpetuation of the American Way. Neither, of course, have the architects and agents of 'low-intensity' wars involving chemical warfare (a million acres of Vietnam sprayed with Agent Orange herbicides) or virtual genocide against entire populations of indigenous and mestizo Central Americans. More Starbuck or Stubb, mundane ship officers, than the rebellious Ishmael, they have been opportunists, cynics or moral cowards, wilfully blind to the consequences of events around them. Like Ahab's officers, they have monitored the steady and perhaps irreversible momentum toward total annihilation.

The purported rulers of the political domain, American presidents, seem likewise not to have been Ahabs at all but pleasantly dimwitted mediocrities. 'Totalitarianism' from that day to this has been the *deus ex machina* by which criticism is deflected and the critic, Communist or non-Communist, effectively demonized. James did not by any means inform their conception of 'totalitarianism'. He has, in the years since, repeatedly described 'Stalinism' as a phenomenon of Russia and Eastern Europe, not to be confused with social forms, however unpleasant, in the Third World. But his limited concept of it here as a communist-gulag phenomenon contributes to the mystification and also contradicts his contention in earlier analytical works that State control over the economy of Russia and Nazi Germany predicted a *universal* totalitarian trend.

Perhaps James simply lacked the required personal empathy, or knowledge, or perspective in the age of concentration camps. But a different hypothesis may be suggested. In *Notes on Dialectics*, he had brilliantly illuminated the stages of development which found Stalinism and for that matter Trotskyism endorsing the nationalization of property as the equivalent of socialism. He correctly pinpointed bureaucracy as the epitome of the emerging leadership mentality in class societies of all types. ('It is not Stalinism which stifles the revolutionary instincts of the American proletariat,' he and his collaborators wrote upon leaving the Workers Party. 'It is the labor bureaucracy.')[18] He failed, however, to predict the consequences of bureaucracy's victory, the following phase in universal development based in the unanticipated recovery of

capitalism after World War II and in the unanticipated 'liberalization' of the Eastern Bloc which has taken place fitfully since the mid 1950s. This stage reached beyond the old barracks-like Stalinism, and beyond the ageing New Deal state, in a manner and with an intent to bolster up the varieties of existing leadership.

'Market socialism', an innovation of the Yugloslavian Communism that James had condemned as only a refinement of class rule, had become internationally manifest by the 1980s when the original bureaucratic model had failed. Renewing the power of market values from Washington to London to Beijing and even Moscow, apparently eroding state property forms and state regulation and bringing new national players into the game, *de-nationalization* now became the mechanism by which to defuse the restlessness of subjects. Here, in a markedly non-revolutionary situation, James's interpretation of the petty bourgeoisie made considerably more sense.

True to the deeper logic of James and the Workers Party intellectuals, it was culture which came to the fore. In providing an ideological gloss upon the transfer of labour demands from industrial representation to more material goods pure and simple, the rogue intellectuals from the WP milieu helped to place culture upon the block as a key totem of social prestige (and little as they liked to admit it, of sales as well). The rapidly expanding universities brought a greater stake in systems of knowledge, in the Rationalism that James had described, which was now lifted up to the level of high-prestige discourse. Here, centred in the official cultural *doyen* districts of English, Sociology and History departments, Marxism with a reverse twist rapidly achieved national celebrity: a Marxism of the End of Marxism. Meanwhile, the working class at large, which steadily and understandably lost its own identification with organized labour (or even 'labour' in the old sense of physical exertion), eagerly collaborated in the consumption of new technologies. *Notes on Dialectics* here, too, might have been applied to an important development in American aesthetics – but only by subordinating the book's (and James's) particular expectation for the proletariat.

To be sure, neither American high culture any more than labour functionaries nor yet the sagging American working class required the services of erstwhile Trotskyists and their milieu for this great transition. The process surely would have happened if the WP had vaporized with its following into thin air. Yet the prominence of such intellectuals – as of ideological aides-de-camp to extreme Cold War labour functionaries as AFL-CIO presidents George Meany and Lane Kirkland, and teachers' union leader Albert Shanker – cannot be regarded as coincidence. Their shrewd perceptions, based originally in Marxism, prepared them for their future perfidy. By the later 1960s, erstwhile WPers and their

protégés had become chief defenders of 'the West' against student anti-war protests, feminism and Black power. In the name of culture as well as politics, they helped lead the desertion from Democratic peace candidate George McGovern's 1972 campaign to Richard Nixon. Champions of a Jewish and high-culture Reaganism, they became articulate enthusiasts of US actions in Central America. As late as the close of the Reagan Years, the two classics of popular conservative rumination bore their clear stamp. Allan Bloom's *The Closing of the American Mind* (1987) with its imprimatur by WP sympathizer Saul Bellow, and WPer Gertrude Himmelfarb's *The New History and the Old* (1987) sought to purge from pedagogy and scholarship all traces of New Left or egalitarian influence. Such intellectuals and their allies welcomed with open arms and institutional support their own proper descendants, a cadre abandoning New Left origins for the lucrative intellectual slots in the next Cold War crusade. Perhaps James could not have anticipated the importance of his erstwhile comrades in these wide-ranging manoeuvres? To have missed it almost entirely in *Mariners, Renegades and Castaways* can be seen as a political failure; it is surely a cultural limitation as well.[20]

Mariners, Renegades and Castaways must also be interrogated today on a related point, the book's confidence in the sailors' relation to their environment. James himself was, abstractly, on the side of the angels. 'Nature,' he says, 'is not a background to men's activity or something to be conquered and used,' but rather, connected with human society, and human society part of it.[21] We would inevitably ask today, What about the whale point of view? The paintings of the sea-trade disasters, on display at the Whaling Museum in the New Bedford, Massachusetts, depict a terrible crime paid, *by the wrong people*, the workers themselves, for a species of extermination just beginning to take off in Melville's time. Do we still wish the *Pequod* to survive and return to whaling? Or do we breathe a pained sigh of relief at the removal of one more energetic killer, and feel perverse gratitude that Ahab has brought it down sooner rather than later? If so, the sickness of intellectuals at the sight of contemporary civilization seems to have contained a larger possibility than James's own confidence in the 'invading socialist society' of Detroit factories.

Such a criticism can be fairly charged with reading back industrial decline and the contemporary scale of environmental brutality into the more innocent 1940s–50s. But James, the least ignorant of Marxists at the scale of colonial bloodshed, seems once more to have displaced the essence of evil from a large field of forces into a narrow source. This suggests a field of error larger than Melville's own more ambiguous and pessimistic treatment. In short, *Mariners* carried essential flaws in its

creation, far more even than in James's works written in Trotskyist jargon with a syndicalist industrial vision never to be realized. So badly did James want his American citizenship, so little did he see the fateful consequences of Cold War stretching decades into the future, that again he denied the implications of his own insights.

Mariners should be seen properly, however, as the published fragment from a larger, unpublished intellectual *oeuvre*. In passing, James brilliantly compares *Moby Dick* to *Prometheus Bound* and *King Lear*. Similar scenes of Man and Nature cut off from civilization reveal in each case the eclipse of a past way of life and the borning of a new one. He puts this analysis somewhat better in private letters. The Greek playwright, he says, 'summed up the transition from blood relation to secular society, the highest point of classical society'. The Bard saw 'the transition to modern individualism'. The American writer confronted the historic moment 'when things, the objective world, capital, become a thing of inscrutable malignity creating desires in man and at the same time ruining him, piling on him *all* the weight of the modern ages'.[22] Shakespeare thus embodied 'both rationalism and a critique of rationalism as inadequate'. He apotheosized the intellectual true to himself. Melville denounced the intellectual, and sought the 'heart', the spontaneous men of the sea.[23] In a recorded lecture decades later, James characterized the archetypal British writer as one who scaled the heights and came down to earth, and his American cousin as one who scaled the heights – and kept on going. A lack of tradition, an absence of solidity, made anything else impossible in the New World.[24] *Mariners* suffers most of all from James's effort to keep the political purposes of the book always at the forefront, with aesthetics. In so doing, he restrains himself from deeper and less optimistic observations of American life and modern civilization at large.

Mariners grew directly out of a work with the tentative or beginning title, 'Notes on American Civilization'. This fragmentary document, unburdened by the necessity of assuming public political postures, dealt with the questions of social crisis, acknowledged and unacknowledged, as James understood them in the American social order and most especially in American culture. Freedom and civic duty, artistic abstraction and mass cultural expression offer the principal motifs. James grasped again at the sense of ungratified yearning, of depression and spiritual emptiness amid material abundance in the America around him. He intended no civics lesson, no popular culture study and no national aesthetics investigation as such, but the elaboration of a set of themes around which his experience in the country could be rendered into a definitive view of the civilization.

He did not shirk from the darkness in sight. Slavery had wrecked the

ancient world, because the Greeks and Romans could not work out a
system of rights and duties for the ordinary inhabitants. Feudalism had
collapsed at the point where peasants' institutions and artisan guilds
could no longer sustain the fabric of society. If a solution could not be
developed to train the personality and potentiality of the masses upon
their daily work of life, inevitably 'the fate of Rome and of medieval
Europe will be our fate'.[25]

To pose that problem, James insisted, demanded an accounting of the
freedom that nineteenth-century Europeans idealized and that their
contemporary Americans (white Americans, at least) *realized*; against
this achievement stood the pervasive but rarely analyzed pessimism into
which the civilization had subsequently fallen. 'I propose,' James stated,
'to write an essay closer to the spirit and aims of De Tocqueville than any
of the others who have followed him.' To do so, he would consider
popular culture as no American intellectual had considered it, no mere
epiphenomenon but rather the functional equivalent of Greek theatre,
the Russian novel, or oriental philosophy – the expression of civilization,
in other words.[26]

James made great claims for the subject. In past times, one had to
look at the economic, social and ideological currents of an age in general
to get an assessment of mass life. Today the newspaper, film and
popular book, the comic strip, jazz and the like removed the guesswork
from assessing mass consciousness. The mass production of culture met
the needs of the populace which made its choices in life not by the
casting of a ballot but by purchasing of one show ticket (or paperback,
or Sunday newspaper comic section) rather than another. 'The moods,
desires, aspirations, needs, strength and weakness of the nation, as much
by what is included as what is omitted', represented 'the vast successes
of these specifically national productions ... truly universal for our age'.
On the other side of the coin, James saw the isolation and aesthetic
insularity lived and articulated by Melville and Poe down to Heming-
way, Faulkner and Richard Wright. The nineteenth-century writers'
unsuccessful struggles to reconcile themselves with the mass anticipated
the dilemma of European writers at the end of the century and the start
of the next; the business-based American culture of the mid-twentieth
century likewise articulated universal sentiments.[27]

One could *not* find this truth in the formal culture and political
thought in the United States, of that James was convinced. No statesman
since the days of Washington and Jefferson had captured worldwide
attention with his ideas. The founding concepts of national indepen-
dence, life, liberty and the pursuit of happiness had never been dialec-
tically understood, let alone transcended. Not even Walt Whitman,
gifted rebel intuitively in touch with the heart of the American dilemmas,

could build a finished and lasting philosophy equivalent to that of a Matthew Arnold or an Anatole France. 'Conceptual thinking is not the practice in America,' testified James, 'and that is why observers like Sartre who see with the eyes of an artist, note the doubts, the fears, the uncertainty, the terror of the future that are obvious everywhere.' For Americans, even the most creative Americans, the 'contradiction between the individual and universal society' remained insoluble.[28]

For world observers of America, James was fond of saying, the country had two great figures: George Washington and Henry Ford. Between the two of them, America had been summed up. The first pointed up the lack of differentiation, the philosophical homogeneity, and therefore rough democracy, of the new country. The second pointed up, at one level, the ultimate consequences for mass production, and at another the potential consequences for the degradation of labour from its erstwhile republican dignity to the forced command of fascist-like controls.

Between these two men stood an eon of mental evolution and devolution, promise and disappointment. Whitman, true to Jefferson in this sense, had (as in *Crossing Brooklyn Ferry*) apotheosized the masses, fusing Nature, humans, present and future generations – but not with himself, despite his desperate striving to do so. 'Free association' could not alone achieve this end, and Whitman's grand dream of America as a nation of equals, of the world like America a world of equals, could only be a fantasy *on the lines proposed.* Whitman discovered in abstracted Science and Industry the lines along which the elusive unity might be achieved. He thereby became, at the end of his life, a virtual publicist for the oligarchy of industrialists rising up to finish off the old democratic ideals. He covered over the reality of the régime with the fancies of individualism.

A century later, the propaganda Cold War America presented to the world still mirrored those Whitmanesque fancies – individualism, free enterprise, science, industry, democracy – but with the content steadily emptied of meaning. Even Whitman's 'body electric' had become the inspiration for advertising deodorants and toothpaste. His Open Road, his freedom's call, was finally to the loose individual, to the bohemian exception, his rebelliousness an individual sentiment despite its heroic character. The end of this road was Existentialism or (as James might have put it) the Beat sentiments of Allen Ginsberg. In James's eyes, Whitman truly and artfully identified himself with some principle in America, above all via free verse; but he had very little new to say within the medium.

The Melville of *Moby Dick* naturally offers the abstract solution to this dilemma, or rather a study of writer and subject poses the abstract

solution. As if drawing upon the themes of his intended theatre piece, James proposed the interrelationship between Blacks and radical journalist–agitators in the Abolitionist movement as symbolic of a concrete solution. While Whitman anticipated the 'loneliness of the American character', while Melville brushed aside slavery and the coming Civil War as too much for him to intelligently encompass, Abolitionists responded to the crisis sweeping America with an international movement for freedom whose widened concept transcended the Constitution and the old racial aristocracy of individualism. They failed to see clearly past the slavery question. But they recognized the extreme radical slave acts – slaves removing *themselves* as property through flight and commanding southern property during the War in the course of what DuBois had labelled the plantation General Strike – to be the salvation of the Republic. For James, these Abolitionists had been as much revolutionaries, in their way, as the Jacobins or the Bolsheviks. Advocates, in effect, of mass revolution at once bourgeois (in fulfilling Northern industrialists aims of defeating Southern agriculture) and permanent (in rousing Blacks and their allies at the centre of American radicalism), they stood at a promontory point vacant for generations afterwards.[29]

The later nineteenth century, whose labour volatility James understood but poorly, seemed an anti-climax to the successful consolidation of industrial capitalism. (Even Populism, which James considered an historic interracial movement of vast significance, escapes his notice here.) The rise of mass production, with Henry Ford's system of labour and accompanying social controls (as in *State Capitalism and World Revolution*), contained for James the nucleus of Permanent Counter-Revolution, an American fascism. But here he considers the bourgeois–utopian vision of the new productive apparatus. The aim of social planners such as Elton Mayo – creation of a durable élite control over the details of the production process – seemed to James both monstrous and, in America, impossible. Americans, with their instinct for individual liberty, would surely resist. But what alternative would they choose? No one knew, least of all themselves.

'The twisted bitterness of the Negro,' James wrote in an inspired phrase, 'is an index of the suppressed angers which permeate the vast majority of the nation.' Racial anger sounded not (contrary to racist propaganda) the music of the jungle, but true 'modern Americanism, a profoundly social passion of frustration and violence', so grotesquely obvious otherwise in film, radio and comic strips. Richard Wright and Chester Himes (known best for his detective novels of Harlem life) had first shown the public the social costs of the suppressed rage; they had not made clear that they spoke for Americans at large.[30]

The most uncertain but also most remarkable sections of 'Notes on American Civilization' addressed the implications of American popular entertainment. Before 1929, the new popular entertainments had been playful and exploratory, like the Keystone Kops of the silent films. The Crash, massive unemployment and lowered expectations changed all that. As James said, the 'bitterness, the violence, the bruality, the sadism simmering in the population, the desire to revenge themselves with their own hands, to get some release for what society had done to them since 1929' – all this found its expression in Dick Tracy, the ordinary guy who went out to fix society himself. The same Depression America devoted itself to James Cagney's gangster portrayals, to the hardboiled detective of Dashiell Hammett and James Cain, to tough characters on both sides of the law whether in films, books or radio drama. All shared a 'similar scorn for the police as the representative of official society'. Sam Spade lived by his own ethics, in warfare with the police and in as much danger from them as from organized crime. The gangster represented the fading American past in which 'energy, determination, bravery were certain to get a man somewhere in the land of opportunity', and which had vanished in real American life; the tough detective articulated the hard truth rendered philosophical. Together, they brought aesthetic compensation for the narrowness of workaday American life, fantasized free individual pitted against free individual.[31]

James strove to bring his themes together. If American culture could be described as theatre, *Moby Dick* was in essence a scenario 'closest to the spirit of the tragedy of Aeschylus as anything written in the nineteenth and twentieth century'. If as film, then Charles Chaplin captured the comic reality born of the age of modern production. The sheer individuality of the tramp, his extreme idiosyncrasy, showed via the comedic method a desperate yearning for community.

These ideas, roughly presented for rumination and internal discussion, reveal a questioning beyond the limits of the published *Mariners, Renegades and Castaways*. They also reveal otherwise hidden fears that the working class might *not* arrive at the rendezvous of destiny through the commonality of socialized labour. One might say that if *Notes on Dialectics* is the study of petty-bourgeois political counter-revolution, 'Notes on American Civilization' approaches a study of dark-side mass response to civilization's decline. James had reached far, perhaps too far for his own enormous intellectual grasp, and certainly too far for sustained optimism. He once complained to his Johnson–Forest comrades that he found himself writing on American political history when his natural task should have been the British 'Glorious Revolution'. This complaint need not be taken too seriously; James relished his observation of American society. Given time, he would surely have

created a synthesis. But as he revealed when wondering at American comrades – who as they obligingly sought to play cricket also denounced the umpire in a most unBritish fashion – James remained the visitor, never destined to shed his Trinidadian and British sensibilities.[32]

'Johnsonism' Winds Down

The trajectory of his collective political work continued the unintended substitution of the aesthetic for the political, until the end of the little Johnson–Forest movement had been reached. Without James on hand (fervent and directive as his letters continued to be for a decade or more), Johnsonism drifted on an uncertain course, sometimes striking out in genuinely new directions, sometimes falling back upon the basic syndicalism of the Trotskyist factory group. Their paper, *Correspondence*, at first a weekly, then semi-monthly and still later a monthly tabloid, sought to straddle these realities and to offer readers their own forum on passing events of the day. It certainly attempted the old message of factory-centred struggle. But as editorial board member Grace Boggs recalls, only a certain type of worker responded. The angry auto worker who spoke through the paper (usually via an amaneusis, in the style James developed in Missouri) was extremely likely to be a Black man who had come into the factory without the full benefits from or nostalgia for the early years of unionism.

When resentment turned into wildcat strikes, *Correspondence* presciently recognized the importance of the struggle. Indeed, the Johnsonites probably recognized and interpreted the importance of the wildcat before any other element of the American Left. Likewise at the level of daily life, *Correspondence* captured the working-class response to *I Love Lucy* or to the World Series better than anyone else on the Left. This accomplishment could be described almost as the mirror opposite of the aesthete, increasingly conservative *Partisan Review*, which had all the national prestige *Correspondence* lacked. (To continue the contrast: members of the *Partisan Review* editorial group signed on with the CIA-linked American Committee for Cultural Freedom, while the Johnsonites took the rap of being officially listed as a subversive organization. This writer, facing the army induction process, compulsively noted his literary appearance in still-proscribed 'Johnsonite' publications. The Army awarded him a reprieve from Vietnam.) But perhaps it is better to see *Correspondence*, by this time, as essentially a gaze at the hidden worlds of Detroit's boom years.[33]

James and his fellow leaders affixed upon this journalism a rather mechanical political structure and an increasingly doubtful teleology. He

was to say later that the group knew what it did not want — another version of Vanguardism — but it could not develop what it wanted instead. The very title had come from a 1920s Comintern experiment, 'Correspondence', intended to mobilize worker–writers from the depths of proletarian life. The experience had not been particularly successful at the time, and faced the same problems thirty years later. Lenin's 1920 distinction of three Bolshevik layers – old Bolsheviks at the first layer, trade unionists at the second layer and the rank-and-file at the third layer – now became the source of an effort in public meetings to subject first and second to the expostulations of the third. At such an apolitical moment as the early 1950s the result increasingly tended toward the rambling and diffuse. Other complaints could also be heard, centring on styles of leadership. Veterans of the group complained later of artificial 'campaigns' created by leaders to generate excitement and of widespread demoralization; of a decentralization into local committees of correspondence that never really emerged, leaving the editorial–political centre in control despite anti-vanguard disclaimers; and most damningly, of the leadership-perpetrated illusion of a self-sustaining publication, with all that implied, when actually the paper scraped by on a hefty financial subsidy. In short, the Johnson–Forest group had been no worse in its personal relations and internal functions than other left-wing organizations, but not much better either.[34]

Perhaps the uncertainty, or the build-up frustrations, or simply James's forced departure, precipitated a major division of forces. Raya Dunayevskaya, chafing at a difference of views over strategies of collective political survival amid McCarthyism, and perhaps chafing at her secondary position in the group as well, departed with roughly half of the little following to establish a rival newspaper (*News and Letters*), an official ideology (later styled 'Marxism–Humanism'), and a demi-organization. More syndicalist and less culturally-inclined, it nonetheless became the most thoroughly feminist-spirited Left tendency until the arrival of the Women's Liberation Movement.[35]

The succeeding James group continued to attempt to listen, as other Left groups now retreating into insularity had never formally set themselves to listen, to the marginal corners of the mass and to the voices long unheard on the Left. A pamphlet such as *Artie Cuts Out* (1953), about a runaway teenager from a blue collar home, might not be a literary classic but it captured something that the sociological studies of restless youth missed entirely: the subjectivity dramatized by *Rebel Without a Cause* and experienced by the runaways themselves as a new sense of renegation from American society. *A Woman's Place* (1953) offered a stunning statement of equivalent alienation, fifteen years ahead of its time.

According to a young activist on the group's margins, the group evolved over the 1950s into a politically marginal but personally and intellectually helpful educational circle. In public lectures and personal contacts, its leaders would urge upon the next generation of emerging local militants an appealing internationalism, a non-dogmatic Marxism and a keen understanding of race-class dynamics. Toward the end of the 1960s, they would make a crucial contribution to the Marxist training of the League of Revolutionary Black Workers' leaders at the apex of an important class–race fusion. In the meantime, they impressed upon their listeners the Jamesian lessons of personal development, understanding of culture, and faith in the undying potentiality of mass movements across the world.[36]

One last political event, the Hungarian Revolution, buoyed the group's optimism and its collective intellectual vigour. *Facing Reality* (1958) sought to depict that volcanic event, with its spontaneous workers' councils and its political aftershocks throughout the Eastern bloc, as proof incarnate of the new society seeking to overcome the bankrupt old one. This text approached as close as James ever came to an anarchist philosophy, in direct confrontation with the ominous strength of the State; it also unmistakably entered the syndicalist tradition by its definition of self-directed workplace groups as the essential lever for wholesale social change. But *Facing Reality* must be regarded as most eloquent in its mordant prediction of collapse for the official order:

> Rulers of states can no longer think in any sane, constructive way. Forty years of continuous violence and bloody destruction organized by the state have taken their toll. A whole generation of men of state have been reared and matured in violence and blood.... Perhaps the greatest damage that has yet been done is the eating away of our consciousness of ourselves as civilized human beings. It is already incalculable and cannot but increase.... Official society is not in decline. As civilization, as culture, as reason, as morals, it is already dead. The need to prepare for universal destruction, to scream the threat, to be unhappy unless balancing on the brink, this is no longer politics, defense or attack. These are the deep inner compulsions of a society that has outlived itself, swept along by mechanical forces it cannot control, dreading and yet half-hoping that one climactic clash may give the opportunity to start afresh.[37]

What could bring salvation rather than disaster? *Facing Reality* offered an almost eclectic series of positive prospects alongside the potential workers' councils: the American Negro masses, Third World peoples struggling for national independence, white-collar workers, and (if they could unlearn their stubborn Vanguard assumptions) political

intellectuals. These views seemed as yet, however, couched in imprecise formulations.

Facing Reality offered its clearest perspectives on the decay of the old Marxist organization and the necessity for a new style. All the previous Marxist formulations, the document insisted, had led to the conclusion that the *organization* and not the masses it purportedly served was the true subject and *élan vital* of history. Today, the Marxist organization had the task instead of providing and coordinating necessary inform-ation. It would develop a view of its own making, a fusion of intellectual and working-class understanding which threw off the dead weight of the old socialist ideology, bringing all the best prospects of contemporary culture for 'a new totality, a new vision of the world, and of humanized relations throughout the length and breadth of society'. Lessons drawn from current practice across the world, where similar groups (such as the French *Socialisme ou Barbarie*) and formations (such as the British shop stewards) had made beginning efforts, pointed to the prospect of a fresh start in elementary democracy along the lines of what the Hungarians had, however briefly, achieved.[38]

Of course, the proposed 'independent editorial groups' of workers and intellectuals had an uphill climb further, relative to the mass media, than any previous generation of Left publicizers. And the validity of *Facing Reality* depended upon the persistence of shopfloor resistance, as well as the recurrence of a Hungary-like phenomenon. James and his collaborators may very well have predicted Polish Solidarity a quarter-century before its arrival; certainly, the mass-mobilization origins and the form that the action took more nearly resembled the projects of *Facing Reality* than any traditional Left perspective. Too much else would happen in the meantime, however, and by the time such events began to take place, *Facing Reality* had become a historic document, more culturally important in its prediction of democracy's human basis than politically or economically in its strategic proposals. The 'Johnson-ites' would not succeed again in producing a comprehensive public worldview.

Correspondence itself continued in a downward slide. With the early 1960s rise of what would later be called Black Power, the primary editors of the paper (Grace Lee Boggs and her husband, brilliant auto-didact Black autoworker James Boggs), along with the group's financial angel and several of its most active members, abandoned the group. James issued in pamphlet form a heartfelt personal protest against the 'destruction of a workers' paper'.[39] Ironically, James Boggs (who would publish his fullest statement as *The American Revolution: Pages from a Negro Worker's Notebook*) already reached closer than James's loyal followers to the spirit of the 1960s, when *Correspondence* under the

Boggs' tutelage had one last creative surge – in tune with local Black poets and writers – before crashing upon the shoals of declining energies and political differences.

As the old class struggle wound down, another set of conflicts (albeit more vague and apparently trajectoryless) would arise in their place. James and his followers had been astoundingly prescient in their critique of Marxist group activity; they suffered because, unlike their former comrades gone mainstream to the centres of power, they could not tie their critique to a new form of social activity. The abstraction showed.

A new era of political insularity, and of personal summing-up, meanwhile opened for James. Apart from eighteen months of hectic activity in newly-independent Trinidad, 1958–60, and a flurry of West Indian lecturing before and after, the isolation made possible James's most truly literary period since the later 1930s. Unwontedly, he had become very nearly a full-time critic.

The end of the 1940s found him in an extremely difficult personal situation. He had, from his first days in America, found the American woman symbolic of the freedom in the civilization. He was fascinated (and, in letters to his second wife, wrote an analysis at great lengths) with her unwillingness to submit to the dictation of men, her striving for self-definition and her demand that a mate understand her newly-perceived needs. Yet what he grasped in theory he could not bring alive in practice. His pursuit of Constance Webb became entangled in the political demands upon him, in the admiration of young women for him (according to legend, the front rows of an auditorium would fill with them grabbing the best seats for his lectures), and in the legal confusion of his first marriage. Despite his years of avowals to make good with the second marriage – as token of his Americanization and as his most deep-felt desire in life – the relationship fell apart shortly after its legalization. He lost Webb, and he lost the opportunity to be steadily on hand, raising his son, C.L.R. James, Jr.[40]

In a few years, he remarried once again, this time to Selma Weinstein, a Brooklyn-reared Jewish woman thirty years his junior. Selma James, later a major theoretician-activist of the Women's Liberation Movement in England, would prove the most politically formidable of his romantic alliances. With her, he made a final attempt to revise his outline of American civilization. Perhaps most notable, because most successfully adapted to the changes of capitalism and its prospective opponents, was the growing critique of the Woman Question. The statement argued:

> Though the middle-class woman is brought up in a society where women are relatively free, at every moment, in spite of personal and physical freedom,

she herself is affected by the constant example of traditional feminine be-
havior, the product of past relations of society. She is still educated in the art
of catching a man, and in the art of keeping him, using feminine wiles and
tricks centuries old. This at the same time that her mind and direction are
turned to revolt against any attempt to inhibit or curb her equality or to force
her into a feminine mould. It is therefore not only between herself and her
man that there is a clash. The clash is inside herself, a reflection of the two
societies into which she is born. Just as in the relations between people in the
plant, two conceptions of society, in fact two societies, are at war, in the world
of public affairs as well as in the individual personality.…

These antagonisms have been growing for decades. But here (as in labor
relations) they have reached a climax.[41]

British Culture Magus

This marks a major conceptual change, for 'the worker' now takes on a
gender counterpart in revolutionary transformation. The document, long
unpublished, also advanced the critique of vacuous materialism ('the
American people … fall back on material goods in default of what they
lack eternally and cannot find, some system of values to correspond to
the energy and sense of power given to them by the magnificent terri-
tory, their special historical past, and their mastery of material things') in
the 'higher standard of living' then widely proclaimed the American
antidote to Marxism.[42] James had been thinking, although very differ-
ently in particulars, along these lines since his return to England. In
some ways, his clearest thoughts about America crystallized abroad.

Repatriation also had other ironies. James had appealed, to no one
less than Sir Anthony Eden, for a statement supporting James's fervent
wish to remain in the USA. Eden (or his aides) replied that banishment
to the UK could in no way be considered a punishment. Meanwhile, a
different society had grown out of the wartime experience and the
virtual collapse of the British Empire. The Labour Party had created a
welfare state *par excellence*, and the Empire's non-white subjects began
to come 'home' (just in time, of course, to meet a labour shortage) in
substantial numbers. The society seemed somehow smaller than before,
but also more pluralist and less absolutely class-bound. The Left, even
the Trotskyist and anti-colonialist (now anti-imperialist) movements,
had grown beyond the scale of James's former participation. Apart from
a political contact here and there (as in the Solidarity group, a sort of
British *Socialisme ou Barbarie*), he lacked natural allies. Not even when
substantial new radical movements, such as the Campaign for Nuclear
Disarmament, crystallized in a few years, did he take part. He had
enormous difficulty, as his friend George Lamming has recently

reflected, in joining a movement from anywhere but the top – in this circumstance clearly impossible. He had been practically forgotten in twenty years. Soon, he would create an educational circle in the West Indian community. For now, he fell into an uncharacteristic period of depression, reputedly reinforced with heavy drinking. He sought openings.[43]

He began to attend cricket matches, no longer the youngish Bolshevik earning a living as he had been on his departure but rather the middle-aged philosopher with a mind to reformulate large elements of theory via the experience of his own life. He had, of course, followed the sport through the international press and such specialized sources as *Wisden's Almanack* even while devoting his actual sporting attendance to American baseball games, especially in the first years of the sport's racial integration, when he went to see the brilliant Black centrefielder for the New York Giants, Willie Mays. James soon finished with cricket reportage as such, after one season more of writing for the *Manchester Guardian*. But he rapidly began to see that another task awaited.

As ever, he had a brilliant and studied eye for the detail. He toyed, for instance, with the notion that off-side hitting on the pre-1914 model had returned, perhaps one omen of a general decline. The fielding, now more flashy, lacked the familiar substance. The crowds cheered more but knew less than of old, and the pressure of publicity's glare had become felt on all sides. For many other seasoned observers, such changes induced a general depression and extreme nostalgia. Not James. Aware of the dangers involved, he found in the newly self-conscious public role of players and media workers a source of added fascination. He therefore concentrated, to an unfamiliar degree, upon the broadly political controversies of the time, such as the suspension of a West Indian cricketer on tour for supposed misbehaviour (he blamed management) or the question of South Africans touring the West Indies (he favoured the athletes' international participation over boycott). He also began, albeit indirectly with praise of the Pakistanis, to concentrate upon the theme of cricket and Third World nationhood.[44]

He had been struck, as historian, with the return of sports mania in the industrial nineteenth century, some fifteen hundred years after the lapse of the Greek Olympic games. Golf, football, tennis, American baseball and many other sports offered examples. He might well have taken up soccer, similarly British in origin but universal in scope. Cricket, however, was *his* game. The questions it raised brought to mind simultaneously the greatest social questions and the intimate details of his early life:

There had been a time when I took the world for granted. What had I wanted

then? I believed that if when I left school I had gone into the society of Ancient Greece I would have been more at home than I had been since. It was a fantasy, but for me it had meaning. The world we lived in, and Ancient Greece. If I had been French or German or African I would have thought differently. But I was British, I knew best the British way of life, not merely in historical facts but in the instinctive responses. I had acquired them in childhood and, without these, facts are merely figures. In the intervals of my busy days and nights I pondered and read and looked about me and pondered and read again. Sport and politics in Ancient Greece. Sport and politics in nineteenth-century Britain. Over the second half of the nineteenth century, sparking the great international movement, drawing all eyes to it, startling millions who otherwise would have taken no notice, creating the myth and the legend, there began to loom the gigantic black-bearded figure of W.G. Grace. All my half-forgotten past in Trinidad, and now my probing into what men live by, had sensitized me to see cricket with fresh eyes as soon as I had begun to think for myself about it.[45]

Through this optic he could reconsider the Greek society that so fascinated him (in 1952 his group had published *Every Cook Can Govern*, James's somewhat speculative treatment of direct democracy in the ancient world), and say something that had not been said about popular participation. The Olympiad was, for him, the origin of philosophy about sports ('One can only envy the Greeks their freedom from intellectual snobbery,' he added in an aside) and also the occasion for convoking the assemblies which would lead at last to Greek theatre. Created by aristocrats, it helped pave the way for democracy and great art.[46]

Through the same optic, he could reconsider pre-Victorian Britain as the last expression of full-blooded pre-industrial life (so much like the Trinidad of his origins) and the seed-bed of popular sport. The Age of Hazlitt saw the traditional amalgamation of rich and poor, rural aristocracy and artisan, aroused (before the ascendance of the middle-class heirs to cricket) one final time by the new pace of life. Thomas Arnold set the essentially conservative task of sports as the moral realization of the bourgeoisie, Hughes devised a liberal philosophy of athletics, and W.G. was himself embodiment of that most dignified and ballet-like game. W.G. broke records, showed a stamina almost beyond belief, and fashioned through play both technique and public approbation. For James, he became the representative pre-Victorian, less inhibited than players would be for many generations, yet (James surmised) also scrupulously fair in the Victorian sense. With his ultimate triumph, the hundredth career century in 1895, the world-historic cricketer evoked an enthusiasm which transcended all national divisions.

James's portrayal of subsequent cricket is the heart of his political

analysis, and perhaps the most concrete point he has reached in his analysis of the human possibility under socialism. World War I had accelerated a decline of national spiritual energy and a consequent penchant for mean and even dishonest tactics, he opined. The Second World War, with its mass mobilization in the name of democracy, marked only a respite from this continuous decay. Security, James insisted, had become the natural sporting style of the fearful Atomic Age.

But this very decline pointed up two essentials. First, the West Indian cricketers, playing with the ambiance of the Gold Age, found a home crowd explosive with emotions captured in the action at the pitch. The struggle for a Black team captain meant the coming of age of Trinidad, and Garfield Sobers's performance in Australia brought international recognition of that fact. Cricket would continue to develop, if not necessarily on British soil, as an expression for ordinary genius.

Second and in a theoretical sense, the very eclipse of actual British cricket greatness *raised* aesthetic and philosophical questions which can be understood only (as Hegel says) upon the day after the heroic moment. James confronted the unwillingness of the other critics, notably Neville Cardus, to designate cricket a fully-fledged art form equal to theatre, opera and dance. To this claim James added a populist amendment: 'What matters in cricket, as in all the arts, is not the finer points but what everyone with some knowledge of the elements can see and feel.'[47] It embodied the elemental human movement which, far from a weakness, constituted the basis and the source of renewal for all arts.

The *visualness* of cricket James put forth as the ultimate proof. To this he applied the interpretation of Italian Renaissance painters by Bernhard Berenson: the essence of art is *movement*, which cricket recorded (James noted) by repetition rather than the final stroke of the painting or frieze. The aesthetic response to such movement could be found alike in children or in ancient pre-civilization, so much did it express basic brain function. The ascendance of the organized game followed the decline of church walls and public monuments as mirror of popular enthusiasm; nothing else (James hinted) so combined the spiritual and the secular art in modern times. 'An artistic, a social event does not reflect the age,' James would write decades later in the anthology of his cricket writings: 'It is the age.'[48]

Sylvia Wynter, distinguished West Indian literary scholar, insists that James has done more than recall the ancient legacy of sport and place modern sport in a social context. Methodologically, *Beyond a Boundary* breaks with the bourgeois aesthetic rooted in production, and sets out the only possible alternative. As James's cricketers struggled to realize themselves on the pitch, they reached toward an autonomy and a

'radical historicity' triumphing over the limits society and history had thus far imposed. James had shown the evolution of that desire, and its concrete expression, through Western history. By indicating precisely what the crowd yearned for and roared for, James indicated the path by which the disguised processes of emancipation might be traced.[49]

In an odd way, the analysis of the 'straight bat' and the almost excruciatingly genteel demeanour of the cricketer had permitted James the untrammeled freedom of intellectual motion to encourage the seemingly opposite tendency of literary modernism. George Lamming has suggested to me that James's sense of mass consciousness encouraged the break-up of the major character into a field of consciousness. *Season of Adventure*, Lamming's novel of Third World revolt stirred by the sounding of the drums, seems at first glance a galaxy away from the cricket pitch. But here, too, as in Wynter's formula, the logic of production ceases to fetter the actors and desire takes hold.[50]

At any rate, the ruminations in *Beyond a Boundary* made James's life whole, despite manifest political and personal disappointments. His return to Britain in the early 1950s charted his path downward in an immediate personal sense. His stay in Trinidad, described below, was far from successful in outcome. His third marriage was fraught with problems, used as literary material by his friend George Lamming in the novel *Natives of My Person*. Lamming encapsulated the relationship as James's continued inability to stay within the boundaries of household sensibility, even to grasp them, and of female (proto-feminist) resignation, rage and ultimate separation from the hapless adventurer. After the age of 60 he had great difficulty recovering from an automobile accident in Jamaica. He has remained rail-thin ever since. A tendency towards palsy now also became almost overwhelming, making the very act of eating (or, as a lecturer, holding his notes) difficult.[51]

And yet this was the James – when social historian George Rawick came to spend considerable time with him in 1962 – who could be found at seemingly endless (both in linear time and in number) cricket matches or at the social gatherings of West Indian markets in London, putting small bets on horse races and playing the slot machines casually in the pubs. And this was the James who, Rawick recalls, carried postcard prints of Picasso's *Guernica* so he could study them at odd moments between overs or waiting at a tube stop. The reception of *Beyond a Boundary* had been most gratifying, the best by far of any book since *The Black Jacobins*. (The American reception, just as glowing, would come almost a quarter-century later.)[52]

He had become a cultural *magus*. He kept company, in London of the 1960s, with some of the outstanding Caribbean personalities of the

day, including Lamming, V.S. Naipaul and Wilson Harris. Now, armed with cultural theory, he would make a triumphant re-entry on to the ground of Third World culture and politics whose way forward he had prepared decades before.

5

Pan-African Eminence
Grise

'I sometimes speak these days about Black Power,' James told an audience in Ladbroke Grove, London, in 1971,

> with great emphasis on the tremendous work that black people are doing everywhere to change this old society. And sometimes some of my old friends tell me when I have finished, 'But James, you have left out the proletariat.' I say, 'But for God's sake, I have been talking about the proletariat since 1935. You mean I cannot make a speech in 1969 and take it for granted that you know I am still a man of the proletariat?' So they go away appeased. I hope ...[1]

James had completed his transition from American Leninist (or post-Leninist) to magnum culture critic with confidence and grace, no doubt because his favourite subject had become that of every great writer: himself. He simultaneously embarked upon another, more perilous theoretical and strategic journey. Political commentator, mentor and guide to the modern Pan-African movement, he now placed his faith in the sudden awakening on both sides of the Atlantic. And on what that awakening might mean for the West as a whole.

He developed a remarkably personal approach to the earth-shaking events. A thinker with a floating centre, he had anticipated by at least a half-century the 'de-centring' of world culture from the West. By making sense of where he had come from, of what values he held dear, he managed to embrace the new developments theoretically and artistically, if not always practically. He saw them as the fulfilment of earlier phases in which he had shared the stage with other pioneers. At rare moments of synthesis, James the Pan-African and the culture critic became one and the same, the veteran thinker intellectually armed for the vast shifts in world culture. At some of the very same moments, an

awkward silence appeared to descend upon that subdivision of his life and work heretofore governed by the concerns of the Western industrial working class.

James's role, always wide-ranging, seemed suddenly to multiply once more. A recognized if generally distant adviser to Nkrumah, a would-be mover of Pan-African Congresses, he served as editor of the Trinidadian independence government's weekly press and spokesman for West Indian federation. As if that all were not enough, he became a most prominent lecturer to young radicals on campuses from Ghana to England to the USA and the Caribbean. James appeared at times on the verge of exerting a crucial influence. Rightly or wrongly, he thought so himself during the high days of the Non-Aligned Movement. The turn of events marginalized him politically again. But not without leaving his mark behind, in an amazing variety of contexts.

Perhaps the newer revolutionary movements were too chaotic and short-lived for his influence to take hold decisively. Perhaps (as James's correspondence with Stokely Carmichael suggested) the generational difference simply loomed too large, his own Pan-Africanism already part of a bygone era. Perhaps – as in the case of his political influence over Dr Eric Williams – he deceived himself in the power of ideas. Certainly his conception of modern politics as a civic exercise taking up where the Greek City States left off had little realistic relation to the troubled context of Third World national liberation. James's penchant to enter movements at the top level, moreover, disadvantaged him from coming to terms with the rough-and-tumble. Age and health setbacks later finalized his status as teacher rather than activist.

Or perhaps, especially outside the Caribbean, James *chose* to exert his energies not as a political leader or prophet but in a somewhat modest and distanced fashion. He emerged triumphantly as something that the newer social movements also desperately needed, a revolutionary man of letters. Along with a mere handful of elder guides, he joined the young rebels heart and soul. He therefore responded sharply, in his talks of the late 1960s and early 1970s, to public complaints against the new movements, as against the purported racism of Black Power slogans in 1967:

It is over one hundred years since the abolition of slavery. The Negro people in the United States have taken plenty and they have reached a stage where they have decided that they are not going to take any more. Who are we to stand, or rather to sit in judgment over what they decide to do or what they decide not to do? I want to take in particular Mr Rap Brown, who makes the most challenging statements, is prepared to challenge American racial prejudice to the utmost limit of his strength and the strength of the Negroes who

will follow him. Who are we to say, 'Yes, you are entitled to say this but not to say that; you are entitled to do this but not to do that'? If we know the realities of Negro oppression in the USA (and if we don't we should keep our mouths shut until we do), then we should guide ourselves by a West Indian expression which I recommend to you: *what he do, he well do.* Let me repeat that: what the American Negroes do is, as far as we are concerned, well done. They will take their chances, they will risk their liberty, they will risk their lives if need be. *The decisions are theirs.*[2]

Not that James considered the judgement of Black intellectuals, historians in particular, above reproach. His own job was to educate, especially about the history of Black people within world history, and he spoke, for the better part of a decade, more often and in more places than his health should have allowed. He might be mistaken in political particulars. But as a teacher, he knew that the time for that educational work had come.

So with the exception of Trinidad, and there for only a few years, he trusted the lecturer–writer–philosopher in himself. A more wilful and determined James might possibly (he suggested slyly to me) even have become, given enough time and luck, the leader of a Caribbean federation. To do so, however, he would have had to confront the odds which overwhelmed revolutionary movements across the world and dragged revolutions down into bureaucratic wrangling for foreign aid to palliate and for military hardware to put down their own post-independence populations. Besides, James the internationalist and Marxist, cosmopolitan and artist, had another foot abroad, in the West, at all times.

The mechanism James proposed for the Third World, the creation of an effective and democratic mass party, seemed at first glance to confound his philosophical labours of the past decade, untangling the revolutionary prospects from the vanguard. In part, the difference could be found in the differing nature of the societies at hand: without an educational mechanism, formerly colonial peoples could not step forward into modern life or deal with the treacherous schemes of the two super-powers. This conclusion, which James did not bother to draw himself but left his admirers to interpret, disguised another.

Despite certain denials and restatements, James had shifted the burden of world-revolutionary momentum in the contemporary era from West and East to the Third World, his banner from the old red flag of Marx and Lenin to the 'banner which the twentieth century will need in the great efforts . . . to overcome the crisis that imperialist domination has imposed upon the whole world. Not only upon the Third.'[3] He had therefore, implicitly and sometimes explicitly, placed more immediate hope in the peasantry and its political representatives than at any

previous time in his long political life. Within the Third World, Pan African forces loomed largest for him.

He had, in the trajectory of his own ideas, come as close to repudiating Trotskyism's Eurocentric legacy as he ever would. (Ironically, so did many varieties of doggedly loyal Trotskyists.) From that viewpoint, he would judge his former IASFB colleagues Padmore and Kenyatta, his fellow West Indian Frantz Fanon and even Fidel Castro far more favourably than did his trusted colleagues and followers who had graduated out of the Trotskyist movement with their suspicions towards nonproletarians and potential totalitarians intact. He judged the role of the personality, the Third World personality in particular, differently from Marxists still haunted by Stalin's memory. He judged the cultural sources of revolutionary change with eyes they did not, for the most part, have or use. Whether practical political spokesman in the West Indies or visionary for Africa and the USA, he spoke in a language previously unknown to him and his own.

He could be as naïve in this respect, toward the 'guided democracy' of many a Third World leader or political institution, as he had proved to be about the purportedly inevitable advance of the working classes in the 1930s–50s. Especially when he knew contemporary leaders as former pupils, he tended in almost a fatherly way to overlook their faults. These were, for him, the inevitable errors of determinedly optimistic expectation. As he had done earlier, he would correct himself, even return (via his hopes for Polish Solidarity) to the old faith. But never entirely. The West, which he had called upon in *World Revolution* to open the way for true internationalism, had failed to do so time and time again. Now he would make the appeal less regularly: he had other, more pressing details to attend to; the Pan-African struggle could no longer wait for signals from the West.

James might be justly accused of a certain lack of consistency. His shift had its purpose. He relied upon his many varied experiences to draw fresh conclusions. He did not rest upon his laurels, but rather used his historic status to raise discomforting questions of direct democracy – as if the Lenin of 1920–24 lived again and had applied the lessons of Russia worldwide. Simultaneously, he felt moved to sum up the Caribbean spirit in particular. Here, more apparently than anywhere else, culture ruled even when power at times seemingly lay in streets waiting for takers. The sense of process would be the elderly James's great political contribution and his key legacy to the youths who gathered around him.

That said, the *self-presentation* of an elderly James more and more coloured the content of his message. From the middle 1960s, when he spoke increasingly to audiences interested in Black Power and Pan-

African revolution, he portrayed himself as a surviving forefather of the common cause. His decades as Trotskyist and post-Trotskyist seemed to recede into a reservoir of information and insights. His memories of Pan-Africanism's early days and his own early days as mentor, ally and comrade of rising revolutionary or aesthetic leaders became all-pervasive. Even his aesthetics, increasingly important in returning *Beyond a Boundary's* insights to high art such as Shakespeare or Michelangelo, seemed the wisdom of world-old eyes. Not that he shied away from new discoveries, far from it; his curiosity continued to bring him to new theoretical territories which he explored with a rare excitement. But he brought to every subject an intensive feeling for who he was and where he had been.

James began politically, it may be remembered, at the age of thirty-two or so. He had written his first fiction less than a half-dozen years before. Now an astute octogenarian, he has spent a good third of his political life as a living monument of sorts. One could say that he had been born old, child of Thackeray and the Greeks living somehow in the New World of the twentieth century. One could say with no less justice that James's deep sense of history had merged with his lifelong study of the personality, in his own being. No modern political thinker, save perhaps W.E.B. DuBois, would dare claim more.

End of a Political Era

The final disintegration of James's US Marxist following framed, in a certain sense, a decisive reorientation. I asked him the first time I met him in person, during one of his collegiate lecture tours in 1968, why he had kept up the pretence when the reality of the emerging New Left made the groupuscule's lack of wide influence patently obvious. He answered with charcteristic Leninist determination: 'Because people all over world ask me, What is my group?' That was, to put it colourfully, a logic as old and seemingly incongruous as the long underwear he showed embarrassedly when I could not drag the phone all the way to his bedside. Spring had already arrived, and with it a new social movement that made previous ones archaic.

Indeed, although various of James's followers exerted important influence as intellectual or political mentors, their archaism as a political group had long been evident. The brave front of *Facing Reality* notwithstanding, the Hungarian Revolution made no lasting impact upon American working-class life and had no effect upon the Left except to hasten the decline of the Communist Party from organization to sect. The 'independent editorial groups' nowhere came into existence. Those

which existed in a manner of speaking, offshoots from the Old Left such as the French *Socialisme ou Barbarie,* steadily disintegrated. (In the end, *SouB* leader Carlos Castoriadis found himself a French Max Shachtman without equivalent influence, an ardent neo-conservative supporter of Euro-missiles and proliferating nuclear power plants.)[4] There is an apocryphal story of James's lieutenants attempting to launch a Budapest-like General Strike with a bus turned on its side, and the Detroit police calmly directing traffic around it. That story, without the slightest element of truth, has been told to me repeatedly – always with a hint of sadness. Society moved on toward the 1960s of mini-skirts and civil rights demonstrations, leaving the old Marxist working-class politics behind. Various groups survived and regenerated by becoming exactly what James's following swore never to become, an interventionist 'vanguard' entity which looked to someone other than the working class for revolutionary transformation.

A sad pamphlet marking the break in the *Correspondence* entity put the issue squarely. *Marxism and the Intellectuals* had originally been written for *Correspondence,* a critique of Raymond Williams's *Culture and Society* and *The Long Revolution.* Crediting Williams with being 'the most remarkable writer that the socialist movement in England has produced for ten years or perhaps twenty', James found him badly wanting. Precisely because of Williams's reputation, he had to be critiqued for failing to grasp that socialism, or Marxism, rested upon a firm materialist, internationalist, historic basis. James scored many hard and useful points, some of which Williams himself would later adopt. But the thrust of James's polemic lay elsewhere. Williams the empiricist and idealist (the very charges hurled, soon enough, at the E.P. Thompson of *The Making of the English Working Class*) saw neither the French nor Russian Revolutions, the Hungarian or the American working classes. 'The hour approaches', James warned, when bourgeois domination above all in America would wear thin and the working class be pushed toward action. Lacking a firm view of socialism as historical *inevitability* in the Marxist philosophical sense of socialized production's own logic, the middle-class intellectual could only add to the confusion all round.[4]

But what if the hour never came? Over the next several years, James attempted in a series of letters and lectures some way out of the crisis. James was wonderfully clear in his conception that the small Marxist group had to offer an expansion of the personalities involved, but terribly muddled about how that might be done. Concretely, a breakthrough depended upon objective conditions:

> Only when the proletariat breaks completely with the conception of the two [Cold War] blocs, and all sorts of party politics, will the advanced countries be

able to involve with the[m] the hundreds of millions who are making the colonial revolution.[5]

Until then, not only the working-class movement but Marxism as a system of ideas seemed to be on hold:

> [W]hen Stalin began to rewrite the history of the Russian Revolution and to prove that Trotsky and all the others were traitors, the Russian ideology fell to pieces. Everybody knew that he was making it up to suit the particular needs that he had. And when Trotsky's predictions failed to come through, the rest of them began to fall apart. Until today Marxism as such is utterly discredicted [sic] in the world. What have the working-class movements or the undeveloped countries anywhere, what have they got to teach any body? Absolutely nothing. The old doctrines before 1917, those have been discredited by Lenin. The Leninist doctrines lasted up to '20–'23 and Stalin corrupted them, twisted them up so that they have no significance now for anybody, and Trotsky's doctrines themselves have been proved so utterly false and wrong, based upon the certainty that Stalin was going to restore capitalism in Russia, and that the different sections of the 3rd International were all going to join their own bourgeoisie, that today there is no doctrine anywhere. And all of them, from before 1914 on, stick to this doctrine of the party.[6]

Ten years after the Hungarian Revolution, amid the excitement of the 1960s, only James's following still seemed to remember. Nihilism notwithstanding, Watts and 'Burn, baby, burn' had displaced the vision of the workers' councils until the memory of the ghetto uprisings had in turn faded and Polish Solidarity briefly raised the banner of industrial workers' struggle to a new height. For now, James's expostulations to his followers had the sound of a dying echo. Some intimates with continuing close relations to industrial workers would judge James's own subsequent shift in course as a degeneration of his politics. Actually, the vagueness of the shift marked an unintended lapse of sorts, from a man who sought a new (or rather, renewed) sphere of radical relevance.

Africa

Meanwhile, James had long been studying the Ghanaian Revolution from the sidelines. Taken by Raya Dunayevskaya to meet Nkrumah in Lincoln, Pennsylvania, where the latter attended college and felt impelled toward radicalism, James quickly drew the conclusion that he had encountered a potential leader of African independence. According to Nkrumah's own later account, James taught him the value and techniques of illegal work. According to James, the politically ill-

educated but overwhelmingly sincere and determined Nkrumah badly needed intellectual and political mentors. Their meetings in Pennsylvania and New York during 1943–5 helped fill the young man's gaps.

James then sent Nkrumah with a letter of introduction to Padmore and the International African Service Bureau in London. Padmore could give him the hands-on training he needed for the struggle ahead. Within a few years, Nkrumah returned to Ghana and to leadership of the Convention People's Party (CPP), through which in 1957 he became premier of the first newly independent African state and a chief symbol (with Nehru, Nasser and others less acclaimed) of rising nationalism. Padmore, Eric Williams and others had already worked out, James would later claim, a comprehensive theory of national liberation which 'owed much to Marxism and was based upon our previous work', and which 'incorporated much of Gandhism' but was strictly original in its grasp of both ends and means.[7]

Yet Nkrumah, as Manning Marable has so ably demonstrated, always served better as symbol than substance. Capable of bold challenges to the British and, later, brilliant addresses on the subject of Africa's destiny, he drew the likes of W.E.B. DuBois to his new nation. Nkrumah also reinvigorated a slipping Pan-African movement, from Africa to the West Indies and the USA, with his defiant posturing against capitalism. But he could not transform radical nationalism into working socialism, and perhaps he did not even mean to do so. As James would say charitably, the Ghanaian leader's failure was not personal but rather 'the impossibility of establishing a viable regime and bringing some order into the messes that the imperialists had left behind'. That symbol individual and national, signified to Africans and to African descendants everywhere that their era of colonial bondage had at last passed and a new day, however fierce its sun, had dawned.[8]

James himself, and more often Grace Lee as his emissary, had been regularly in touch with Nkrumah since the middle 1950s. After his expulsion from America, James reacquainted himself with childhood friend George Padmore, until James's own departure for the West Indies in 1958 and Padmore's for Nkrumah in Accra the same year. (As it turned out, Padmore had gone to Africa to die; James sometimes thought of the same end for himself, but stopped short of pursuing it.) From the time of a 1960 personal visit to Ghana until the 1966 coup, James had privately warned Nkrumah even while refraining from public criticisms. By 1964, James washed his hands of responsibility and published his views of democratic degeneration and impending collapse.

All the while, he had been working on the Ghana experience, offering sections of his work-in-progress here and there (among other places, in my *Radical America*) and publishing the whole at last in 1977 as

Nkrumah and the Ghana Revolution. Here, James carefully recounted
the myths of colonial beneficence, and the reality of legalized repression.
More important, he carefully analysed the steps taken by Gold Coast
masses themselves, once the business and middle classes had initiated
unrest over the proposed new constitution. The resulting riots he
compared to the stirrings of the French Revolution, in the cellular
nature of the popular response, the transfer of energy from city to
countryside and back. Here, the newly-returned Nkrumah acted with
precision and speed, organizing the organizers of the masses into a
powerful party. The Ghana revolution was no episode of 'backward'
Africa, James insisted. On the contrary it was a pre-eminently modern
event.

What lay behind this apparently sudden success? James the historical
maestro drew a page from *The Black Jacobins*, updated by subsequent
experience. Beyond tribalism, Gold Coast natives had been brought
together intimately through industrial and urban life. Like the rural US
Blacks and whites drawn into the CIO by a need for reorientation, but
with the creativity that comes of deeper necessity, future Ghanaians
created their own forms of social unification. They used as a foundation
what came naturally, the tribe:

> On a tribal basis they formed unions and associations of all kinds, mutual
> benefit associations, a vast number of sports clubs, semi-political associations
> or associations which provide in one way or another for one or some or all of
> these activities ... these are not tribal mechanisms in the old sense. They are
> fundamentally a response to the challenge and the perils of town life in a
> modern community.[10]

Manning Marable would suggest later that even James, the shrewd judge
of politics and of character, had been taken in by Nkrumah's public
posturing on the subjects of colonial revolution, democracy and social-
ism. But perhaps the man was, for a moment, the symbol that the
ordinary people made of him. And they made a great deal. 'In the
struggle for independence one market-woman in Accra, and there were
fifteen thousand of them, was worth any dozen Achimota graduates.'[11]
The intelligentsia would misunderstand, manipulate and distort what the
combined strength of the market women had created. That was, for
James (as for a later Marable), more damaging than all the tricks of neo-
imperialism.

Against that generation stood a power that James described as
'politics in the Greek-city sense of the word', politics which 'embraced
the whole man, symboliz[ing] the beginning of a new stage of existence'.
The CPP spread from village to village, becoming overnight a mass

organization such as that society had never seen. More uniquely Jamesian than even this insight was the interpretation of the cultural outpouring, 'new words, new verses, new passwords' revealing a transition 'sometimes pathetic, sometimes vastly comic, ranging from the sublime to the ridiculous, but always vibrant with the life that only a mass of ordinary people can give'. In Black America, a quarter-century earlier, James had first seen the political power of the spiritual; in Ghana he saw the crowd intoning 'Lead, Kindly Light' in an ode to the imprisoned Nkrumah. Even The Lord's Prayer had become a radical curse ('O Imperialism which are in the Gold Coast/Disgrace is Thy Name ...').[12]

Through this evocation of mass energy, James returned in theme to Nkrumah and to the importance of the Third World revolution for the mid-twentieth century. Nkrumah absorbed the impulses, disdaining to prepare for oratory, so sure was he of the crowd's expectations and of his own lifelong preparations. He appealed for mass action because no other road remained open. He sounded, to James, like United Mine Workers' leader, John L. Lewis, who had taken on the whole of World War II government bureaucracy, including Franklin Roosevelt (and the Communist Party to boot), in the name of workers' rights. Nkrumah spoke *with their voices* and the power of his words carried a profound lesson:

> No mean or calculating spirit can ever mobilize masses of people for a revolution. Western civilization has forgotten or learnt to distrust the revolutionary temper, the revolutionary spirit, the revolutionary personality built on the great heroic scale. It was on view in the Ghana revolution. It is everywhere in Africa, and Hungary has shown that contrary to all the defeatist lamentations, it burns in Europe still in millions of ordinary people. If it did not, civilization would be at an end, destroyed not by hydrogen bomb explosions from without, but by the congealing within.[13]

From this high pitch, Nkrumah and the Ghana revolution came down a precipice. In its last years, the colonial regime did its level best to poison the wells of coming independence. It tortured with one hand, and corrupted with another, the political leaders-to-be. Nkrumah won the general election of 1951 but decided to work within the British-promulgated constitution at great risk to the revolutionary process. Now the masses had been safely removed from the front line. The end had already been foreshadowed in that beginning.

James devoted the rest of *Nkrumah and the Ghana Revolution* to documenting his own speeches and letters to Ghanaians (including Nkrumah) during the declining years of the regime, and to his reflections

published on the subject variously since. It was a strategy typically Jamesian, placing the events into a historical context which emphatically included himself. He believed, to the end, in the necessity of a socialist party which would embrace the masses, replace the bureaucratic state machinery with their energy and their devotion, and in that manner set things right. Lenin would have done so, James insisted and described in great historical detail.

Anything less meant, to James, that Nkrumah was 'fooling himself and a lot of other people with a dangerous fiction – its name is democratic socialism'.[14] It could be mere words, as it would be for the liberal politicians of the West Indies who presided over moderate neo-colonial regimes. If taken seriously, dramatic state intervention without mass mobilization meant both no socialism and no democracy. Either way marked a major disappointment in pre-colonial aims and promises. Camouflaging the aping of Western-style consumption by the bureaucracy and a thin layer of privileged workers, this 'democratic socialism' ultimately brought a disaster: the destruction of what communitarian values had been carried over, without the creation of any new communitarian values to substitute for the ones lost. James would say elsewhere that

> Nkrumah studied, thought and knew a lot. But one thing he never mastered: that democracy is not a matter of the rights of an opposition, but in some way or other must involve the population.

The African leader had, in other words, erred in assuming so much power for himself and for the CPP, ruling out all democratic opposition. But he erred far more severely when he ruled the masses out of the process. Again the errors of Toussaint.[15]

In a draft document for the Detroit group, James pushed this understanding backward and outward to the French Revolution's peasant legacy (all but ignored in James's own earlier accounts) and to the independent role of peasant associations in revolutionary Russia, China, India and (above all in contemporary events) Vietnam. He seized upon the Tanganyikan political thinker, D.K. Chisiza – a youthful fatality in an automobile accident – to show the contradictions and the continuing collective verve of village life. As Lenin had grasped at the end of his day, these were the real secrets to the twentieth century.[16]

In the 1960s, James explained this historical lesson to his audiences almost every time he spoke about Africa. By the mid-1970s, James sought to impress it upon the African leaders at large. Tanzania's Arusha Declaration seemed, at the time of its promulgation and for some years after, to be the fundamental statement of democracy that

African life required: beyond nationalization and militarization to grass-roots democracy based upon African traditions. Nkrumah had erred in his forced economic Westernization, promoting latent tribal conflicts and adding yet new layers of bureaucracy. Dr Julius Nyerere and Ujamaa could, James believed, still operate in the other direction, toward the strengths of tribal and regional traditions. In the end, however, the second strategy, with its anachronistic undertones, served as poorly as the first.

Worse yet, James's praise for Zambia's conservative president, Kenneth Kaunda, seemed to close observers altogether too represent-ative of the elder thinker's desperation at finding hope, most uncharac-teristically for him, in the wrong place – among the leaders rather than the mass. James saw 'African Socialism' differently, the reawakening of socialist thought in a specific, concrete matter where it had not seriously advanced since Lenin's death:

> Its depth, range and repercussions which flow from it, go far beyond the Africa which gave it birth. It can fertilise and reawaken the mortuary that is socialist theory and practice in the advanced countries. 'Marxism is a Human-ism' is the exact reverse of the truth. The African builders of a humanist society show that today all humanism finds itself in close harmony with the original conceptions and aims of Marxism.[17]

If James erred here, he sought to make up for lost time in his urgency for a Sixth Pan-African Congress with a decisive political agenda. Prodded by him during an African lecture tour, a Call sent out in 1974 articu-lated the distinction between mere political independence (with the retention of Western controls) and true social–economic independence. It was immediately reminiscent, for the few who recognized the fact, of his 1950 call for the Fourth International to draw a line between mere national-ization and real socialism. And it was a self-conscious advance over the Fifth Congress, in 1945, which spoke strictly to political independence and drew strictly from the existing leadership elites to do so. James lectured and spoke privately from Africa to the West Indies for this agenda. In the end, the Sixth Congress officials discouraged his partici-pation even while acknowledging his historical role. Possibly they actually feared him, as some rumoured. No doubt they felt the usual tension that African leaders have expressed toward West Indian intellec-tuals. They had already begun to be drawn away from the Eurocentric remnant in James's thought, that the West Indian legacy from Europe could serve as an international-theoretical guide in the Third World. Most likely, they feared the implications of any agenda such as the one James put forward: admission of the failure of the national state and the

necessity of federation; second, the limits of any elite unadapted to, and uncommited to, the ordinary African; and third, the central importance of the mass, their great capacities and their consciousness, for any future society. The leaders were not ready for *that*.[18]

Trinidad Again

James might have substituted the names and acts of the West Indian politicans for the Ghanaians and, without missing a beat, added an interpretation of his own recent political intervention in Trinidad. That would have been consistent with the scope of his Pan-Africanist logic and with his personal disappointment at the outcome. But unlike Ghana, Trinidad was James's own turf. Here, in his one great personal opportunity to influence Third World decolonization, James would have to abandon the philosopher's pose and take responsibility for the problems immediately at hand.

James had been a long time gone from Trinidad. The end of Cipriani's era (the pioneer labour leader died in 1945, but had lost much of his influence a decade earlier) brought a single stroke of proto-revolutionary activity, and decades of apparent entropy. The riots and general strike movement which permeated the islands in 1936–7 centred, in Trinidad, among the most organized and militant workers, in the oil fields around San Fernando. Tubul Uriah ('Buzz') Butler, a Black Moravian Baptist evangelist and oil worker, had already seized the momentum among Afro-Creole workers from Cipriani in 1935 and took his opportunity amid the rampant unrest.

James, at a distance, took satisfaction in the colonial intelligence reports that *The Case for West-Indian Self Government* circulated from hand-to-hand and achieved its purpose as an agitational–educational document. But Trinidad suffered for the absence of a real James or Padmore on the scene. Butler built a new party around his own personality, urging fundamental reforms for oil (and other) workers through legislation. Up to a point – especially as an agitator – he did very well. But personalism had a price. Seized in the riots that swept the islands, put on trial, he left his leaderless followers in the hands of middle-class politicians. The Oilfield Workers Trade Union survived in moderate form, because the British so badly needed oil reserves to fight a war. But politics had been once more personalized and racialized, contrary to Cipriani's dreams.

Moreover, the wartime stationing of US troops in large numbers tightened colonial dependence just when British influence had been waning. The technological expertise of the Americans, their consumerist

hungers and free-spending behaviour (importing and thus making available American films), all tended to create among Trinidadians the self-image of a second-class, racially divided society yearning to be ... American.

Another decade of drift saw British and local whites gradually relinquishing power to the coloured middle class and to the power-brokers from among the minority Chinese, Portuguese and Middle Easterners. But not with happy results. The context essentially reinforced the middle-class commitment to the capitalist development model. It also led to inchoate resistance from below, unable to break through the web of traditions and institutions. The cooperation of the Colonial Office (sometimes with British Labour Party leadership) and the coloured bourgeoisie against Butler's repeated attempts at an industrial and political comeback set the limits upon any incoming, constitutional rulers of a Commonwealth Trinidad. As James would later analyse the denouement of radical independence hopes, an inheriting middle class with 'no trace of political tradition', with no outlook beyond its own individual upward mobility, and for that matter no burning desire for national independence (until the benefits in status and salary became clear) continued just as before to set itself apart from the common herd. Upon these weak shoulders fell the rule of the emerging nation. The mistrust of ordinary Trinidadians criticized so damningly in *The Case for West-Indian Self Government* changed colour without changing anything essential at all.[19]

Let us suppose for a moment that James had stayed behind in Trinidad, or even returned at the time of his 1953 expulsion from the USA. What would he have been able to do, buffeted by potential arrest from one side and by the dubious offers of middle-class political comradeship on the other? He would certainly have avoided the weaknesses of Butler, a demagogy and personalism without intellectual substance. He would not likely have been able to lead change effectively until the collapse of British colonialism had begun in earnest – until the 1950s, that is. By that time, Eric Williams had returned to the scene to do (up to a point) just what James might have done.

Indeed, James had introduced Williams to Padmore, in the Bronx of the middle 1940s, and coached them as they worked out the plans for the constitutional organization of national freedom. Judged by past behaviour toward his mentors, Williams seemed the political link with the masses that Trinidad had lacked and the middle classes would not themselves create.

James's former pupil twice over (at ten years of age and again at thirty-five), 'the Doctor' Williams boldly abandoned a distinguished academic career (his outstanding work, *Capitalism and Slavery*) to

return to Trinidad in 1948, so as to serve on the Caribbean Commission. Dismissed in 1955 for his controversial stands, Williams plunged into politics. Quickly, he became the open link between the educated middle classes and the Black–Indian masses. The People's National Movement (PNM), not a personal party but close to it, actually found Colonial Office approval for its 1956 election triumph. The PNM, the British correctly perceived, would become the appropriate instrument for a smooth transition to ostensible independence with Commonwealth guidance. Williams, a remarkable orator despite deafness in one ear, established a public forum in Port of Spain, the 'University of Woodford Square', which became almost literally the school of nationhood. Meanwhile, he carefully maintained, especially for international consumption, a non-socialist image. He also played the anti-imperialist card in demanding the return of the Chaguaramas Peninsula from the Americans who had long used it for military purposes. Williams thus spoke often and broadly about non-alignment, making visible overtures to Nkrumah and the principles of an envisioned Third World bloc.[20]

From London, James had made his own contribution to this struggle. That contribution, destined to take myriad different forms but always in touch with radicalized Caribbean intellectuals, is all the more impressive because he began as if from the beginning. Young West Indians had heard of him, if at all, as a distant pioneer of anti-colonialism. Only through his re-introduction in cultural and political life did his stature become evident – and then only to those lucky enough to make personal contact.

From the middle and late 1950s, when the Black diaspora began to accelerate its growth and a handful of novels such as George Lamming's *The Emigrants* dramatized the lives of the new British population, James had begun to gather younger West Indians around himself socially and intellectually. Acting much as his circle had for Africans in London in the 1930s, but on a smaller scale and without any claims to political status, he introduced intellectuals and activists to one another, held or encouraged informal seminars and generally strove to precipitate a sensibility. Upon those students in particular who would return, bring-· ing their professional talents to bear in new nations, James could leave a profound impression. Within the West Indian London that grew up, he made himself both a historic figure and a winning personality.[21]

In these circumstances, Williams recalled his erstwhile mentor to be editor of the weekly PNM organ. James did not exactly relish the prospect. He had been working on *Beyond a Boundary*, on preliminary studies of Nkrumah and on a sheaf of collaborative projects. He lavished additional energies on his son Nobby, now out of touch except for occasional visits, and for affecting short stories written to amuse the

child. He anticipated personal hardships and political perils. Above all, he knew that his sojourn would demand a strict demotion to Williams's political shadow. Not so much as one speech did he plan to make in Woodford Square, nor take any positions critical of Williams in public. If James (and his then wife Selma) undertook the project, it was both out of extended-family obligation and also the desire to participate directly in the nationalist politics of the day. He used his Trinidad base to speak across the region, from Guyana to Jamaica to Barbados, analysing politics and culture, offering suggestions and warnings for the path ahead. But even this bold venture he did with the prospect of a limited duration.

Setting his task before him, James portentously renamed *PNM Weekly* into *The Nation*. He assumed the editorship, and Selma James a like responsibility, for one essential purpose: the building of the PNM from a partisan force into a body that could transform Trinidad and Tobago. So long as 'Bill' Williams would follow James's lead, provided in public and in private, the work went forward properly. The couple did more than their part, submerging their other projects and even political identities, working long days and into the night. James scholar Kent Worcester has detected a radical influence leading out from the *Nation* to Williams's own addresses, a 'defiant international posture' against the mores of imperialism.[22] James himself insists to this day that Williams – always excellent at taking advice – seemed to recommence the mentor relationship where it had left off decades earlier.

The symbolic significance seen by James in American-held Chaguaramas, and his disparaging editorial notes on the international Cold War, underlined an ambience unmistakable if generally low-key. He would not assail 'American imperialism' or threaten to overturn capitalism. Too easily the Marines could march in. But he placed the need for real independence – from the arms race and from dominating cultures alike – in evident relief. Self-rule meant self-knowledge, and that in turn meant an awareness of place in the ever dynamic world scheme. But the editing of a weekly paper inevitably had another another and more cultural aspect. James sought to entertain his audience, to uplift it spiritually to a new appreciation of Trinidadian and West Indian popular selfhood. The result read like a West Indian *Correspondence* with peoplehood substituting for class.

Thus, no Trinidadian political campaign exceeded in enthusiasm *The Nation*'s effort to place cricketer Frank Worrell as West Indies captain. Essays on the importance of calypso, steelband and carnival stood alongside political treatments, literary reprints from Naipaul, Lamming, James himself and even Baudelaire! Special supplements celebrated Cipriani and Abraham Lincoln. Considerable coverage extended to

Third World leaders such as Nehru, and readers could whet their inter-
est in new discoveries about ancient Greece and Egypt. James's own
'Without Malice' column drifted conceptually far and wide, considering
modern art, modern history, regional unification and the Woman
Question. 'The Doctor' had a weekly feature which set out more or less
official views on culture and other subjects, but these seemed mainly to
amplify James's own perspectives.

Strategically, in politics as well as in culture, James believed himself
(or so he now recalls) to be at the ideological–strategic helm of the Non-
Aligned Movement in the West Indies. So long as Williams followed
James's guidance in such matters and gave him a wide latitude in the
paper, the arrangement was quite satisfying. Early on, Williams's sub-
ordinates began to rumour their resentment of the new arrival's radical-
ism and (even more) his influence. They did not buck Williams's choice
head-on. But they showed little of the necessary enthusiasm that secon-
dary leaders of a healthy political party must have for the party's princi-
pal means of public expression. James, perceiving the threat, moved (he
believed) cautiously to bring his enemies out into the open.

James did not make any formal criticisms of the government as such.
On the contrary, he celebrated its historical origins in his own mutual
background with Williams, through publishing his memoirs of Padmore
and the elder Pan-Africanism. (*The Nation* also celebrated him, in
reportage of a Ceremonial Dinner with messages of praise from
Nkrumah, Ralph Bunche, John Arlott, Fenner Brockway, Tom Mboya
and others.) But James could not resist pointing up the uniqueness of
the paper's achievement, by contrasting *The Nation* with other contem-
porary Third World party organs. It did not, James stated flatly, 'put
forward very consistently the point of view of the government', but 'the
problems of the people in particular as stated by the people themselves
have a ready welcome in our pages'. Indeed, James placed the PNM
bureaucrats on notice that *The Nation* would 'view their behaviour
critically, that is to say from the point of view of the public not from the
point of view of the Party or the Government'.[23]

Such criticism amounted to very little in space, reserved almost
exclusively for the letters column. But the audacity of the posture
enraged PNM functionaries and made Williams himself uneasy. James
sought repeatedly to avoid the pitfalls he had already observed in
Ghana, by making the party responsible to the masses. Given the politi-
cal dilemma – the almost certain unwillingness of the USA to see a
radical, neutralist nation in the Caribbean and the impossibility of satis-
fying mass demands *without* radical measures – the perpetuation of
political mobilization posed a task beyond the power of James or anyone
else, except perhaps Williams himself, to accomplish. It depended upon

a social momentum which only a steady march of crucial events could maintain.

More than at any other time in his life, James sought to impose a realism upon himself and his revolutionary aspirations. 'When the British flag goes down and the national flag goes up,' he warned in 1958,

> ... there will be no more cruisers and soldiers to come, and all authority depends upon what is native and rests upon the attitude of the people, then these islands are going to test for themselves how far it is possible for them to achieve the democracy which has evaded so many other territories in these parts.[24]

He set his sights upon federation as a practical goal, and mobilization of the masses as a means: together, the two could (although he refrained from such phraseology) provide a transition to a socialist order.

But Williams held the key to such mobilization, and 'Doctor Politics' meant, after all, the rule of the individual so familiar to West Indian life. Just below Williams huddled the time-servers and the timid, those who would not and could not take responsibility for making the mass energy expressed at political high points (such as the 1957 march, led by Williams, upon Chauguaramas) into a guide for party success. They wanted not excitement but the social peace required for foreign investment and steady economic growth. James could organize and agitate for a more responsive movement; Williams bid the discussion of party self-criticism and party revival to be silenced. Perhaps he did not mean to close off the question entirely. Having achieved independence, the Doctor knew his own mind less and less. But the official re-introduction of discussion (by him, of course) at a following party congress fell flat. The moment had passed. James could write almost as he wished, in *The Nation*, on a variety of issues. But party leaders outside Williams increasingly considered themselves free to ignore the paper entirely.

James himself came to believe that certain PNM elements, encouraging and encouraged by the opposition party, began actively to plot his downfall – and understandably so, because a party in his image would be the end of their prerogatives. A serious scholar of the region, Ivar Oxaal, suggests that the US State Department may have called for James's ouster as quid pro quo for the American military's abandonment of Chauguaramas. Whatever the source, rumours began to pass about James's 'Communism' and his supposedly opportunistic return from a lifetime exile to the spoils of office. (Inasmuch as James had barely enough to live on, that charge would have been laughable had not its consequences been so serious.)[25]

The role of *The Nation* became, for James, not only symbol but substance of regenerative possibility. His last, urgent effort to compel Williams and the PNM to assume financial responsibility for a twice-weekly *Nation* fell upon deaf ears. The leadership did not deign to answer blatant attacks upon the paper and its two distinguished editors. The hopes for a daily, nourished by his first return to Trinidad and observation of the mass enthusiasm, now vanished along with his vision of a Trinidad emerging into independence armed intellectually for all the great questions of the age. A stomach ulcer plagued him as it had not since his days on Ellis Island. His resignation from the paper, offered in a letter to Williams that James later published in full, outlined amiably the gulf between their lives and their experiences:

> You have had a very easy time in politics, Bill. You don't know what political struggle is at all in the internal party sense. That is what makes me now so nervous.... I doubt if you are in any position for a variety of reasons to undertake the reorganization of your party. If you do, you will do it under a sense of pressure. You are, I think at present, temperamentally disinclined to it.... I do not want to be in that opposition where I will be one of the main advocates of a course that you will either refuse to take or undertake, I am sure, with a sense of grievance and great irritation.... I want to be out of this business.[26]

Later, he added that 'in the immeasurable cruelties of the age in which we live (the most cruel in human history), a politician has to watch above all himself. But it is much better if his colleagues, and still more his party, watch him.'[27] James continued to seek a meeting with Williams – but Williams had finished with him. Remaining in Trinidad until 1962 off and on, as a private citizen, James notably delivered a series of addresses on art and political–intellectual history at the Port of Spain Public Library, collected and published as *Modern Politics* (1960). Williams ordered the copies seized and held. Not long after a serious automobile accident in Jamaica in 1961, leaving him unconscious for a week and provoking the worst fears among his friends and followers, a recuperating James departed for England.

He very well may have been wrong strategically, in his precipitous departure. (He told me that he had felt old, set back, and deprived of his opportunity to write.) By the early 1960s, strike waves broke out in Trinidad against the neo-colonial manipulation of the economy, and fresh radical leadership emerged among both Afro-Creole and Indian workers. One of the two key leaders, George Weekes of the Oilfield Workers Trade Union (OWTU), owed much to James and spoke often of the connection. The disaster of 'Doctor Politics' had begun to become apparent, despite the high regard in which a population – whose lives

had palpably improved with better medicine and education and with a partial repatriation of oil revenues – still held Williams personally.

In truth, radical opposition lacked a unifying political figure. After sending out feelers about his willingness to oppose Williams in the latter's home district, James returned in 1965, ostensibly to cover the England Test tour for *The Observer* and *The Times*. Anxious about the visitor's potential role in a national strike wave, Williams briefly placed him under house arrest until his departure. The next year, acting from a distance, James helped to form the short-lived Workers and Farmers' Party. Despite the enrolment of a popular East Indian workers' leader, despite the sudden development of a youth movement, it was all too little, too late. The base for a lasting movement had not been solidly laid. James had not done enough personally to fill the gap left by Williams's crumbling credibility.[28]

Friendly critics would say that James had made a critical error years earlier, and compounded it with his attempts at correction of the PNM's course. He had entered at the leadership level, subordinating those party veterans beneath him as if he had been absent from Trinidad only a year or two rather than twenty-five. He thereby alienated a potential left-wing bloc of activists who by and large shared his criticisms of the PNM. He hardly seemed to grasp until too late that the Williams in power was no longer the Williams of the 1940s or the 1950s, eager to be given an agenda. Turned away by the Doctor, James had few choices at hand. By challenging Williams to a head-on duel, he opted for the course least likely to succeed. A slower, more patient and more democratic method might well have had different results at least in shaping future conflicts.

More than a decade later, novelist Earl Lovelace described the wasted passions of post-independence Trinidad via the lumpen proletarians who gave their soul to Carnival. In *The Dragon Can't Dance* (1979), of which James wrote, 'Nowhere have I seen more of the realities of a whole country disciplined into one imaginative whole', the steel-bands battle each other, often brutally, for no evident purpose. Their members understand their own unemployment or bad jobs in the cities, the sharp decline of countryside life (and even more, of the prestige of country life), the race and class prejudices which persist in the face of claims to nationhood. Most of all, they do not believe in themselves, in their own power to remake society. In Lovelace's imaginative adventure, four angry young band members steal a police car and drive around the island. Only one of them has the vaguest notion of political revolution, and that strictly at the level of slogans. Confronted with the official stratagem of virtually ignoring them, they all but invite arrest. Over at the margin of the entire community stands the East Indian who wanted so badly to be part of the excitement and, shunned, becomes the

cautious and conservative businessman of the era ahead. The Carnival can still recreate reality for moments at a time. But neo-colonial society persists, its legacies vampire-like weakening the efforts and energies of the radical democracy, which at last are turned in upon themselves.[29]

Something else in *The Dragon Can't Dance*, however, signalled James's misapprehension of post-colonial culture. When the protagonist (and maker of the dragon costume) returns to daily life from prison, he finds the slums changed most of all by the power of political patronage which has brought up a selected minority into privilege and relative affluence. Contrary to James's expectations, trade unionism in economic life and patronage in politics marked the Trinidadian working-class transition from nationalist mobilization to post-independence languor. The racial antagonisms of the island underlined the problems of transformation, but the recuperative powers of capitalism, especially within a system which increasingly promoted public cynicism, proved far stronger than he imagined.[30]

Lovelace's novel is, in part, a metaphorical treatment of the lost potential and real frustration with events of the later 1960s and early 1970s. Black Power touched down among college students in Trinidad in the late 1960s, raising public hackles against 'Afro-Capitalist' middlemen who served the wealthy investors abroad. The identification of radical or revolutionary change as 'Black' already suggested serious problems in a society some forty per cent East Indian. Guyanese historian and political activist Walter Rodney, among others, struggled to redefine 'Black' somehow inclusive of all powerlessness. But explosive events never lost a definite Afro-Carib connotation.

High unemployment of young workers, growingly militant nationalism and the political leadership provided by a new generation of intellectuals from the University of the West Indies (UWI) led to an explosion in early spring 1970. Even the symbolism of Carnival fed the mood that year, with pictures of Rap Brown and native-born Trinidadian Stokely Carmichael held aloft by the bands, 'King Sugar' and 'White Devils' posed as the old and familar evil. As students spread their activity to the community, most especially the very Black Port of Spain, the struggle took on a national character. A sequence of campus demonstrations, police crackdowns, a Black Power march of some ten thousand through Woodford Square in 1970 and a general sense of social deterioration brought others into motion. Following the police assassination of a leading young radical, the unions among Afro-Creole oil workers and Indian sugar workers with their own agendas joined a movement toward General Strike.

Strikes, marches, individual acts of violence against businesses and private homes all seemed united by a certain symbolism of Afro-Carib

consciousness. The government could not easily contain the situation. But it relied correctly upon the utter hostility of the middle classes (along with the passivity of relatively well-paid urban proletarians) and the suspicion of most East Indians. Just as the possibility of an organic alliance between Blacks and East Indian sugar workers emerged, Williams declared a state of emergency, arresting leaders and, with the help of US troops from the *Guadalcanal*, brought temporary quiet. At the last moment, his own troops began to mutiny, and only a successful blockade of rebels from leaving the Chauguaramas Peninsula, along with days of negotiations, ended the crisis in Williams's favour.[31]

From a rather cynical point of view, the revolt had been a futile outburst of pent-up steam from the lumpen proletariat and college radicals unable to alter their own conditions. Seen from the eye of the tiger, however, it had also expressed great cultural potential among those whose talents and intellectual skills gave Trinidad its best sense of past identity and future hopes. If these were to be denied in favour of 'stability' and individual acquisitiveness, what could be the future of the islands?

At the risk of incurring great disappointment among the radicalized Black Power intelligentsia, James removed himself physically still further from the unfolding tragedy. Not that he lacked sympathy or advice from militants, but he did not feel his own direct intervention would be decisive. The events had taken place ten or twenty years too late for the application of his political talents.

In any case, he left behind a legacy which he summed up in *Party Politics in the West Indies* (1962), a pamphlet documenting his two-year struggle. His preface reads like a testament:

> We live in a tremendously disturbed world. We are a very small and insignificant part of it. But there is much that we can be and do on a national and even an international scale. What that is or can be we shall never be able even to find out far less carry out unless the people are politically organized. Even when they elect the government of their choice they have to remain politically alert, and to make it clear that they are not to be bamboozled, trifled with or pushed around. There is another lesson of history that must never be forgotten, one of the greatest lessons which history teaches. It is this. Know it and never forget it. Any government that is not conscious of the power of the people, and the people have no power unless they are independently organized – any government that is not aware of the power of the people is bound to be a bad government, that is to say, it will fool you, cheat you, and if need be reduce you to hewers of wood and drawers of water, and without mercy keep you in what it considers to be your place. That is the last hill which the people of the West Indies will have to climb. It is hardest of all. When you climb it you will have arrived at a height from which you will never fall.
>
> People of the West Indies, you do not know your own power. No one dares to tell you. You are a strange, a unique combination of the greatest

driving force in the world today, the underdeveloped formerly colonial coloured peoples; and more than any of them, by education, way of life and language, you are completely a part of Western civilization.... Be of good cheer. Know that at this stage of world history and your own history there can never be any progress in the West Indies unless it begins with you and grows as you grow. All that these underdeveloped countries are striving for is at your feet. You have to know what you are, and what you can do. And this nobody can teach you except yourselves, by your own activities and the lessons that you draw from them.[32]

From that point on, he would live in the West Indies only briefly and temporarily, with the exception of several years in the early 1980s when the Oilfield Workers Trade Union accommodated him adjoining their San Fernando headquarters. He would speak often, especially on West Indian university campuses. His influence would be manifested indirectly, through individuals, almost pervasive in serving as a reference point on West Indian self-identity, but generally more vague than he had hoped.

James later expressed a somewhat more philosophical view of his own failure and of Williams's survival: 'The oil saved him' – that is, the mobilization of OPEC for higher prices allowed him to continue a decade or more beyond an internal collapse of programme and ideology. When Dr Eric Williams died in 1981, James correctly predicted that he left no political legacy: 'He left nothing with anybody.'[33]

Worse, for Trinidad, James's failure and Williams's survival had deprived the nation of leadership from James's youthful aides in 1966 and later, amalgamated into a 'New Beginning' New Left of the early 1970s, and of OWTU leader George Weekes who swept into office only when the bankrupt PNM had been defeated by a doubtful 1986 right–left coalition. The most promising moments, evidently for decades, had passed without important changes. Trinidad had lost its vanguard political status in the English-speaking Caribbean for the foreseeable future.

Still worse, because more bloody, could be said for other important islands. During the 1976 Jamaican campaign, James had been summoned for advice by Michael Manley, a moderate but politically courageous socialist then at his most leftward point. Successful in election, Manley saw his efforts destroyed by the collusion of the World Bank, the US State Department, and local politicians cut in Ronald Reagan's image. During the ferment of the early 1970s, James's disciples could be found in scattered former British islands across the Caribbean. In Antigua, they mounted a serious challenge to the power structure. But none of the movements could maintain themselves at a high level amid the mixture of economic pressures and political repression. Proliferating violence, widespread impoverishment and despair brought Jamaican Edward Seaga into office for an era likely to

be remembered mainly for the massive increase in the drug trade and for the depoliticization of reggae.

James suffered his own most severe blow with the assassination of Guyanese Walter Rodney, easily the most promising of the young political intellectuals. Self-avowed disciple of James, Rodney wrote pamphlets and books on Pan-Africanism, most notably the small booklet *The Groundings with My Brothers* (1969) which summed up and also summoned regional Black Power impulses into existence. He also led the Working People's Alliance against Forbes Burnham's corrupt and authoritarian (if sometimes radical-sounding) People's National Congress. James's public addresses in Guyana during the late 1950s had helped prepare the way for a Rodney. Later, James, among many others, feared for Rodney's safety and urged caution. In 1980, Rodney was killed with a remote-controlled device, evidently by government agents trained in CIA terror techniques.

With Rodney's death, far more than Williams's a year later, a promising era of Caribbean politics had nearly come to an end. The 1983 Marine invasion of Grenada, whose revolutionary leaders also felt the stamp of James's influence, swept bleakness across the political landscape. James spoke glumly about power 'lying in the streets', where no one picked it up. But the streets were also evidently under guard. James would occasionally visit and frequently advise into the early 1980s. By and large, he had become a distinguished (if also slightly dangerous) senior figure. To a handful of outstanding political intellectuals – by the mid-1970s, mostly West Indian students in exile in Canada – he remained a foremost guide. With the strident exception of Tim Hector, Jamesian leader of the Antiguan left, they, too, bided their time. Or became themselves neo-colonial administrators.[34]

Revolutionary Elder

In the USA, James had another type of influence, still more modest but far from insignificant, foremost in the maturation of Black scholarship. Permitted re-entry from 1968 onwards, he lectured at dozens of universities over the course of the next decade or so, visited for a semester's lectures at Northwestern University and ensconced himself at Federal City College in Washington, DC, by the mid-1970s. Too late for maximum impact upon the New Left, constrained by the always uncertain status of his passport ('we have learned,' he wrote in this time, 'to run with the hare and hunt with the hounds'), but early enough to reach the survivors of its defeat. Now, at *his* last potential moment for this task, he re-Americanized himself.

It would be only fair to say that James remained somehow (no doubt because of his absence from the American scene for fifteen years) out of synch with the spirit of the white New Left which plunged overnight from libertarian to Maoist hegemony. Only at the end of the generational experience did he take on something like direct political disciples. Some of the factory-oriented groups which stressed Black Power in their own strategic situation, and others which simply sought to continue semi-anarchist 1960s modes, found him a guide or helper. In this category might be placed my own *Radical America* which in publishing his works envisioned itself as a theoretical expression of such a general tendency. *Facing Reality*, descendant of *Correspondence* and publisher of a lively but sporadic newsletter, had expired in 1971 as a consequence of the same general circumstances.

But these currents remained marginal within a larger, doomed campus-to-factory movement, and lost their impetus after the recession of 1973 and continuing automation had reduced the workforce and further disoriented rebels within union ranks. Only in Canada, directly across the border from Detroit, did the direct political influence continue for a time further (among a group known, significantly, as the 'New Tendency'). James continued to be read seriously by activist-intellectuals who felt drawn to his subtle Marxist critique of culture, but who fumbled at a current political application of his mostly older works about the crises of advanced capitalism. One could find, with effort, the richness of promise in popular and blue-collar cultures, as per James's long-standing predictions. The vision of American Soviets of industrial workers belonged, however, to the Marxist past.

Among young Black radicals, on the other hand, James had more nearly met the crest of intellectual–political energy. As far back as the middle 1950s, he had met informally with Martin Luther King, Jr, in London, and exchanged views. His Detroit group's *Negro Americans Take the Lead* (1964) adequately if somewhat obscurely put forward the notion that 'the tremendous Negro movement is an American form of radical thought and radical action', but mistakenly argued that this movement would usher in a working-class political renaissance and result in a new, mass party. The eclipse of James's collective entity had been definitively foreshadowed. A decade and more later, James singularly failed despite correspondence and contacts to impress his ideas upon the Caribbean-born Stokely Carmichael or the Afro-American writer LeRoi Jones/Amiri Baraka, who went their own nationalist and vanguardist ways. But James did not by any means fail, nor did his group fail, entirely.[35]

A substantial number of activists in the first Black generation to attend college by the tens of thousands felt the impress of James's

distinguished past, his deep sense of history and his very physical 'Blackness'. For the likes of Vincent Harding and Manning Marable, leaders in the next generation of studies, he would serve as guide and model. For poet–critics such as E. Ethelbert Miller, he would personify the inherent but often unconsummated links between scholars, artists and activists. For activists at the college level who would become neither professors nor artists, he was an extraordinary personality heard once or twice on a campus, read in *The Black Jacobins* or in the *C.L.R. James Anthology*. Physically weak and growing weaker, James still had the charisma of the orator and mentor. His classroom presence, old-fashioned in style, commanded something like awe. Even his opposition to Black Studies – on the fear that 'Black' subjects would continue to be marginalized in the curriculum – made him no less popular among those who would soon lead Black Studies departments. Among West Indians, as always intellectually prominent in exile, he loomed larger than life. In short, his final turn at teaching had been the grandest of all.[36]

As a scholar, he would be remembered for his impatience with intellectual sloth in the name of 'Blackness', and for his energetic intervention into the controversial districts of Afro-American history. His 'The Atlantic Slave Trade and Slavery: Some Interpretations of Their Significance in the Development of the United States and the Western World', written for *Amistad* (1970) with the assistance of his then personal aide William Gorman, could be regarded as one of the gems of the emerging field. Here, James reprised the literature on the ancient and modern slavery, the slave trade in Euro-American civilization, the Civil War and the impact of slaves' own actions. As in the West Indies, the Black contribution to the creation and internal governance of plantation economics proved decisive for general economic advance. The runaway slave fired the popular imagination, and helped the free Black and radical white to set Abolitionism in motion. Abolitionism, 'an absolutely necessary stage in making America a distinct civilization', in turn created drama with the impact of the Greeks (*Uncle Tom's Cabin*) and helped free the Russian serf. In the 'last great voluntary war in the history of mankind', the Afro-American showed all the courage, skill and personality publicly denied him. He *forced* America to acknowledge him and his importance, however quickly white authorities would seek (and continue to seek) to forget.[37]

Nor did James reach only the scholars. The Detroit-based League of Revolutionary Black Workers, which offered an ideological and (at least in its immediate area) political alternative to the lumpen-based 'pick up the gun' Black Panther Party, had arisen from circles intellectually influenced by members of James's group. The League's *Inner City Voice* radiated a Jamesian embrace of mass action and cultural dynamism,

curiously intermixed with eclectic combinations of Mao and Che Guevara. James himself secretly met with industrially-oriented Black militants in a local basement. Too quickly, however, these tendencies collapsed for similar reasons as other movements. In the short run, the combined opposition of employers, union officialdom and state authorities proved daunting. In the long run Black industrial labour, so long held in reserve and so long super-exploited, would not be required in the same degree for increasingly automated factories.[38]

Thus the politics, if not the personal influence, came to a crashing halt. And yet James persisted as an elder statesman of a revolution which had disappeared like an underground stream and would sometimes reappear. As such, he seemed to come to public terms with other Black giants who stood politically apart from him (in or around the Communist Party, that is) during their active years: W.E.B. DuBois, who had emigrated to Ghana and in a last gesture, founded the CPish *Freedomways* magazine, to which James now contributed occasionally; and Paul Robeson, long a friend but still longer identified with things Russian and Communist. The spectre of 'Stalinism', so vivid in *Mariners, Renegades and Castaways*, had grown dim in America, where the Communist Party had itself become a mostly geriatric organization.[39]

In old age, James could cut quite a figure. As the *Trinidad Express* reported in 1982, he entered a trade-union convention like some character from a novel:

Red and blue were the colours on the opening day of the Oilfield Workers' Trade Union's 43rd annual conference of delegates last Saturday: revolutionary red and working-class blue....

The grand old Marxist arrived, in dark coat and white hat, leaning on his relative's arm, and was led onto the stage while the sea of dark blue shirts rose and applauded. Mr James raised his arm in response, then took off his hat and coat and sat at the executives' table while microphones were arranged around him. He had come to talk, poignantly, about 'The Seizure of Power'.[40]

He could still stir an aesthetic fuss as well, aligning himself with Toni Morrison, Ntozake Shange and with Alice Walker, whose novel *The Color Purple* would thoroughly enrage one of James's chief literary admirers, Ishmael Reed. (Reed, incidentally, had placed in the mouth of a white character in the novel *Mumbo Jumbo* the deathless curse: 'Son, these niggers writing. Profaning our sacred words. Taking them from us and beating them on the anvil of Boogie-Woogie, putting their black hands on them so that they shine like burnished amulets. Taking our words son, these filthy niggers and using them like they were their god-given pussy. Why ... why 1 of them dared to interpret, critically mind

you, the great Herman Melville's *Moby Dick!*')[41] No matter. James the lifetime reader of literature saw in the evocation of Black women's daily lives (including their collective commitment to religion), their friendships among each other and their forceful character in resisting Black men and white society, the promise of revolutionary possibility undiminished, indeed raised by the consciousness of gender.

West Indian Giant

James's transition from politics to culture, parallel to that earlier undertaken in regard to the industrialized West, arrived at a most propitious moment for the Caribbean. According to Antiguan scholar Paget Henry, the cultural energy of the final colonial period had begun to peter out with the very arrival of independence. The valorization of Blackness which effected writers and cultural innovators alike culminated in the 1960s and early 1970s. Literature and theatre for the middle class, calypso, steel band, ska and reggae music for the masses, all took on national tones. As an unintended sidelight, the old comic ironies of colonial days yielded first to escapism and hedonism, then to a fusion of cultural awareness and commercial appeal.

True cultural independence proved as difficult to achieve as true economic independence. American-dominated media moved in with force. The local cultural systems actually became more comprehensively integrated into a mostly imported culture. Unlike the British, who offered a model version of life out of reach to the native, the Americans supply visions of consumption available piecemeal. The proliferation of writers, singers, theatrical and even ballet companies did not staunch the tide or necessarily give the emerging national societies more self-understanding.[42]

James anticipated the problem, if he could not necessarily offer a viable solution. In the early 1960s, amid the rampant political disappointments of the region, he had begun to emphasize the cultural possibilities which remained alive and urgent. He insisted that the 'supreme artist exercises an influence on the national consciousness which is incalculable', in a possible Caribbean just as in Greece of antiquity, the Florentines in their glory, and Elizabethan England. The very compactness of the virtual city-states in the Caribbean suggested like possibilities. A few novelists had achieved great things already.[43]

Of those, James had often written brief commentaries on his friend George Lamming and on his sometime correspondent V.S. Naipaul. But Wilson Harris struck James as an especially illuminating example, perhaps because Harris's technique stood so far distant from James's

own. Harris was living proof that the serious philosophers of twentieth-century Europe had literary if not analytic counterparts in the Caribbean. The innovations of Heidegger and Jaspers among others, emphasizing phenomenological insights into perception and other normal mental processes, held no mystery for Harris, the Guyanese engineer who had spent decades in the rainforests. In his study of every-dayness and of inauthentic existence, Harris had exceeded the apparently supreme effort of Sartre to transfer philosophical notions into literature. Harris, James says, *knows* that the New World is not going to recapitulate mainstream European rationalism.[44]

Wilson Harris himself likens the New World perception to the alchemical in European traditions, the preoccupation with a 'poetry of science ... informed by a solution of images, agnostic humility and essential beauty rather than vested interest in a fixed assumption and classification of things'.[45]

In a later novel, *The Whole Armour*, Harris in effect interrogates James and through him, Toussaint. Perhaps the uncertainty of post-independence plans by the revolutionary giant suggested not so much an absence of strategy (as James claims) but rather the compulsive 'groping towards an alternative to conventional statehood, a conception of wider possibilities and relationships which still remains unfulfilled today in the Caribbean'.[46] That James has never delivered a rebuttal suggests that he can see Harris's point. The non-rational *has* ruled in the Caribbean from the beginning. The fanciful realism of *Minty Alley* only carried the cultural interpretation as far as possible for the early era. Other possibilities lay by the side in his own generation. James has taken pains to celebrate his contemporary, Aimé Césaire, and *Cahier d'un retour au pays natal* as supreme creator and creation of that early period; indeed, he agrees with surrealist magus André Breton that it is Césaire's use of 'discredited materials' from the daily life of the colonized makes the supreme artistry and the exalting political–aesthetic *négritude* of the text possible.[47]

West Indian cricket might be regarded, like literature, as an extended and revised but nevertheless European form. James admits as much even while lavishing praise upon extraordinary cricketers such as Rohan Kanhai, who (to James's eye) had discovered a new dimension, 'cat and mouse' batting. Music held distinctly different possibilities. Francisco Slinger, known as 'The Mighty Sparrow', had like other calypsonians been shaped and maintained by West Indians themselves, by rules virtually of their own making. Through the independence years and after, Sparrow spoke to Trinidadians with a frankness unknown to politicians, and they spoke back to him in their eager support. Unlike the novelists, he didn't need and indeed could not afford to go abroad for long (after a

time, James insisted, the self-exiled calypsonian lost his touch).[48] He and the steelband marked off the new, post-1950 era:

> I am sure that it is not at all accidental that in the very same decade that the West Indian artists are finding West Indianism, the native popular music and the native popular song find their most complete, their most vigorous expression and acceptance. Here I tread very cautiously but I think I see that our historical existence and the kind of world in which we live, are forcing upon us a rapid combination of historical stages which took centuries in the older nations. Ghana, Ceylon, India do not have the same premises. They have a native language, native religion, native way of life. We haven't. We are Western, [but] have yet to separate what is ours from what is Western, a very difficult task.[49]

'Outsiders' and the West

To that task Sparrow brought his ability to make lines of West Indian speech memorable, and through speech, the West Indian way of thinking. He symbolized and showed the way forward for the masses to express themselves. As James would say later, Sparrow would not make as great a contribution to the post-independence era. He was too successful a part of native capitalism.

With more conceptual difficulty, James located what lay beyond Sparrow's generation, the reggae artist and the rastafarian messianism. If their 'irrationality' was perhaps too strong for James's eclectic tastes, if they spoke considerable nonsense, they echoed Césaire's condemnation of Western values. In response to Bob Marley's death and the international anguish it provoked, James noted that 'for the first time, a West Indian made an international contribution which was not based on an intellectual understanding'. West Indians had, through Marley and others, established themselves, their own meaning, within Britain and America.[50]

It is difficult to measure the impact of this cultural intervention upon the region. As Paget Henry has suggested to me, the emphasis of West Indian politicians upon the urgency of economic growth push James's suggestions, both cultural and democratic, to the sidelines. Moreover, the larger Afro-Pop sensibility in globally popular music by the 1980s – a vindication of Pan-Africanism in a moment of political-economic despair – seems to have come too late for James's understanding. He made his impact through individuals, over the long run, more than any mass movement. This is not necessarily a comfortable tradition. As a writer in the Jamaican *Sunday Gleaner* noted in 1972:

He is [now] being honoured by the young of a society that did not – still does not – know how to use him fully.... They are faced with a man whom they must concede was a revolutionary before they were born. They have had to examine a body of work to which there are no easy answers; only the ceaseless questioning by a magnificent mind of what we can do with each other, in disagreement, man to man [sic].[51]

Beyond the fact of race itself, an elderly James sought to press home two very large points non-racial in character but nevertheless decisively connected with the historical situation of non-whites. These concepts had been with him from the 1920s, in one way or another, and might well stand for his own essential identity apart from the vast range of particulars he has embraced over the decades.

First, James repeatedly described the history of culture, of great literature above all (especially British literature, with which he was best acquainted) as *a history of outsiders*. Some were self-made outsiders, like Byron or Lawrence or (among the French) Rimbaud – those who could not stand their bourgeois surroundings. Most had been really from the outside, from Ireland most obviously (Swift and Shaw among many others), from India (which could claim even Kipling's literary origins), from the West Indies (James frequently reminded audiences that Alexander Dumas had initiated French Romanticism) and more recently, from Africa. What was it the outsider saw? What the insider could not see, social relations stripped of pretence, but also human potentialities undestroyed by the layers of stultifying artificialities. Even Shakespeare, the ultimate insider of a society undergoing tremendous upheaval, saw the outsider characters as the key to the same – as he showed in Othello and in Shylock. James, the colonial littérateur, had seen all this early, but grew more self-conscious of and philosophical about it now.

Second, as James wrote of the Rastafari:

Their world is just beginning. They do not suffer from any form of angst. They have no deep-seated consciousness of failure, no fear of defeat. That is not in their history.... The colossal stupidities, the insanities of the Rastafari are consciously motivated by their acute consciousness of the filth in which they live, their conscious refusal to accept the fictions that pour in upon them from every side.... These passions and forces are the 'classic human virtues'. As long as they express themselves, the form may be absurd, but the life itself is not absurd.[52]

No stronger statement could be made about the disappointments and distortions, seemingly bizarre ideological and cultural manifestations of a world struggling to emerge from Western domination. No towering

historic figure but James proclaimed the inevitability, and justice, of the Rastafarian-linked urban uprisings across Britain in 1981, rising to a fever pitch in James's own adopted Brixton neighbourhood. He did not have to make any claims for himself in order for the most far-sighted of these rebels to recognize him. They knew of him as one knows of an aged prophet, as much myth as human being.

From these two monumental insights, other conclusions could readily be drawn. *The Black Jacobins* had forcefully demonstrated that the 'outsiders' to the West – actually the human sources for vast capital accumulation – had been prime actors from the beginnings of modern revolutionary history. Subsequent developments, the erosion of empires and the rise of new societies, placed the earlier events into proper perspectives. Likewise in culture, the relation of West to non-West has been interactive to a degree rarely suspected. A chief task of the 'post-colonial' intellectual, whatever his or her personal origin, would be to trace that historical interaction in the light of the emerging world culture. Ironically, just as some of James's former political colleagues of the old Workers Party had set themselves upon the public rehabilitation of Western cultural superiority, James's conscious and unconscious disciples across the geographical and language barriers moved to place the great achievements of all world culture into a proper relation with each other and with the common human fate. James, and those who followed him, did not need to give up Shakespeare, the ultimate proper dramatist, in order to honour reggae; they recognized that to understand each is to understand the other better.

These thoughts had a larger political application. In the later 1930s, the 1940s and much of the 1950s, James had emphasized the role of proletariat as outsider whose labour had none the less constructed the physical and social structures which made Western civilization possible. Without renouncing those insights, James followed the evidence which was thrown in relief by colonial revolution back to the point where he had begun his own creative literary and political thought. The proletariat had become the people (largely, peasants or just-removed peasants) and the great artists became those who could grasp the subject just emerging upon the horizon. Toussaint led to Lenin, but Lenin also led to Toussaint.

6

Conclusion:
The Old Man in His Study

Outside, half a mile up Railton Road from the Brixton tube station, the neighbourhood initially looked to me more like a US ghetto than a British slum, too modern in its poverty for my expectations. Inside, at first glance, James's third-floor room seemed stifling: overheated, airless nearly to the point of fetid, and above all claustrophobic. Appearances, as ever, deceive. The atmosphere of American street violence, inhabitant against inhabitant, is missing, even if Brixton nights are scarred by drug-related crimes. Relations between races are warmer, less loaded with suspicions, than in America. Gentrification in various colours will get the neighbourhood long before lumpenization and/or revolution. Meanwhile, James's room has the amenities that the old man wants most.

Since childhood, he held dear the fantasy of laying in bed, brought all the books he wished. His taste for literary variety has diminished in the last few years with his waning energy, but he still returns in spurts to texts brought or sent by admirers ranging from Manning Marable to Edward Said to Edward Thompson. (On my last visit, James made me promise to send him a popular biography of the 1950s–60s Black American baseball star and my own childhood hero, Willie Mays.) One particular admirer, who helped for years to fund his current part-time secretary, built a bookshelf before James's eyes, and brought some order to the approaching chaos – as Hegel might have put it – in both substance and subjects.

Since the 1950s, James has also been a close (both in critical energy and distance from the screen) observer of television, despite the fact that only in recent years has he owned a set. But he virtually always has it on, with an eye straying toward the screen except during the most intense personal conversations. He likes old movies. He likes daytime variety shows. He even likes soap operas, which he claims offer him priceless

insights into the social psychoses of late capitalism. Most of all, of course, he likes cricket. During a test match his attention is inseparable from the video action.

Naturally, then, the visitor's own attention tends to stray from the old man to Anna Grimshaw (apart from being his secretary, she is an anthropologist, a regular contributor to *The Times Literary Supplement* and the most serious James scholar of us all), who brings in pots of tea and sandwiches; and to the noises from the adjoining kitchen, where the *Race Today* collective, composed mostly of bright and amiable Black women working in downstairs offices, cooks snacks for itself and evening meals for him.

I think about a forgotten novel, *Celebrations*, by one-time Workers Party member, Harvey Swados. A Bertrand Russell-like ageing radical spends his final days confronting his somewhat sordid personal past while attempting to hold at bay all the competing courtiers gathered around his prestige and political–intellectual legacy. Some choose respectability for him, holding out links to powerful government leaders; others demand his support for direct-action militance against the evils of poverty and war. The moral of the novel is deliberately ambiguous. (Swados, who had himself become a speech-writer for liberal Democrats, died before the book appeared.) The famed intellectual, who had himself chosen early on to lean toward the mainstream, closes out with a recuperation of youthful radicalism by avowing his own hitherto undisclosed biological paternity for the most articulate young militant around him. The final meaning of this revelation remains open, undetermined.[1]

James is by no means the original for this protagonist. But the coincidence of Swados the novelist and James the world-famous *éminence grise* – both serious artists from the same small political circle – is certainly a striking one. The intellectuals in the WP, as we have seen, themselves emerged into public importance just as they abandoned political activity; they had ample opportunity to ruminate on power and powerlessness. The differences between internationalist James and the fictional, American-style B. Russell (James, it might be recalled once more, debated the real, British one) and how those differences have been acted upon by people around the two, tell us more than a little about radical celebrity and old age.

'"Humble" is not a word one would apply to C.L.R. James,' says Noel Ignatiev, whose twenty years in factories nevertheless humbled the old man into the wish that he, too, had had some of that experience.[2] James speaks with the authority of an internationally-recognized author and a political world figure of the twentieth century. But the setting in which I find him belies what the world knows as celebrity. I remember

meeting James almost fifteen years ago, at a once-splendid but long decayed hotel which served as his residence for teaching in America and also reputedly as a base for a call-girl operation. It was simultaneously grand and greasy. And he was in bed there, too, books scattered about, television on, conversation animated.

In short, and quite unbelievably for the visiting intellectual who expects this Pan-African giant to be accoutred with suitably posh surroundings and prestigious institutional retainers, James remains an old artist–revolutionary at home (and mostly alone at home) within a stone's throw of Britain's historic inner-city riots. Either he never chose the royal road or it never chose him. Unlike his old friend Fenner Brockway who ended up a peer, unlike younger friends and protégés who made their way to Harvard or Oxford or the World Bank, James has no pedigree at all. Not that he would do without good books or good brandy – he would drink it in the daytime if permitted to do so – but he is a thinker from another, more bohemian time before the days of fellowships and prizes awarded to the Left.

For another thing, and unlike the fictional Russell, old age did not sneak up on this graceful gazelle of the intellect. As noted earlier, he seems to have been old forever, which is striking for a former athlete who never suffered anything worse than a stomach ulcer and an automobile accident. A one-time personal secretary, himself a chain-smoking proletarian–autodidact rabbi's son and freewheeling historical dialectician, remarked to me that James seemed intent upon rationing every ounce of strength through studied conservation of energy. He has abandoned public speaking, long his joy and into his late seventies a self-declared duty ('one must perform', he told me after an address in Washington, DC, where he looked weak and ashen moments before summoning his energy for a spirited delivery during which colour came to his face as if he were the sudden recipient of heart by-pass surgery). He did not even show up for the 1986 dedication of a London branch library to him. Nor did he return to his native land to accept the Trinity Cross, Trinidad's highest award, the same year. Sometimes now, when the phone rings, he says to Anna, 'Whoever it is, tell them I'm dead.' A little joke.

And yet he persists, in spirit when the body no longer responds. He told a New York City audience, at the end of an address in 1981 on Polish Solidarity, that he planned to be around for the Revolution. Even if he were not, he added ambiguously, he would in some sense be present. A touch of mysticism once more, not Christian but West Indian and artistic. He has tremendous life-strength, based upon the desire to see his own ultimate curiosity gratified. He always knew that the common people of the world *could* make the revolution. Before the

proliferation of nuclear weapons, he insisted upon the inevitability that they would. He wavers now ('the machines are in control' – his instinctive mistrust, amply justified, for science removed from human values). Or he says frankly that we stand 'at the gates of hell'.[3] But *it could happen.* He wants to know if it will.

In one of his last political messages, written for *Race Today* in 1981, he observed the uprisings of young Blacks and whites in Manchester, during Britain's time of troubles. 'Freedom For All,' he says, sizing up the subject. 'I love that title. Freedom is a very rare thing. It is for example rare in the account of great events.' He then reads from a newspaper account that notes an absence of apparent premeditation in the actions of white and Black youths who met and decided to march on a nearby police station. And he comments:

> That, my friends, is the revolution. There is no highly educated party leading the backward masses. There is no outstanding leader whom the masses follow because of his great achievements in the past. There had been no prearranged plan. They met and joined, they shouted and stormed off (note this particularly) in the direction of Moss Side Police Station.[4]

The point may be summed up a little too neatly. But it is not the revolutionary implications of the particular event which interest him so much; rather, the *flow* of social insurrection, with the familiar anonymity of leaders and the familiar massed energies.

Brought up to that present, 'Polish Solidarity has abolished the contradiction between politics and power, or between the factory and the community.'[5] At least for the space of time permitted its existence. When will that time grow into a sustained reality? James recently told a friend, visiting for the first time since James wrote the preface to a pamphlet of hers about participation in the Spanish Civil War, something like: I'm sorry to be old and dying; but I have the satisfaction of knowing that capitalism is collapsing all over the world. Which means, the Time is not too far distant. Even if the particulars are, in the nature of things, unforeseeable.

Modern Politics

He doesn't dwell upon the subject of World Revolution these days: events of that magnitude will happen whether he says anything more or not. If someone mentions it, he is happy to make his views known. More often, he speaks in specific terms about cultural phenomena, philosophical notions, in short, the world of ideas that has surrounded him all his life.

His approach, his manner of speaking, infallibly recall *Modern Politics*, the attempt to sum up for the public library audience of Port of Spain, Trinidad, in 1960, the general movement of what I would call the World Spirit.

He began with the Greeks, and the secret of direct democracy. Greek experimentation naturally produced direct democracy as the logical form of self-guidance. The balance of the individual and society produced the fully realized citizen, or vice versa. Compared with little Athens, Rome had vast power but less influence on world culture. The Christian prophets, in their revolutionary aspect, knew that the Empire had to be destroyed. Only through that destruction could the necessary peace and harmony be realized.

From this point forward, world history assumes a spiral upward which recapitulates the original in many ways, albeit at ever higher stages. The European City States recreate the local democracy of Greece, but perish of their own internal conflicts. The modern states set out to be modern Romes; but the intensifying struggle inside and against them, from the time of Cromwell to Lenin and beyond, constrains what they do and nearly overthrows them altogether. Philosophers, historians and artists among others develop interpretations. James quotes Rousseau with warmth, for the rebuking of representative government's claims to near-perfection. Rousseau, philosopher of the unrepresented, knew better. So, in a more complicated way, did Hegel, Kant and, inevitably, Marx. But Western Marxism nearly collapsed with the West, after World War I.

Amid the resulting rubble James seeks, as he says, 'a reasonable interpretation [which] allows us to look upon the prevailing barbarism with some sort of confidence not only in human nature but in the development of a new state of society which will allow mankind to give rein and to develop those qualities and characteristics for which people have been struggling over the many centuries'. That's all.[6]

The rest of his text in *Modern Politics*, and most of his conversation a quarter-century later, bear this impress. The Communist state tried the Plan, without any possibility of satisfying human needs and desires; Western living standards have been raised and raised again, while the sense of alienation grows greater. Notwithstanding all the usual claims of progress, 'the good life for a modern citizen is impossible', that is, until the populace itself can democratically master the resources at hand. And something else: we are back to what Gregory Rigsby calls the James's 'Law of Relation' in human affairs. Until community can be achieved, on an international scale, no material advance can meet the most basic psychic needs of the species.

James's own chief contribution to the process, at this late date for

him, is self-clarification. In a related, subtle sense, it always has been. He has lived almost this entire century. His life stands, in many ways, for the century's promise and its multifold disappointments. The prospects for the human species he discovered in Shakespeare more than three quarters of a century ago, and the good life he discovered in the classics about the same time. He returns to the personal sources now, exploring the byways of a spiritual autobiography.

Family Memories

He is, despite a recurrent imprecision of memory for names, places and date, alive with the memories of his early days. These memories (as so often described in geriatric practice of any kind, most especially the kinds of interviewing I've done with old-time radicals) grow if anything more vivid, his discussion about personal details more candid. He is no exhibitionist but he has no reason to hold back.

He has for years been intensely interested in his place within the extended family that he knew when growing up. He feels himself, more than ever, one of them. But he now puts special emphasis upon his mother's influence. 'The centre of my life', he calls her. Because she was a unique personality, he could become one.

This intimation seems to conflict with his reflections of forty years ago on the lack of love he felt for her, even when she appeared to be mortally ill. That C.L.R. James felt a rush of longing when she died, and a sense of satisfaction that he had made her proud of him. This James has placed a more complex interpretation around the effect of her distant quality upon him. Perhaps it is simply that he can see better how she shaped him as a writer. The domestic confrontation between her and his father (the 'notable philistine') represents a classic attack upon patriarchal hegemony. Her singular triumph, the exultant 'You see!' when her son became an internationally-recognized author, was her key victory and her vindication.

Of course, perhaps James has painted a mental portrait idealized like those of later women in his life, a vision uncomplicated and uncompromised by reality. But we may recall one of his own favorite maxims, that the old man repeats the prayers he said as a child, but with the knowledge of a lifetime. He *admired* his mother the literary personality. *Minty Alley*, dedicated to her, is in a sense her book. We see here and in every hidden corner of his life the literary possibility she encouraged in him, an artistic approach toward subtleties of scene and character and the self-conception of the artist as a vital part of the scene.

If so, then the confrontation with feminism (or the so-called 'sex war', in its many earlier twentieth-century forms) should logically have been resolved better in James's own life. He might have attained the one satisfaction denied to him by fate, or by his own insufficient consciousness. He would presumably have protected himself against his deepest fears. He has dreaded, for at least twenty years, being left alone. For good reason. A sense of guilt or at least failure on this score infiltrates his recollections. He views his past generally with a suitable pride. He cannot view it without equanimity.

Then, again: it is precisely the contradictions of James's own life which have opened up his awareness to social contradictions. Ideas, he has written, move by contraries – an old thought but one especially suited to him. Without over-psychologizing, or viewing his entire life as a manifestation of childhood experiences, we can readily see that the emotional aloofness of his mother helped him to substitute art for life (or love), and that when politics supplanted art the hierarchy remained nevertheless in place. The unsatisfied dimension impelled him from relationship to relationship, sharpening his keen sense for women's outrage upon his own tender nerves. *Minty Alley*, and even more his short story 'Triumph', reveal a precocious self-consciousness upon this score. He returns to it, at the end of life, with a level of emotion that surprises the visitor. A more suitable intellectual companion and aide-de-camp than Anna Grimshaw, feminist and anthropologist, could not be imagined. And he knows it.

Prospero or Caliban?

I see this dimension of his character as a rune upon the final subject of this book, the importance C.L.R. James's ideas hold for the modern world. Between Prospero and Caliban, the active role seems to fall to the former, the reactive to the latter. Or so the relation has generally been discussed. But perhaps we have got it backward, and when James discovered the Master–Slave relation in Hegel he merely recognized what he had suspected all along to be true. Early experience permitted him a rare glimpse at the personal dynamics of history's revolutionary moments.

Within a year or two after I had come into contact with his ideas, they seemed the single beacon, from the illumination of older political generations, upon the world before our eyes. As the campuses and ghettos grew bright with incendiary light, Jamesian theory explained so perfectly the culmination seemingly at hand. The rest of the 'Old Left', inveterate members and refugees, reprimanded us for our failures to establish solid

organizations and responsible officers. James thought differently. He caught the unique quality of the radicalism in the era, quite genuinely in line with predictions he and his collaborators had made since the middle 1940s.

In addition to his Pan-African appeals, with all their resonance for young Black intellectuals, he had set out methodological guidelines and key texts for political education. He made Marxism coherent as a theory of mass revolt, and Leninism humane as an organized insight into the central role that Third World masses would play. He intuitively understood our desires and our sense of rage as well as did Herbert Marcuse. Unlike Marcuse, he was capable of giving us very serious tactical advice. 'None of the regular institutions must be allowed to enter into negotiations on behalf of any section of the revolution', James warned,

> Over the next period new upheavals must understand this from the very beginning. Students will represent students and discuss with university staffs. Workers will represent workers, peasants will represent peasants, blacks will represent blacks, women will represent women.... No question of anarchism arises here. The very structure of modern society prepares the working class and sections of society to undertake immediately the creation of socialist institutions....
>
> Marxists have to be quite clear as to the stage of development so as to be able to recognize, welcome and intensify the advances that are taking place instinctively in the nation and in the world at large. This work has to be done. The greatest mistake would be not to do it at all. Equally mischievous would be the idea that it can be done apart from the concrete struggles that are taking place everywhere. The World Revolution has entered in what could be a decisive and final stage.[7]

Of course, the timing of this advice was off. Capitalism and Communism had already begun to recuperate from the blows struck in Paris, Prague and so many American campuses. The fierce struggles of the next few years, from Portugal to the Caribbean, could be safely isolated and turned back.

James had certainly not helped as precisely as we hoped, perhaps because we were listening for the wrong things. We joined, in one fashion or another, a Children's Crusade from the universities to the factories and blue-collar communities. There, enlightened (we thought) as no generation of previous radicals, we would proclaim the revolutionary imperative. Marx's *1844 Economic–Philosophical Manuscripts* had been written, we believed for a few years, not for James's milieu of the 1940s but for us! It was our society which questioned, deeply and popularly, the worthwhileness of wage-labour and the alternatives. It was we who had come to the end of the road in automation and intensi-

fication of labour. Those of us faithful, in whatever our way, to the spirit of the 1960s bent many a bottle (and puffed out many a joint) in the ritual of self-pity over our failure.

And yet even in our defeat, he gave us a method to ponder. In the words of a poet and newspaperman, speaking of how the masses do not think as the intellectuals do, James's insight

> can serve as a tombstone for the New Left, an epitaph both for those who withdrew into theory and sealed the tomb after them with the declaration that theory was all that remained of practice; equally for those who impatiently – and, as they sometimes correctly imagined – stepped forward to 'accept' the leadership of history before being ground down by it. That's the rebuke.
>
> The consolation, of course, is the assertion that for the masses 'the matter goes deeper'. Despite the repeated failure of American intellectuals to make decisive interventions into the historical experience of the masses in recent history ... the process continues in the daily experience of ordinary people. Hope is not absent.[8]

The thought is profoundly Jamesian, and even more profoundly suited for the political vacuum which has not yet been filled.

But something still waits. Have we passed the day when the industrial worker and the socialization of specifically *industrial* labour can still be described, in the West, as the source of revolutionary change? If so, what remains of Marxism? Faced with past eras of relative conservatism in the Western proletariat, James has preferred almost always to dig deeper, toward the most oppressed strata, Black workers and women. These workers and their community-support networks, he has insisted, would energize the working class in general, on parallel international and national levels.

I press the old man a little on these questions, because his earlier answers seem to evade a major philosophical point dreadfully clarified by the present sharp decline of the Western industrial workforce. Perhaps that specific proletarian mission was destined never to happen? In a symposium I organized for predictions about the 1980s, he wrote something that probably would still stand. The 'workers and peasants must realize that their emancipation lies in their own hands and in the hands of nobody else'.[9] Perhaps his larger view, masses of all kinds from various rebellious strata in motion to replace representative with direct democracy, has become the proper perspective for the dusk of the twentieth century?

He demurs from an absolute judgement. He cannot quite believe in the scale of industrial displacement now underway. It has come too recently for him to weave it thoroughly into his system. Second, and perhaps more important, he forswears any definitive geopolitical

prediction of specific revolutionary developments ahead. Any revolt, he ventures to suggest, will be crushed unless it spreads region-wide, or unless it occurs within such a balance of forces that repression becomes impossible to implement.

Is this all? Certainly not. But in order to project from his interpretations, we need to draw in the other elements whose relationships with political strategy he has never quite made clear. For this we return one last time to Wilson Harris, the C.L.R. James (so to speak) of modernist West Indian literature. Harris, ever the prophetic voice, argues that James's work is full of intuitive realities which appear to take one shape and then suddenly, with a shifting context, take on another set of relations entirely.

James and the West

Sandra Drake, in the most important study of Harris to date, puts the matter into the largest possible context. The formation of Western Man presumed the Other, in the populations and geographies conquered, and for a millennium the West reinforced its self-conception upon that Otherness. Of course (Drake does not add here) the woman, the peasant and the handicraft worker had long provided existing Others (so did the Jew, Catholic, Protestant, and so on, for various societies) and would continue to do so. But the opening of the New World along with expanded raids upon the Old gave a fresh meaning to the bi-polarities.

From World War I onward, as James has frequently averred, the West has been palpably in decline, relatively speaking, and its intellectuals borne the weight of the *Weltschmerz* or at least articulated it best. Seen from the other (or Other) side, however, the unleashing of the non-West, under whatever wretched political and physical conditions, reintroduces possibilities latent for centuries.

The psychic dimensions inherent in this development can scarcely be exaggerated. 'The behavioural sciences which coloured Marxism' (writes Harris) 'have underestimated the life of the psyche and of the intuitive imagination in its peculiar densities and cross-cultural values.'[10] Drake sees the result as 'de-centering', in the post-structuralist argot. But unlike most post-structuralists, even those from the Left, she sharply differentiates the possible implications. On the one hand, de-centering can bring an implosion of the self, so evident in the writings of Jacques Derrida, in which the very process of learning language alienates the child helplessly from an organic connection with reality. Down this road lies desolation and despair. On the other hand, de-centering may bring a reconciliation of the myriad varieties of particular genius, not merely of

a few powerful cultures in our own age but of every cultural expression from the past which is still, in any meaningful sense, recuperable.[11]

That is a different, broader 'political' reading of James. It encompasses not only the writer's ideas but the experience of the writer himself. For James's life, from childhood to the present day, is in fact synonymous with the process of de-centering. The breakdown of the West coincided with his own first assumption of self-identity before the little world of Trinidad, in school and on the cricket pitch. His life, by this reading, has been inscribed upon the fork of those two great possibilities, barbarism or communitarian world society.

A Jamesian Politics

A Jamesian politics, for the end of the twentieth century and beginning of a new millennium, would surely begin with the wholesale changes wrought in world politics and the world economy since James effected his fullest theoretical 'system' roughly forty years ago. The breaking point appeared with the calamity of World War II and the impossibility of recovery short of socialism. The breaking point now must be seen as the flat impossibility of global survival on the present class-dominated basis. Nothing *less* than James's vision of direct democracy can overcome the disadvantages set against us, from chemical poisoning, deforestation and vast species eradication to nuclear war.

James's intimations in *Mariners, Renegades and Castaways* about the portentous links between First and Third Worlds have been borne out with a vengeance. Ahab's contemporary Tashtego, the Ayahtollahs and Zias, have acquired the finances, the skills of mass mobilization and even the weaponry that Ahab once reserved strictly for his own kind. Where, then, is the invisible thread running from Ishmael to Queequeg?

One very hopeful sign is that the polarities have begun to be reversed here. Generations of Western radicals have gone to school with the ideas of James, Gandhi and Amilcar Cabral among many others. The true history of the cosmos or at least the world, once written cryptically upon Queequeg's body, has become universally available in outline form. The code of race has not been shattered, but it has been eroded beyond restoration to the original absolutes. The gauntlet has also been thrown down within the intimate surroundings of the imperial centres, by the challenge to male prerogatives and the price they have demanded. The questions of class remain open. The current flux is tremendous. But James's working class, alienated and enraged at the quality of labour itself ('Be his payment high or low,' as Marx put it and James's group styled their agitational pamphlet of the 1960s), has not vanished by any

means. It has grown world-wide, more educated, more sophisticated by far than ever before.

One of the less-understood facets of Jamesian politics has been the insistence upon the obsolescence of the national state. He acquired this understanding quite naturally within the mini-societies of the Caribbean, and came to understand it better in Europe. He has never ceased to preach federation to the West Indies and has put it forward to Africans when opportunity permitted. The obstacles remain tremendous but the needs steadily more obvious. Federation will come, if only to meet calamity.

'There is only one human nature,' James told me, a conclusion he appropriated from the four great Shakespearian tragedies, *Hamlet, King Lear, Othello* and *The Merchant of Venice*. That nature, he learned from Marx's *Eighteenth Brumaire*, is to retreat from rebellion as long as possible and then to move with lightning speed when alternatives have disappeared. A Jamesian schema, if he allowed himself such revolutionary shortcuts, might be an economic and social crisis in the USA which permitted (or forced) both sides of the Caribbean, the West Indies and the Central Americas, into socialistic federations of their own making. A successful democratic resolution in Southern Africa could turn the tide likewise toward federation, in that part of the continent. Sweeping Russia and its dependencies, a transformation of which *perestroika* is the merest preparation could restore the promise of the 1917 revolution.

Much of the world remains missing from this mini-portrait. But the final steps, with reconciliations as seemingly unlikely as Arab and Jews, depend upon the validity of James's cultural intuitions as much as any political formulations. How is it possible that James, the lover of Verdi, felt himself no less drawn to Louis Armstrong, or the devotee of Thackeray considered cricket to have been his worldly education? The answer cannot be eclecticism, for nothing in James's worldview is out of place. For him, human nature encompasses all this and more. We have only to place the contemporary fracture-lines in a new light. And to recognize in age-old resentments against privilege of every kind a glimmer of universality awaiting escape from confinement.

The road will not be easy. It has never been. But the look of confidence the old man retains, beneath and beyond the immense tiredness he projects, has good prospects of vindication. At least he thinks so. And I, a disciple as heterodox and independent-minded as he could hope for, can only agree.

C.L.R. James:
A Brief Chronology

1901 Born, Port of Spain, Trinidad.

1910 Wins island exhibition to Queen's Royal College.

1918 Graduates from QRC with School Certificate.

1928 First short story published.

1929–30 Publishes two issues of literary journal *Trinidad*, with Alfred Mendes.

1930 Marries for first time, Port of Spain, to Juanita.

1932 Leaves Trinidad for London, and goes to Nelson, Lancashire; begins giving political lectures. First appears in *Manchester Guardian*, cricket column; *The Life of Captain Cipriani: An Account of British Government in the West Indies* published.

1933 Joins Marxist Group, moves to London; *The Case for West-Indian Self Government* published, revised version of *The Life of Captain Cipriani*. James winters in France to study the 1791 Revolution in San Domingo.

1934 Joins Marxist Group within Independent Labour Party and becomes active in Finchley (North London) ILP Branch.

1935 Collaborates with Amy Ashwood Garvey in forming the International African Friends of Ethiopia, in response to the Abyssinian crisis.

1936 James's play *Toussaint L'Ouverture* is performed in London, with Paul Robeson in the lead; *Minty Alley*, James's only novel, appears.

1937 *World Revolution 1917–1936: The Rise and Fall of the Communist International* appears. James joins George Padmore who had taken the lead in forming the International African Service Bureau (to replace the International African Friends of Ethiopia); assumes editorship of IASB publication, *International African Opinion*. Founds and edits Trotskyist tabloid, *Fight*.

1938 *The Black Jacobins: Toussaint L'Ouverture and the San Domingo Revolution* and *A History of the Negro Revolt* appear. James leaves England for the USA and begins extensive speaking tour for Trotskyist movement.

1940 With collaborators, leaves Socialist Workers Party for Workers Party; with Raya Dunayevskaya and others, forms Johnson–Forest Tendency.

1941 Active in South-East Missouri, speaking and writing for sharecroppers.

1942–9 Lives in New York City; writes frequently for *The New International* (until 1947); a leader of the Workers Party, then the Socialist Workers Party; writes *Notes on Dialectics*, issued in mimeographed form, and published as a book decades later.

1950 *State Capitalism and World Revolution* written in collaboration with Grace Lee and Raya Dunayevskaya; with Johnson–Forest Group, James leaves Trotskyist movement entirely. Divorced from Juanita James, marries Constance Webb.

1952 Interned on Ellis Island, as undesirable alien.

1953 *Mariners, Renegades and Castaways* appears; James expelled from the US to England.

1954 Returns to cricket journalism, *Manchester Guardian.*

1955 Divorced from Constance Webb.

1956 Marries Selma Weinstein.

1958 *Facing Reality*, a US group document, published; James returns to Trinidad as editor of *The Nation*, organ of People's National Movement.

1960 *Modern Politics*, series of Port of Spain lectures, published; James breaks politically with Dr Eric Williams.

1962 Returns to England; *Party Politics in the West Indies* published.

1963 *Beyond a Boundary* published.

1965–6 Re-enters Trinidad, placed under house arrest and then released; founds Workers' and Farmers' Party, which unsuccessfully contests 1966 elections.

1967–8 Lecture tour, East and West Africa.

1968–80 Permitted to re-enter USA for lectures and for university appointments, mostly at University of District of Columbia.

1970 *The C.L.R. James Anthology*, first selection of writing appears, published as *Radical America*, IV (July–August 1970), edited by Paul Buhle.

1974 Initiates call for Sixth Pan-African Congress.

1977 *Nkrumah and the Ghana Revolution*, also *The Future in the*

Present, first volume of *Selected Writings,* published.

1980 *Spheres of Existence,* second volume of *Selected Writings,* and *Notes on Dialectics* published.

1980 Returns to Trinidad to live, hosted by Oilfield Workers Trade Union.

1981 Returns to London, moves to Brixton.

1982–3 Relationship with Selma James terminated, but divorce never finalized.

1984 *At the Rendezvous of Victory,* third volume of *Selected Writings,* published.

1986 *Cricket,* selected writings, edited by Anna Grimshaw; and *C.L.R. James: His Life and Work,* edited by Paul Buhle, appear. James awarded Trinity Cross, highest distinction of Trinidad.

C.L.R. James:
A Select Bibliography*

Books by C.L.R. James

Selected works in three volumes:

The Future in the Present (London, Allison & Busby, 1977).
Spheres of Existence (London, Allison & Busby, 1980).
At the Rendezvous of Victory (London, Allison & Busby, 1984).

Other major works (in order of original publication):

Minty Alley (London, New Beacon Books, 1971 edition from 1936 original).
World Revolution (Nendeln, Kraus, 1970 edition from 1937 original).
The Black Jacobins: Toussaint L'Ouverture and the San Domingo Revolution (London, Allison & Busby, 1980 edition from 1938 original).
A History of the Pan African Revolt (London, Race Today 1986 edition from 1938 original).
Notes on Dialectics: Hegel, Marx, Lenin (London, Allison & Busby, 1980 from 1948 private circulation and 1965 mimeographed editions).
State Capitalism and World Revolution, written in collaboration with Raya Dunayevskaya and Grace Lee Boggs (Chicago, Charles H. Kerr Co., 1986, from 1950 original).
Mariners, Renegades and Castaways: The Story of Herman Melville and the World We Live In (London, Allison & Busby, 1986, from 1953 original).
Facing Reality (Detroit, Bewick Ed., n.d. [1973], from 1956 original).
Modern Politics (Detroit, Bewick Ed., 1973, from 1960 original).
Beyond a Boundary (New York, Pantheon, 1983, from 1963 original).

*A comprehensive bibliography, compiled by Margaret Busby, is appended to *At the Rendezvous of Victory.*

Nkrumah and the Ghana Revolution (London, Allison & Busby, 1977).
Cricket (selected writings, edited by Anna Grimshaw; London, Allison & Busby, 1986).

Books About C.L.R. James

Paul Buhle, ed. *C.L.R. James: His Life and Work* (London, Allison & Busby, 1986, from 1981 original).
Kent Worcester, *C.L.R. James: A Political Biography* (Lanham, Md, North & South, 1988).

Notes

All C.L.R. James's correspondence is quoted with permission of Constance Webb.

Introduction

1. Letter from Wilson Harris to the author, 2 September 1987.
2. Unpublished address, Wilson Harris, 'C.L.R. James as Writer and Critic', delivered at Riverside Studios, Hammersmith, London, February 1986; manuscript supplied by author and quoted with his permission.
3. 'The West Indies: Microcosm', in Paul Buhle, Jayne Cortez, Philip Lamantia, Nancy Joyce Peters, Franklin Rosemont and Penelope Rosemont, eds. *Free Spirits* (San Francisco 1982), p. 93.
4. Wilson Harris, 'C.L.R. James as Writer and Critic'.
5. Wilson Harris, 'A Unique Marxist Thinker', in Paul Buhle, ed., *C.L.R. James: His Life and Work* (London 1986), pp. 230–31.
6. Perry Anderson, *In the Tracks of Historical Materialism* (London 1983), p. 15.

Chapter 1

1. 'On Wilson Harris,' 1956 pamphlet reprinted in *Spheres of Existence* (London 1980). The novel is Harris's first and most famous, *Palace of the Peacock* (London 1960).
2. C.L.R. James, *Beyond a Boundary* (New York 1983), p. 131. See also Eric Williams's critique of the region's deplorable treatment at the hands of scholars, *British Historians and the West Indies* (London 1964).
3. George Lamming, *The Pleasures of Exile* (London 1984), p. 152.
4. *The Black Jacobins* (New York 1963), Ch. II; 'The Middle Classes', *Party Politics in the West Indies* (Port of Spain 1962), pp. 130–9.
5. See C.L.R. James, 'Introduction' to J.J. Thomas, *Froudacity* (London 1969).
6. C.L.R. James, *The Case for West-Indian Self Government* (London 1933), pp. 7–8.
7. Gordon K. Lewis, *The Growth of the Modern West Indies* (New York 1968), p. 63.
8. The best treatment is Eric Williams, *History of the People of Trinidad and Tobago* (Port of Spain 1962), Ch. VII–VIII.
9. Williams, *British Historians and the West Indies*, Ch. IX. It should be noted that

Trinidad was joined to nearby island Tobago by an imposed Act of Union, 1888–9.

10. Williams, History, p. 190 and all of Ch. IX.

11. Ibid., pp. 180–81; James, *The Case for West Indian Self-Government* (as the *Life of Captain Cipriani* was retitled), Ch. I.

12. Paget Henry, 'Decolonization and Cultural Underdevelopment in the Commonwealth Caribbean', in Paget Henry and Carl Stone, eds., *The Newer Caribbean: Decolonization, Democracy, and Development* (Philadelphia 1983).

13. Quoted in William Aho, 'Steelband Music in Trinidad and Tobago – the Creation of a People's Music', unpublished essay, 1986.

14. See the full-length version of Sylvia Wynter's essay, 'In Quest of Matthew Bondman: Some Cultural Notes on the Jamesian Journey', in Paul Buhle, ed., 'C.L.R. James: The Man and His Work', *Urgent Tasks*, no. 12 (Summer 1981).

15. See Charles and Angela Keil, 'Polka Happiness', in Paul Buhle, ed., *Popular Culture in America* (Minneapolis 1987).

16. *Beyond a Boundary*, p. 18.

17. Ibid., p. 25.

18. James to Constance Webb, July 1944, Schomburg Collection, New York Public Library.

19. Ibid.

20. Ibid., James to Webb, undated, 1944.

21. James to Webb, 13 September 1944.

22. Interview with James by Paul Buhle, May 1987.

23. *Beyond a Boundary*, p. 32.

24. Wynter, 'In Quest of Matthew Bondman'; *Beyond a Boundary*, p. 42.

25. *Beyond a Boundary*, pp. 50, 41.

26. Ibid., p. 28.

27. Ibid., p. 59; James to Webb, 13 September 1944.

28. Ibid., p. 40.

29. Untitled manuscript, C.L.R. James Archives.

30. Interview with James by Paul Buhle, May 1987.

31. V.B. Karnik, *M.N. Roy, [a] Political Biography* (Bombay 1978), Part 1.

32. Harry Haywood, *Black Bolshevik: Autobiography of an Afro-American Communist* (Chicago 1978), Ch. I–II.

33. James R. Hooker, *Black Revolutionary: George Padmore's Path from Communism to Pan-Africanism* (New York 1970), Ch. I.

34. Wynter, 'In Quest of Matthew Bondman', pp. 58–9.

35. *Beyond a Boundary*, p. 71.

36. Ibid., p. 76.

37. Lewis, *The Growth of the Modern West Indies*, p. 206; Williams, *History of the People of Trinidad and Tobago*, pp. 224–5; *Beyond a Boundary*, pp. 117–18.

38. Interview with James by Paul Buhle, May 1987.

39. *Beyond a Boundary*, p. 71.

40. 'Discovering Literature in Trinidad: the Nineteen-Thirties', *Journal of Commonwealth Literature*, July 1969, reprinted in *Spheres of Existence*, p. 238. See also the selection from *Trinidad* and *The Beacon*, in *From Trinidad: An Anthology of Early West Indian Writing*, edited by Reinhard Sander (London 1978).

41. See Rhonda Cobham, 'Introduction' to Alfred Mendes, *Black Fauns* (London, 1984); Cobham, 'The Background', and Reinhard W. Sander, 'The Thirties and Forties', both in Bruce King, ed., *West Indian Literature* (Hamden, Connecticut 1979).

42. Quoted in Kenneth Ramchand, 'Introduction', *Minty Alley* (London, 1971), p. 9.

43. Quoted in Ramchand, 'Introduction', *op. cit.*, pp. 6–7.

44. Ibid., p. 10.

45. C.L.R. James, 'La Divina Pastora', *Saturday Review*, October 1927, reprinted in *Spheres of Existence*, pp. 5, 8.

46. C.L.R. James, 'Turner's Prosperity', in *Spheres of Existence*, pp. 9–13.

47. C.L.R. James, 'Triumph', *Trinidad*, 1929, reprinted in *The Future in the Present* (London 1977), p. 11.

48. Ibid., p. 15.
49. Ibid., pp. 14–16, 18, 24.
50. Sylvia Wynter, 'James and West Indian Culture', in *C.L.R. James's West Indies*, edited by Paul Buhle and Paget Henry (forthcoming); see also e.g. Selwyn Cudjoe, *Resistance and Caribbean Literature* (Athens, Ohio, 1980), Ch. VII, or James's own classic treatment in the Appendix to *The Black Jacobins*.
51. 'Triumph', p. 17.
52. Gregory Rigsby, 'The Gospel According to St James', pp. 223–4; Sylvia Wynter, 'James and West Indian Culture'.
53. See Elliot Parris, 'Minty Alley', in Paul Buhle, ed., *C.L.R. James: His Life and Work* (London 1986).
54. C.L.R. James, *Minty Alley* (London, 1971), p. 169.
55. Ibid., p. 244.
56. 'Triumph', in *The Future in the Present*, p. 12.
57. Interview with James by Paul Buhle, September 1987; James to Webb, no date, 1944.
58. James to Webb, 4 January 1944.
59. Interview with James by Paul Buhle, September 1987.
60. Ibid.
61. *Minty Alley*, p. 168.
62. C.L.R. James, 'My Life With Women', in Paul Buhle and Paget Henry, eds, *C.L.R. James's Caribbean*, London 1988.
63. C.L.R. James, *The Case for West-Indian Self Government* (London 1933), p. 32.
64. *The Life of Captain Cipriani*, especially pp. 15–40.
65. *Beyond a Boundary*, pp. 116–17.
66. Unpublished memoirs; C.L.R. James, 'Paul Robeson: Black Star', in *At the Rendezvous of Victory* (London 1984), pp. 259–64.

Chapter 2

1. C.L.R. James, 'George Padmore: Black Marxist Revolutionary – a Memoir', a 1976 lecture printed in *At the Rendezvous of Victory* (London 1986), p. 254.
2. C.L.R. James, *Beyond a Boundary* (New York 1984), p. 113.
3. Ibid., p. 115.
4. Ibid., p. 121.
5. Ibid., p. 124.
6. Robert Hill, 'In England 1932–1938', in *C.I..R.James: His Life and Work*, pp. 66–7.
7. Neville Cardus, *Autobiography* (London, 1985), Part One.
8. *The Sporting Chronicle*, 18 July 1932, reprinted in C.L.R. James, *Cricket* edited by Anna Grimshaw (London 1986), p. 5.
9. C.L.R. James, 'The Greatest of All Bowlers: An Impressionist Sketch of S.F. Barnes', published in *Manchester Guardian*, 1 September 1932, reprinted in *Cricket*, pp. 7–10.
10. C.L.R. James, 'Lancashire's Bleak Cricket', *Manchester Guardian*, 20 August 1934, reprinted in *Cricket*, p. 40.
11. Eric Williams, *Inward Hunger: the Education of a Prime Minister* (Chicago 1969), p. 77.
12. James to Constance Webb, 7 July 1944. Also see the incisive account of London days for the 1930s West Indians in Ivar Oxaal, *Black Intellectuals Come to Power: The Rise of Creole Nationalism in Trinidad and Tobago* (Cambridge, Massachusetts 1968), Ch. IV.
13. Stuart MacIntyre, *A Proletarian Science: Marxism in Britain 1917-1933* (Cambridge 1980), Ch. I-V.
14. James Jupp, *The Radical Left in Britain 1931-1941* (London 1982), Ch. V.

15. Sam Bornstein and Al Richardson, *Against the Stream: A History of the Trotskyist Movement in Britain 1924–38* (London 1986), pp. 176–80. For another account, see the pamphlet *C.L.R. James and British Trotskyism: An Interview* (London 1988), especially pp. 1–10.

16. Bornstein and Richardson, *Against the Stream*, Ch. X; Oxaal, p. 69. Decades later, James would say about his experience with British Trotskyist grouplets, 'I left them, which is the strongest of all comments....' *C.L.R. James's 80th Birthday Lectures* (London 1981), p. 65.

17. C.L.R. James, 'Is This Worth a War? The League's Scheme to Rob Abyssinia of its Independence', *New Leader* 4 October 1935, reprinted in *At the Rendezvous of Victory* (London 1984), p. 16. See also C.L.R. James, 'The Workers and Sanctions: Why the ILP and the Communists Take an Opposite View', *The New Leader*, 25 October 1936, summarized in Bornstein and Richardson, *Against The Stream*, pp. 183–4.

18. *Against The Stream*, pp. 248, 254–6; Fenner Brockway, *Inside the Left* (London 1942), p. 326; James, 'Revolutionary Socialist League', *Fight*, April 1938; and 'Whither the ILP?', ibid., October 1938, for James's critique of the ILP.

19. C.L.R. James, *World Revolution* (London 1938), p. 37.

20. Ibid., pp. 52–3.

21. Ibid., p. 147.

22. Ibid., p. 162.

23. Ibid., p. 311.

24. P. Olisanwuche Esedebe, *Pan-Africanism: The Idea and Movement, 1776–1963* (Washington, DC 1982), Ch. II, especially pp. 81–96.

25. Tony Martin, *Race First: The Ideological and Organizational Struggles of Marcus Garvey and the Universal Negro Improvement Association* (Westport, Connecticut 1976), p. 13.

26. Ibid., Ch. XI.

27. T.J.S. George, *Krishna Menon: a Biography* (London 1964), especially Ch VII.

28. James Hooker, *Black Revolutionary: George Padmore's Path from Communism to Pan-Africanism* (New York 1967), pp. 35–6.

29. Quoted in Esebede, *Pan-Africanism*, p. 118, from *The Keys* (Jan.–Mar. 1936).

30. T. Ras Makonnen recorded and edited by Kenneth King, *Pan-Africanism from Within* (Nairobi 1976), pp. 116–17; Robert Hill, 'In England 1932–1938', pp. 74–7.

31. Esebede, *Pan-Africanism*, pp. 122–4.

32. Makonnen, *Pan-Africanism from Within*, pp. 112–20; interview with James by Paul Buhle, September, 1987.

33. James's recollection 'Paul Robeson: Black Star', in *Spheres of Existence*, pp. 256–64.

34. *A History of Pan-African Revolt* (Washington, DC, 1969 edition of *A History of the Negro Revolt*), pp. 76–7.

35. Ibid., pp. 76–7.

36. Ibid., p. 82.

37. Ibid., p. 100.

38. See E.P. Thompson, *The Making of the English Working Class* (London 1963); Christopher Hill, *Puritanism and Revolution* (London 1958), and *Intellectual Origins of the English Revolution* (Oxford 1965), among other of Hill's distinguished works.

39. C.L.R. James, *The Black Jacobins: Toussaint L'Ouverture and the San Domingo Revolution* (New York 1963), p. 7.

40. Ibid., pp. 25–6.

41. I owe this point to a conversation with Robin Blackburn.

42. *The Black Jacobins*, p. 283.

43. J.R. Johnson, 'The Negro Queston', *Socialist Appeal*, 28 August 1939.

44. James, unpublished autobiographical manuscript.

45. Fredric Warburg, *An Occupation for Gentlemen* (London 1959), pp. 214–15.

46. George Lamming, *The Pleasures of Exile* (London 1984), p. 153.

47. James to Webb, undated 1944.

48. Unpublished ms, James Archives. Also undated letter, James to Webb [1944?]: 'I

was sick for a year at losing her but then I came to America. Since then I have thought over it a lot, and have learnt much.... Beautiful as she was she felt instinctively that physically my need for her was not overpowering. In that respect she wanted me more than I wanted her. And as she was not a half-way person, she hesitated and finally said no, we had better part.'

49. Lamming, *The Pleasures of Exile*, p. 153.

50. *Beyond a Boundary*, p. 128.

Chapter 3

1. See Tim Wohlforth, *The Struggle for Marxism in the United States* (New York 1968), pp. 23–5. For the history of US Trotskyism, see also James P. Cannon, *The History of American Trotskyism: Report of a Participant* (New York 1944).

2. Constance Webb, 'C.L.R. James, the Speaker and His Charisma', in Paul Buhle, ed., *C.L.R. James: His Life and Work* (London 1986), pp. 168–9.

3. Discussion printed in *Leon Trotsky on Black Nationalism and Self-Determination* (New York 1967); especially Section 4; James, unpublished autobiographical ms.

4. Ibid.

5. J.R. Johnson, 'The Negro Question', *Socialist Appeal*, 22 August 1939.

6. Ibid.

7. J.R. Johnson, 'The Negro Question', 25 August 1939.

8. See e.g., J.R. Johnson, 'Labor and the Second World War', *Socialist Appeal*, 27 October and 14 November 1939; 'The Negro Question', 1 December 1939, 6 January and 13 January 1940. His final column appeared 9 March 1940.

9. 'Origins of the Crisis', internal SWP document [1940?], Socialist Party Papers, Duke University.

10. Letter to Constance Webb, 6 August 1943; Schomburg Collection, New York Public Library. Raya Dunayevskaya's account of their relationship differs from this biography in attributing less warm feeling between the two Tendency leaders. See, for example, Dunayevskaya, 'The Emergence of a New Movement from Practice that is Itself a Form of Theory', in *A 1980s View: The Coal Miners' General Strike of 1949–50 and the Birth of Marxist–Humanism in the US* (Chicago 1984).

11. H.L. Mitchell, letter to author, 1983; James, unpublished autobiography.

12. Leah Grant-Dillon and Stan Weir interviews (conducted by Paul Buhle), OHAL Archives, Tamiment Library, New York University.

13. See especially James's letters to Webb, 15 December 1943; April 1945[?]; Constance Webb, correspondence with author, 1987.

14. Stanley Weir, 'Revolutionary Artist', in *C.L.R. James: His Life and Work*; and Weir interview, OHAL Archives.

15. Wohlforth, *Struggle*, pp. 38–9.

16. 'Origins of the Crisis'.

17. See the Daniel Bell File, Columbia University, for evidence of Trotskyist activity within the UAW. See also Paul Buhle, ed., *The Legacy of the Workers Party, 1940–49: Recollections and Reflections* (New York 1985). Interviews with Stan Weir and Paul Andreas Rasmussen (an SWP factory militant expelled from the Trotskyist movement shortly after World War II), OHAL Archives.

18. See the essay–introduction to Paul Buhle, ed., *The Madison Intellectuals* (Philadelphia, forthcoming, 1989), on the presence of anti-state radicalism during World War II; and see James P. O'Brien, 'Charles A. Beard', *Radical America*, IV (November-December 1970), for reflections on the slanders against Beard and the implications for the writing of US history. On wartime strikes and their context, George Lipsitz, *'A Rainbow at Midnight': Class and Culture in Cold War America* (S. Hadley, Massachusetts 1980), is the best source; see also Martin Glaberman, *Wartime Strikes* (Detroit 1980).

19. Alan Wald, *The New York Intellectuals* (Chapel Hill 1987), Section III, conveys

this history as neo-conservative drift; *The Legacy of the Workers Party* illuminates the individual exceptions such as Herman Benson, leader of the Association for Union Democracy.

20. 'Capitalism and the War', *New International*, VI (July 1940), p. 28.

21. J.R. Johnson, 'Trotsky's Place In History', ibid., VI (September 1940), pp. 151-67; unpublished autobiography.

22. *'My Friends': A Fireplace Chat on the War, by Native Son* (New York 1940), pp. 6, 8, 12.

23. 'Down with Starvation Wages in Missouri', reprinted in *The Future in the Present*, p. 94. David Burbank Interview (by Paul Buhle), OHAL Archives, casts doubt upon James's agitational efforts, but James's own unpublished autobiographical account describes at some length his rural encounters. Constance Webb points out, in a letter to the author, the considerable personal danger to an outside figure such as James in the rural South of the time.

24. James to Webb, 26 August 1943, Schomburg Collection; see also Dunayevskaya's account, 'The Emergence of a New Movement', especially p. 43, and related documents in the Raya Dunayevskaya Papers, Wayne State University. Unfortunately, neither Dunayevskaya nor Boggs has detailed much of the earliest, happiest days of the collaboration. James has provided a bit more, in an obscure source, *Letters on Organization* (Detroit, n.d. [1963?]), emphasizing his own leadership in the early period. Fragments of the unpublished autobiography also deal with the early group, but not in great depth. A contemporary document, *Education, Propaganda, Agitation* (Detroit 1968, from 1943 original), elaborates best the Tendency's practical recommendations for the Workers Party.

25. Interview with Grace Lee (by Dan Georgakas), OHAL Archives.

26. Grace Lee interview; on Trotskyism and Communism at large, see Alan Wald, *The New York Intellectuals*, and Paul Buhle, *Marxism in the USA*, Ch. VI.

27. James to Webb, 1 September 1943, Schomburg Collection. See also James, 'Russia – a Fascist State', *New International*, VII (April 1941), a view which James later considered exaggerated but insightful; James, 'The Way Out for Europe', *New International*, XI (April 1943), p. 154.

28. 'Historical Retrogression or Socialist Revolution, a Discussion Article on the Theses of the IKD', *New International*, XII (January 1946), pp. 28-9.

29. Julius Jacobson perhaps conveys best the rightward turn of many Workers Party members and the resistance of others to this tendency, in 'Socialism and the Third Camp', *New Politics*, New Series, I (Summer 1986).

30. Interview with Filomena Diddario (by Paul Buhle), New York, 1983.

31. Interview with Steve Zeluck (by Paul Buhle), OHAL Archives.

32. J.R. Johnson, 'The Elemental Urge to Socialism', *Militant*, 18 August 1947, my emphasis; see, e.g., also J. Meyer [C.L.R. James], 'Negro Life in the South: An Honest Report', *Militant*, 22 July 1949.

33. J.R. Johnson, 'The Elemental Urge to Socialism', *Militant*, 11 August 1947.

34. Matthew Ward [Charles Denby], *Indignant Heart* (New York, 1952); interview with Steve Zeluck (by Paul Buhle), OHAL Archives; Wohlforth, *The Struggle for Marxism*, Ch. IV.

35. The Communist-inclined writers among this group who had not (like Ruth McKenney) already been alienated from the Left regathered around the short-lived *Mainstream* magazine. Still others, such as K.B. Gilden (a husband–wife writing team close to the Communist Party), simply came of age too late for affiliations to matter very much. Katya Gilden interview (by Paul Buhle), OHAL Archives.

36. Paul Romano and Ria Stone, *The American Worker* (Detroit 1949); Matthew Ward, *Indignant Heart* (New York 1952).

37. *The Invading Socialist Society* (Detroit, 1967 edition). Raya Dunayevskaya, 'The Emergence of a New Movement', emphasizes her own special intellectual contributions.

38. C.L.R. James, *State Capitalism and World Revolution* (Chicago 1986), especially Ch. II, V, IX and X. I have drawn freely from my own Introduction to this new edition.

39. I published this document as *Dialectic and History* (Cambridge, Ma 1973) from the 1947 original in the Raya Dunayevskaya Papers, Wayne State University. It has been

printed in its full original, 'Dialectical Materialism and the Fate of Humanity', in *Spheres of Existence* (London 1980).

40. Constance Webb to author, 15 December 1987.

41. C.L.R. James, *Notes on Dialectics* (London 1985), pp. 20–21, 99–100.

42. Ibid., p. 65.

43. Ibid., p. 153.

44. Ibid., pp. 192–9.

45. Ibid., pp. 226–7.

46. 'On Marx's Essays from the Economic–Philosophical Manuscripts' reprinted in *At the Rendezvous of Victory*, p. 69.

47. Interview with Steve Zeluck (by Paul Buhle), OHAL Archives.

48. 'The Revolutionary Solution to the Negro Problem in the USA', in *The Future in the Present*, pp. 126–7.

49. Tony Martin, who may be fairly described as the leading intellectual Garveyite of today, has an interesting comment upon James in 'C.L.R. James and the Race/Class Question', *Race*, XIV (1972).

50. See Mark Naison, *Communists in Harlem During the Depression* (Urbana 1983), for a very different scenario; the subsequent history of Blacks and the CPUSA, a vital subject, remains to be written.

51. *A History of the Negro Pan-African Revolt* (Washington 1970, from 1938 original), pp. 5–6.

52. 'Dialectical Materialism and the Fate of Humanity', in *Spheres of Existence*, p. 104.

53. James, unpublished autobiographical ms.

Chapter 4

1. C.L.R. James, *Beyond a Boundary* (New York, 1983), p. 149.

2. James to Constance Webb, June 1945[?], Schomburg Collection, New York Public Library.

3. Fredy Dutton, 'My Experiences of Splits and Unifications in the American Movement', *Johnson–Forest Bulletin*, no. 3 (31 July 1947), available in Raya Dunayevskaya Papers, Wayne State University.

4. See, e.g., James to Webb, 15 December 1943.

5. James to Webb, undated 1944; 14 June 1944.

6. Unpublished manuscripts, James Archives.

7. Constance Webb, letter to author, 15 December 1987.

8. See e.g., James to Webb, 4 February 1944.

9. Unpublished manuscripts, James Archives.

10. *Mariners, Renegades and Castaways* (London 1986), pp. 50–1.

11. Wilson Harris, letter to author, September 1987.

12. *Mariners*, p. 22.

13. Ibid., Ch. IV. Equally odd, and surely connected with James's experience among the intellectual Left, is his fleeting reference to homosexuality here as one of the psychological maladies produced by modern civilization; doubly odd, because he recognizes the homosexual relationship of Ishmael and Queequeg; and triply so, from the intellectual standpoint of James the pronounced Grecophile.

14. See James to Webb, 5 April 1946.

15. *Mariners*, p. 110.

16. See Caryl Emerson, 'The Outer World and Inner Speech: Bakhtin, Vygotsky and the Internalization of Language', in Gary Saul Morson, ed., *Bakhtin: Essays and Dialogues on His Work* (Chicago 1986), pp. 21–40.

17. *Mariners*, Ch. VII.

18. *Trotskyism in the US 1940–47: The Balance Sheet* (New York 1947), p. 11.

19. See Alan Wald, *The New York Intellectuals: The Rise and Decline of the Anti-*

Stalinist Left from the 1930s to the 1980s (Chapel Hill 1987), Part III.

20. The best tracing of this development and the influential personalities involved is in Sidney Blumenthal, *The Rise of the Counter-Establishment: from Conservative Ideology to Political Power* (New York 1986).

21. *Mariners, Renegades and Castaways*, p. 93.

22. Ibid., Ch. VI; James to Webb, 'Sat'y and Easter Sunday' [1949?].

23. Ibid.

24. C.L.R. James, *The Old World and the New: Shakespeare, Melville and Others* (no studio given, 1970).

25. C.L.R. James, 'Notes on American Civilization', unpublished ms, not consecutively paged.

26. Ibid.

27. Ibid.

28. Ibid.

29. Ibid.

30. Ibid.

31. Ibid.

32. Ibid.

33. *The Correspondence Booklet* (Detroit 1954) offers some insights into the publication. But for the popular culture sensibility, one must return to the scarce originals. See Grace Lee Boggs interview, by Dan Georgakas, OHAL Archives.

It may be noted here that *Correspondence* (and the original 'Workers' Correspondence'), along with James's work in general, helped to inspire the creation of *Cultural Correspondence*, published and edited by myself, 1975–81, which carried James's critique of popular culture forward. See Paul Buhle, ed., *Popular Culture in America* (Minneapolis 1987), for a representative sampling from that Jamesian publication, and especially the Introduction for an elucidation of James's methodological contribution to the newer generation of culture critics.

Martin Glaberman, who emerged as leader of the group by the middle 1950s, best articulated the economic–political side of the critique and has continued in recent years to do so. See his pamphlets *Punching Out* (Chicago 1971, from 1953 original) and *The Working Class and Social Change* (Toronto 1975). Glaberman, *Union Committeemen and Wildcat Strikes* (Detroit 1971, from 1955 original), gives a general commentary upon the general politics of the group, and a militant attack upon the failure of its earliest editor, a radical union leader, to carry those politics successfully into the paper.

34. Ivar Oxaal quotes an anonymous source on this 'rambling' quality: Oxaal, *Black Intellectuals Come to Power* (Cambridge 1968), p. 78. Grace Lee Boggs's recollection also jibes with this: see Nettie Kravitz interview, OHAL Archive.

35. The Raya Dunayevskaya Collection massively documents the 'Marxist–Humanist Tendency' at Wayne State University. See also the material in the *News and Letters* issue dedicated to the memory of Raya Duayevskaya, 25 July 1987. Dunayevskaya has given several short accounts of the split. One of the most interesting is in Raya Dunayevskaya, 'The Emergence of a New Movement from Practice that is Itself a Form of Theory', in *A 1980s View: The Coal Miners' General Strike of 1949–50 and the Birth of Marxist–Humanism in the US* (Chicago 1984). James's own interpretation is made, informally but at greater length and with a considerable amount of self-criticism, in *Letters on Organization* (Detroit n.d. [1963?]), especially pp. 1–10. See also James to Webb, 'First Letter, Reno, Nevada, 1948', Schomburg Collection, for a prescient view of internal tensions which would make a split likely.

36. Dan Georgakas, 'Young Detroit Radicals, 1955–1965', in *C.L.R. James: His Life and Work*.

37. *Facing Reality*, 'By C.L.R. James, Grace Lee, Pierre Chaulieu' (Detroit 1974), p. 48; 'Chaulieu', in reality Carlos Castoriadis, apparently signed the edition in political solidarity, rather than serving as a full collaborator. This is the only one of James's major works (and the only full-length work, along with *Modern Politics*) which has not been republished by a major firm.

38. *Facing Reality*, p. 102.

39. 'The Destruction of a Workers' Paper', in *Marxism and the Intellectuals* (Detroit 1962).

40. Letter of Constance Webb to Paul Buhle, 15 December 1987; James to Webb, undated 1944.

41. By Selma James, drafted during the 1950s but published for the first time as 'The American Family: Decay and Rebirth', *Radical America*, IV (February 1970), pp. 4–5.

42. Ibid., p. 7.

43. Interview with George Lamming, 24 November 1987.

44. See James's essays in *Cricket*, edited by Anna Grimshaw (London 1986), dating from the 1950s.

45. *Beyond a Boundary*, p. 152.

46. Ibid., p. 154.

47. Ibid., p. 194.

48. 'Introduction', to *Cricket*, p. xi.

49. Sylvia Wynter, 'In Quest of Matthew Bondsman: Some Cultural Notes', in *C.L.R. James: His Life and Work.*

50. Interview with George Lamming; Lamming, *Season of Adventure* (London 1960), especially Part II, 'Revolt of the Drums'.

51. George Lamming, *Natives of My Person* (London 1972), especially Ch. VI.

52. George Rawick, 'Personal Notes', in *C.L.R. James: His Life and Work.*

Chapter 5

1. C.L.R. James, 'The Old World and the New', published for the first time in *At the Rendezvous of Victory*, p. 211.

2. C.L.R. James, 'Black Power', a speech delivered in 1967 and published for the first time in *Spheres of Existence*, p. 229.

3. Ibid.

4. C.L.R. James, *Marxism and the Intellectuals* (Detroit 1962), reprinted in *Spheres of Existence*, pp. 114, 127.

5. *Letters on Organization* (Detroit n.d. [1963?]), p. 35.

6. Perspectives and Proposals (Detroit 1966), p. 26.

7. C.L.R. James, unpublished autobiographical notes.

8. C.L.R. James, 'Kwame Nkrumah of Ghana', in *At the Rendezvous*, p. 184.

9. See Marable's discussion of the Nkrumah and the James–Nkrumah–Padmore link: *African and Caribbean Politics* (London 1987), Ch. I–II.

10. C.L.R. James, *Nkrumah and the Ghana Revolution* (London 1977), pp. 54–5.

11. Ibid., p. 56.

12. Ibid., pp. 107–08.

13. Ibid., p. 120.

14. C.L.R. James, '1962: Twenty Years After', in *Nkrumah*, p. 183.

15. C.L.R. James, 'Kwame Nkrumah of Ghana', *At the Rendezvous*, p. 180.

16. 'Peasants and Workers', reprinted from *Radical America*, V (November 1971), in *Spheres of Existence*.

17. 'The History of the African Revolt; a Summary of 1939–1969', in *A History of the Pan-African Revolt* (Washington, DC, 1969), p. 143.

18. C.L.R. James, 'Toward the Seventh: The Pan-African Congress–Past, Present and Future (1976)', reprinted into *At the Rendezvous*.

19. Perhaps the best source remains Ivar Oxaal, *Black Intellectuals Come to Power: The Rise of Creole Nationalism in Trinidad and Tobago* (Boston 1968), Ch. V–VIII. See also Scott B. MacDonald, *Trinidad and Tobago: Democracy and Development in the Caribbean* (New York 1986), Ch. III–V.

20. Compare Oxaal's version with MacDonald, *op. cit.*, Ch. V–VI, and with two rather official accounts, Ken I. Boodhoo, ed., *Eric Williams: The Man and the Leader* (Lanham,

Md., 1986); and Eric William's own autobiographical, *Inward Hunger: The Education of a Prime Minister* (Chicago 1969). James's 'The Nation and the Party', Part II of 'PNM Go Forward', reprinted from an earlier pamphlet in *Party Politics in the West Indies* (Port of Spain, n.d., 1962). conveys best his exasperation.

21. Thanks to George Lamming for two conversations in Barbados, 23 and 24 November 1987, emphasizing these points.

22. Kent Worcester, *West Indian Politics and Cricket: C.L.R. James and Trinidad 1958–1963* (San German, Puerto Rico n.d. [1986], p. 8.

23. James in *The Nation* (Port of Spain), 'Without Malice', 17 April 1959; see also, e.g.: 'The Americans and Ourselves, III', 20 December 1958; 'Are We a Philistine Society?', 27 December 1958; 'Without Malice', 7 August 1959; 'Notes on the Life of George Padmore', 30 October 1959; '"M"', "Steelband History Is Ourselves', and Williams's weekly column, 'The Doctor Says', 10 January 1959.

24. C.L.R. James, 'On Federation', a 1958 lecture reprinted in *At the Rendezvous*, p. 98.

25. Oxaal, *Black Intellectuals Come to Power*, Ch. VII.

26. *Party Politics*, p. 105.

27. Ibid., p. 109.

28. Described adequately nowhere, but see MacDonald, *Trinidad*, Ch. VII.

29. Earl Lovelace, *The Dragon Can't Dance* (London 1979), James quoted from front cover.

30. I am grateful to Paget Henry for stressing this point.

31. David G. Nichols, 'East Indians and Black Power in Trinidad', *Race and Class*, XII (1971), pp. 443–59.

32. *Party Politics*, Introduction, p. 4.

33. 'Williams Was No Genius ... The Oil Saved Him', an interview with Harry Partrap in *The Trinidad and Tobago Express*, 7 April 1981, reprinted in 'C.L.R. James: His Life and Work', *Urgent Tasks* (1981), p. 83, but not reprinted in the Allison & Busby edition.

34. Walter Rodney, *The Groundings With My Brothers* (London 1969); his murder is discussed in Marable, *African and Caribbean Politics*, 178–80. I am grateful to Eric Perkins for extended discussions of Pan-Africanism.

35. C.L.R. James, 'Facing Reality', *Negro Americans Take the Lead* (Detroit 1964), p. 17. Glaberman points out to me that the New Tendency survives as an intellectual–political network keyed to working-class-oriented sociology and history. Letter to author, 11 February 1988. Thanks also to Bruno Ramirez for a conversation about James's influence on the Windsor, Canada, area New Left of the early to middle 1970s.

36. See 'Conversation', with Vincent Harding and Ken Lawrence, in *C.L.R. James: His Life and Work*. The *Urgent Tasks* edition includes still other commentaries of interest here, especially Richard Thomas, 'Black Scholar', and John Bracey, 'Nello'. I am also grateful to Eric Perkins and Ellen DuBois for recollections of James's coming to Northwestern University for a semester, and his classroom role there.

37. C.L.R. James, 'The Atlantic Slave Trade and Slavery: Some Interpretations of Their Significance in the Development of the United States and the Western World', *Amistad 1: Writings on Black History and Culture*, edited by John A. Williams and Charles F. Harris (New York 1970), pp. 141, 148. Reprinted in *The Future in the Present*.

38. Dan Georgakas, 'Young Detroit Radicals, 1955–1965', in *C.L.R. James: His Life and Work*. I am grateful for a private communication from Martin Glaberman, February 1988, on James's wider influences on Black militants of the era.

39. See the historical tracings in C.L.R. James, 'Black Studies and the Contemporary Student', about DuBois and others, in 'The Historical Roots of Black Liberation', *Radical America*, II (July–August 1968) and 'W.E.B. DuBois', reprinted from a 1965 edition of DuBois's *The Souls of Black Folk* in *The Future in the Present*; 'Paul Robeson: Black Star', reprinted from *Black World*, 1970, in *Spheres of Existence*, and 'George Padmore: Black Marxist Revolutionary', a speech printed in *At the Rendezvous*.

40. Anthony Milne, 'C.L.R. James on Nuclear War', *Trinidad Express*, 9 November 1982.

41. Ishmael Reed, *Mumbo Jumbo* (New York 1972), p. 130.

42. Paget Henry, 'Decolonization and Cultural Underdevelopment in the Commonwealth Caribbean', in Paget Henry and Carl Stone, eds, *The Newer Caribbean: Decolonization, Democracy and Development* (Philadelphia 1983).

43. C.L.R. James, 'The Artist in the Caribbean', a 1959 address published in *Radical America*, IV (July–August 1970) and reprinted in *The Future in the Present*.

44. C.L.R. James, 'On Wilson Harris', a 1965 speech printed in *Spheres of Existence*. See also Kenneth Ramchand's introduction to Wilson Harris, *Palace of the Peacock* (London, 1969 edition).

45. Quoted in Ramchand, ibid., p. 3.

46. Ibid.

47. C.L.R. James, 'Appendix: From Toussaint L'Ouverture to Fidel Castro', *Black Jacobins* (New York, 1963 edition), p. 399.

48. C.L.R. James, 'Kanhai: A Study in Confidence', reprinted from *New World*, 1966, in *At the Rendezvous*, p. 169. C.L.R. James, 'The Mighty Sparrow', reprinted from *Party Politics in the West Indies* in *The Future in the Present*, p. 199.

49. 'The Mighty Sparrow', reprinted in *The Future in the Present*, p. 199.

50. 'West Indies – Microcosm', *Free Spirits* (San Francisco 1982), p. 93.

51. Jay Monroe, 'C.L.R. James: A Tribute', *The Gleaner* (Jamaica), 6 February 1972.

52. C.L.R. James, 'Rastafari at Home and Abroad', published in 1964 in *New Left Review*, reprinted in *At the Rendezvous*, p. 164.

Conclusion

1. Harvey Swados, *Celebration* (New York 1975); some of the political and intellectual implications of Swados's work are discussed in Paul Buhle, ed., *The Legacy of the Workers Party, 1940–49: Recollections and Reflections* (New York 1985), especially pp. 21–34.

2. Noel Ignatiev, 'Meeting in Chicago', in Paul Buhle, ed., *C.L.R. James: His Life and Work* (London 1986), p. 246.

3. Anthony Milne, 'C.L.R. James On Nuclear War: We Live in the Shadow of the Gates of Hell', *Trinidad Express*, 9 November 1982.

4. C.L.R. James, 'Free for All', *Cultural Correspondence*, NS2 (Winter 1983), p. 21.

5. C.L.R. James, 'On Poland', ibid., p. 20.

6. C.L.R. James, *Modern Politics* (Detroit, 1973 edition), p. 74.

7. C.L.R. James, 'The Way Out – World Revolution', *Radical America*, VI (September–October 1973), reprinted in Paul Buhle, ed., 'A Fifteen-Year Anthology', *Radical America*, XVI (May–June 1982), p. 125.

8. Dave Wagner, 'Philosophy and Culture', *C.L.R. James: His Life and Work*, p. 203.

9. 'Feet First', *Cultural Correspondence*, nos. 12–14 (Winter 1981), p. 6.

10. See especially Sandra Drake's final chapter, 'Language and Revolutionary Hope as Imminent Moment', *Wilson Harris and the Modern Tradition: a New Architecture of the World* (Westport 1986), Ch. IX.

11. See for example Edward Said, 'Intellectuals in the Post-Colonial World', *Salmagundi* nos. 70–71 (1986).

Index